American Art Pottery

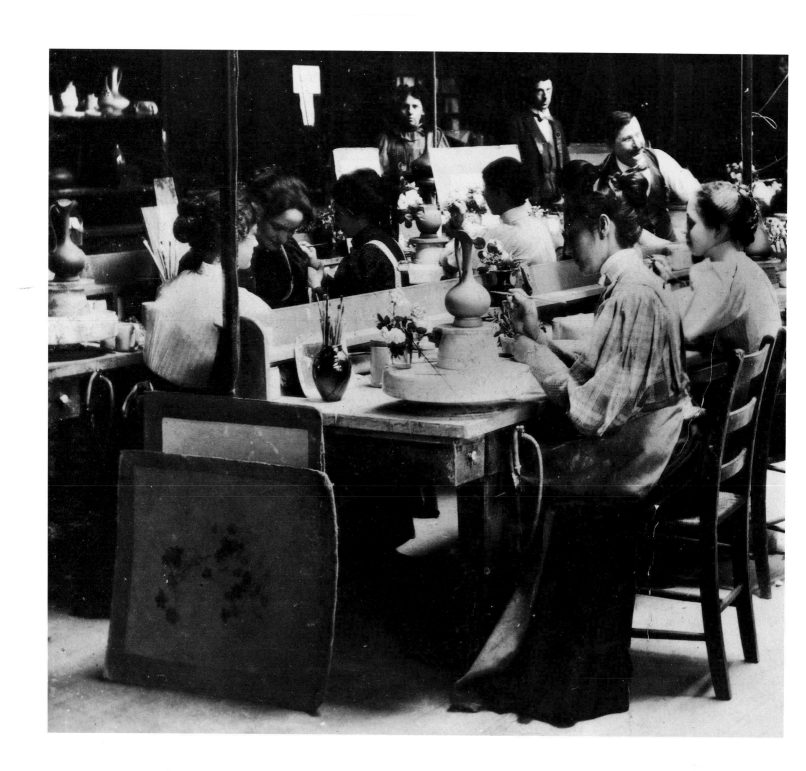

American Art Pottery

Cooper-Hewitt Museum

The Smithsonian Institution's National Museum of Design

Distributed by
University of Washington Press
Seattle and London

Cooper-Hewitt Museum
2 East 91st Street
New York, New York 10128

Typeset by Trufont Typographers
Printed in Great Britain by
Balding + Mansell International Ltd.

Library of Congress Cataloging-in-Publication Data

Cooper-Hewitt Museum.
 American art pottery.

 Bibliography: p.
 1. Pottery, American—Catalogs. 2. Pottery—19th
century—United States—Catalogs. 3. Arts and crafts
movements—United States—Catalogs. 4. Decoration and
ornament—United States—Art nouveau—Catalogs.
5. Goodman, Marcia—Art collections—Catalogs.
6. Goodman, William—Art collections—Catalogs.
7. Pottery—Private collections—New York (N.Y.)—
Catalogs. 8. Cooper-Hewitt Museum—Catalogs. I. Title.
NK4007.C66 1988 738'.0973'07401471 87-72601
ISBN 0-910503-51-6

This publication is made possible, in part, with public
funds from the New York State Council on the Arts.

Contents

Donors' Statement

The philosophy and work of the Arts and Crafts movement in America attracted us largely because of the freedom, the humanism, and the naturalness of style that it inspired. The pottery that came out of the movement seems especially to exemplify these ideals, for although the potters shared the same ideology, each piece of pottery, due to the nature of clay, is extremely personal and individualized.

Ultimately, a piece of pottery must be interesting, honest, and worthy of entertaining a tabletop in the same way that a good painting entertains a wall. The importance of the work we love is measured by how well it meets these criteria. Our collection of art pottery began as a selection of individual pieces that gradually evolved into a related and extended family of works by virtue of certain properties that they share. For us a piece of pottery embodies the energy and profound intentions of the artist. We have always appreciated the fact that clay demands an intense relationship between artist, fire, and object; in a successful work of art the artist's experience and intelligence are bound together for the viewer to behold.

Todd Volpe of the Jordan-Volpe Gallery has been most helpful and sympathetic to our feelings about art pottery. The Gallery's now historic exhibitions on the Rookwood, Fulper, and Grueby potteries stimulated our interests and made us want to explore further.

We also want people to know how pleased we are that this collection will be permanently housed at the Cooper-Hewitt Museum. Our pottery could not reside in a more appropriate or wonderful space.

And, of course, we wish to express our gratitude to David Revere McFadden, whose knowledge, sensitivity, and good humor have helped to make this rather emotional transfer of our treasured goods relatively painless.

Marcia and William Goodman

Foreword

Surprisingly, the founders of the American art pottery movement and the Hewitt sisters, who established the Cooper Union Museum for the Arts of Decoration, as our museum was once called, had remarkably similar goals—to work toward elevating public taste and toward improving the quality of American craftsmanship and design. A century ago, when the Hewitts were briskly collecting for their museum-to-be, American potteries were about to gain international recognition and to attract the attention of leading museums abroad; yet the Hewitts showed little interest in collecting the arts and crafts of their time. Thus, there remained a serious gap in the collection, which was only filled in 1984 by Marcia and William Goodman through their generous gift of seventy-six important pieces representing major potters, potteries, techniques, and forms of the American art pottery movement.

A new generation of scholars has begun to assess the history of American ceramics, so we were delighted when the Goodmans offered to help subsidize a catalogue of their collection. Believing that such a publication would be a valuable reference for historians and collectors, the New York State Council on the Arts provided additional support. Our enthusiasm for the project was increased by our ability to engage Vance Koehler, a graduate of the Cooper-Hewitt Museum/Parsons School of Design Master of Arts Program, to conduct research on the collection and to write the catalogue. We were fortunate, as well, that Kenneth Trapp, Curator of Crafts and Decorative Arts at the Oakland Museum, agreed to write the introduction. For the catalogue's physical appearance we are indebted to Katy Homans, designer; Carmel Wilson, photographer; and Nancy Aakre, editor who also oversaw its production.

As this publication goes to press, the Goodman Collection is being circulated by the Smithsonian Institution Traveling Exhibition Service to more than a dozen cities around the United States. We are especially grateful to our Curator of Decorative Arts, David Revere McFadden, who organized this unique exhibition and who is responsible for the Collection's having been entrusted to the Cooper-Hewitt's care.

Both sets of founders, the Hewitt sisters and the leaders of the art pottery movement, will be remembered with gratitude as having made a lasting contribution to the history of American decorative arts. And, although the art pottery movement as documented in the Goodman Collection has long since become history, a renewed spirit of creativity in the ceramic arts flourishes in the United States today.

Lisa Taylor
Director Emeritus

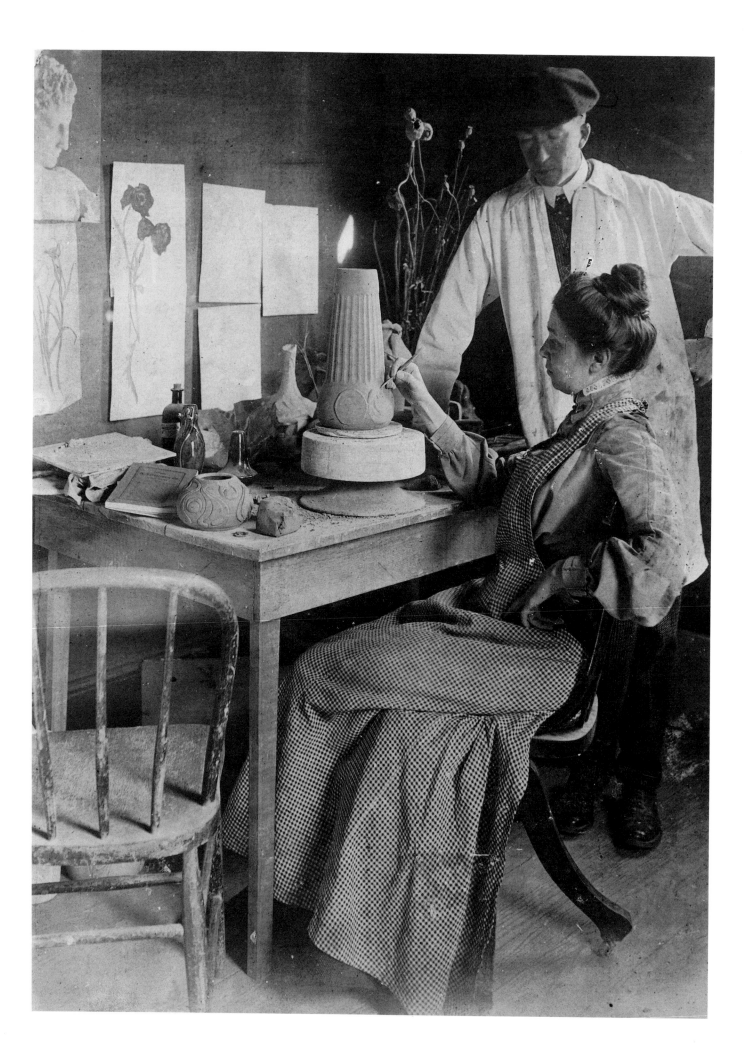

Introduction

In the history of American decorative arts, the term *art pottery* identifies a distinctive approach to clay, within the broad context of the Arts and Crafts movement, from the mid-1870s into the 1930s. Art pottery companies, small pottery studios, and independent decorators and artist-potters were at work in at least twenty states during the height of the movement. Despite its national scope and the astonishing diversity of its creations, art pottery production was dominated by relatively few individuals and companies. Their contributions gave it enduring vitality even as the artistic and philosophical forces of the Arts and Crafts movement itself were waning. No current within the parent movement survived longer, had a more far-reaching effect, or left a richer legacy.

Any discussion of the art pottery movement in America, however brief and general, must begin with the Centennial Exhibition held in Philadelphia in 1876. This event, the first major international exposition hosted in the Americas, proved to be a revelatory catalyst, setting in motion events that were to transform American decorative arts from provincial imitations to original works commanding international admiration.

The Centennial Exhibition introduced millions of Americans to the most recent developments in British and French ceramic art. Doulton and Company of London sent displays of its Doulton Ware, a richly colored and ornamental salt-glazed stoneware, and of its Lambeth Faience, an earthenware painted with bold underglaze designs in brilliant hues. And for the first time in America, Haviland and Company displayed an elegant faience painted under the glaze from its Auteuil studio near Paris.

Japanese ceramic artistry captivated the American public as well. It was inventive in shape and design, imaginative in its use of materials, glazes, and colors, and decorated with exotic subjects. With astute calculation, Japan organized exhibits of pottery and porcelain, bronzes, screens, lacquers, textiles, and bric-a-brac to impress Americans and to create a demand for Japanese wares. France and England had suc-

cumbed to the charms of Japanese design only a few years earlier. Now the Centennial Exhibition gave rise to an American fascination with Japanese arts. More than a fashion, the Japanese mania became a potent and enduring force in American decorative arts.

Although America's own ceramics displayed at the Exhibition revealed at least a few good offerings, native productions in clay suffered by comparison with foreign wares. One humble exhibit, however, came as a pleasant surprise. The Cincinnati Room in the Women's Pavilion displayed examples of china painting done by a circle of women amateurs working in Ohio. Mineral painting over the glaze, such as that employed by the Cincinnati women, had enjoyed a long history in China, Japan, and Europe prior to being introduced to America from England in the early 1870s. The table and household objects in the Cincinnati Room received commendation not so much for their artistic merit as for their suggesting a new avenue of gainful and honorable employment for American women.

Yet many Americans were embarrassed, if not dismayed, by their nation's show of art manufactures at the Philadelphia Centennial. In terms of art and culture, the evidence of the Centennial made it all too apparent that the United States remained a colony. The American exhibits were generally inartistic, imitative, and markedly inferior to those from Britain, the Continent, and Japan.

Even before the Centennial closed, comparisons were being drawn between America's exhibition and England's Great Exhibition of 1851, which had exposed Britain's inferior design standards to its international competitors. France established her supremacy in design and craftsmanship and shamed the shoddy productions of Britain, her traditional cultural rival. So shaken were the British by this national embarrassment that the government, the educational system, advocates of design reform, and British art manufacturers immediately undertook a concerted response to this challenge. Within a few short years such positive results had accrued that, by the time of

Ann and Artus Van Briggle in their studio, c.1902–04. Colorado Springs Pioneers Museum

9

the Philadelphia Centennial, Britain stood in the vanguard of high quality in design. Such a lesson could hardly be ignored by Americans.

Yet more than national pride was at stake in 1876. Extant and newly opening markets for artistic goods, worth millions of dollars annually, stood to be lost unless actively cultivated. Among those Americans who visited the Centennial, several left the grand fair with vivid memories that inspired them to attempt new artistic ventures. Four of these—M. Louise McLaughlin, Maria Longworth Nichols, Hugh Cornwall Robertson, and Charles Volkmar—later contributed significantly to the art pottery movement.

Apart from their amateur efforts in china painting, McLaughlin and Nichols had no experience with or knowledge of ceramics, nor had Volkmar ever worked in clay. Only Robertson had any knowledge of pottery-making and ceramics, having been born to a Scottish-English family of potters who had emigrated to the United States and opened a ceramic manufactory in Massachusetts. Each of these four, however, was inspired by the same work: Haviland's underglaze faience, and the Chinese and Japanese designs. McLaughlin, whose china painting and woodcarving were shown in the Cincinnati Room, left the Centennial determined to replicate the Haviland process, a carefully guarded trade secret.

Nichols found Japanese ceramics so irresistible that she began to consider a pottery of her own, entertaining the romantic idea of bringing a Japanese pottery—workmen and all—to Cincinnati. In Massachusetts, Robertson turned his attention to underglaze decoration and began his quest to reproduce the elusive Chinese oxblood glaze, or *sang de boeuf.* And finally, Volkmar traveled to France to learn underglaze faience decoration as an apprentice at Haviland's Auteuil studio. In the coming years, each of these visionaries would influence, in a special way, the development of an art pottery movement in America.

As early as 1873 the Chelsea Keramic Art Works (CKAW), owned by Robertson's family in Chelsea, Massachusetts, had introduced a line of ceramics made of terra-cotta, a contemporary interpretation of antique shapes and decorations. By 1876 the line had proven unsuccessful and was discontinued, evidence that Americans had yet to develop a taste for art pottery. Nevertheless, the following year CKAW introduced Chelsea Faience, no doubt inspired by the remarkable faience shown in Philadelphia. Simple shapes of classic design, some derived from metal forms, were decorated by various methods: floral decorations were applied or carved in relief; surfaces were given a "hammered" appearance similar to those on Japanese-style metalwork popularized by Tiffany & Company; and designs were cut into the body and then filled with white clay. Softly colored glazes, which adhered well with little or no crazing, were then applied. But this line, too, was discontinued for want of a market.

Robertson introduced a ceramic line he called Bourg-la-Reine of Chelsea in 1878. Named in tribute to the French town where the underglaze decorative process was revived, the CKAW art ware was painted in colored slips on blue or green grounds in the Haviland manner.

The successive introductions and discontinuations of art-ware lines by CKAW prefigured the artistic and financial uncertainties that beset the development of other potteries. History has revealed that Robertson was ahead of his time artistically. But it was not enough merely to produce art pottery. Markets for these wares had to be developed as well.

The early efforts in Chelsea notwithstanding, the American art pottery movement is recognized even in the earliest literature to have had its birth in Cincinnati. While individuals outside of Cincinnati may rightfully claim to have initiated certain developments, the Queen City's artists gave the movement its initial momentum and determined its character and direction. Nor was the area to lose its dominance as the nation's most important center of art pottery.

Back in Cincinnati after her inspirational visit to the Centennial, M. Louise McLaughlin experi-

mented in developing an underglaze painting process that would approximate Haviland's effects. In December of 1877 she succeeded. Her basic process was quite simple: a still moist clay form was painted with mineral oxides mixed in white slip. Under proper conditions the body and the applied decoration would fuse as they dried. When thoroughly dried the piece was fired to the bisque (biscuit) state, then covered with a soft, colorless glaze and fired a final time. Crude as McLaughlin's first specimens of underglaze painting were, they proved the feasibility of her process and its rich promise.

Within months of one another, McLaughlin in Ohio and Robertson in Massachusetts had succeeded in producing underglaze-decorated pottery by the application of slips. McLaughlin herself acknowledged that Robertson probably succeeded first. But her work in developing underglaze painting as a replicable process allowed her, along with Maria Longworth Nichols, to apply the technique successfully in creating a viable art pottery industry.

Volkmar, the fourth American ceramist inspired by the Centennial, figured importantly in the development of American art pottery as well. After two years in France learning the Haviland technique of underglaze decoration, he returned to the United States in 1879 and put his knowledge into practice, both in commercial ventures of his own and with several other potteries. Volkmar's American ceramic work was influenced by the finest of contemporary French productions, and set standards of excellence for American art pottery decorators. Moreover, Volkmar shared his knowledge of the Haviland technique with a considerable number of his countrymen.

The art pottery movement in America can be divided into three phases. The first covers the years between the Centennial Exhibition of 1876 and the World's Columbian Exposition of 1893 in Chicago. The Rookwood Pottery in particular dominated this early developmental phase, although art pottery clubs and art pottery companies had also sprung up in metropolitan Boston, Chicago, New Orleans, San Francisco,

and other scattered places. China painting was being practiced throughout the United States; nonetheless, during these early years art pottery production remained largely confined to urban centers east of the Mississippi.

Art pottery's second phase covers the years between the Columbian Exposition and the end of World War I, from 1893 to 1918. During this period the movement spread nationwide, with small art pottery ventures and larger companies springing up across the country. In these brief twenty-five years the creative and financial success of art manufacture reached its height—and entered a rapid decline. While Rookwood maintained its artistic excellence by introducing new glazes and decorative treatments, the tension between art and profit surfaced in a most visible philosophical change: the company began to mass-produce unsigned pieces.

What might be called the modern period of the art pottery movement, its third and final phase, spans the restless years between the two world wars. Even in the late 1930s, on the very eve of the Second World War, a few new art potteries were being founded, but only as the last gasps of a once vital movement.

The only company that survived beyond these three phases was Rookwood. Unlike the confusing and highly involved histories of many companies, Rookwood's has a clearly defined beginning and end. Founded in 1880 by Maria Longworth Nichols with the express purpose of making art wares, Rookwood operated for eighty years in Cincinnati until 1960, when it was closed and moved to Starkville, Mississippi; there it ceased all operations in 1967. The company did, however, suffer breaks in the continuity of its managerial philosophy, and most of its productions from the 1930s to its demise cannot be considered art pottery.

The art pottery movement in its initial developmental stage grew out of two separate but closely allied pursuits, one commercial and professional, the other amateur but engaged in by many individuals eager to become professionals. These two forces are well represented by Robertson and Nichols.

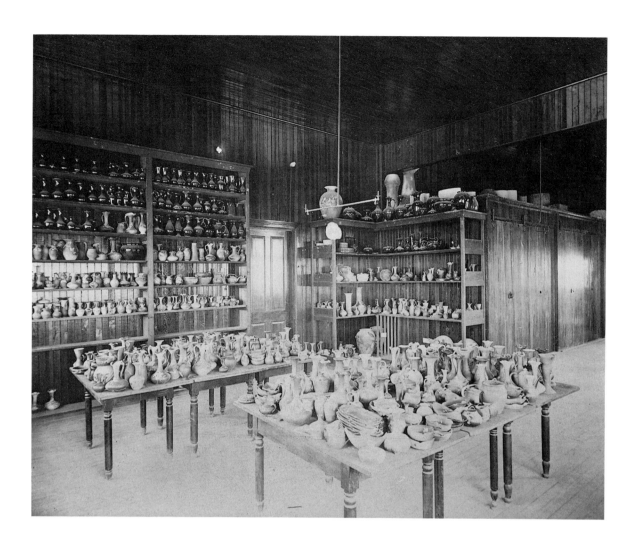

Storage area, Rookwood Pottery, no date. Courtesy of the Cincinnati Historical Society

The most logical place for art pottery manufacture to flourish was within the setting of commercial potteries, which needed only to diversify and enlarge their productions and philosophy. If art pottery was not immediately profitable, its development could be sustained by profits from the company's regular commercial production. Obvious as this premise seems, its application often failed, for men of business were prone to be conservative and impatient with changes that did not produce rapid profits.

The second pursuit from which art pottery developed was amateur china painting. Through this activity, Susan Frackleton, Pauline Jacobus, M. Louise McLaughlin, Clara Chipman Newton, Maria Longworth Nichols, Adelaide Robineau, and Mary Chase Perry entered the movement, to cite but a few of the more prominent names. Initially a genteel diversion limited to mere surface decoration, china painting became for many a passion that embraced the potter's art itself. For such deeply committed amateurs,

pottery became nothing less than an ultimate synthesis of form, ornament, color, and glaze that resulted in a coherent artistic statement. Either ignored or snubbed as the pursuit of hobbyists, china painting has yet to be accorded serious study in terms of its influence in American decorative arts.

The art pottery movement of the 1880s, which is best exemplified by the work of CKAW and Rookwood, was characterized by rigorous experimentation towards the perfection of forms, colors, glazes, and decorative treatments; by an intense search for artistic identity among potteries; and by an ongoing campaign to create a strong market for their wares. The established ceramics manufactories that actually undertook the production of art wares and those benevolent firms that lent their craftsmen and facilities to amateur decorators greatly advanced the art pottery movement. Many of these companies, founded by and staffed with British craftsmen, operated in the manner of British potteries to

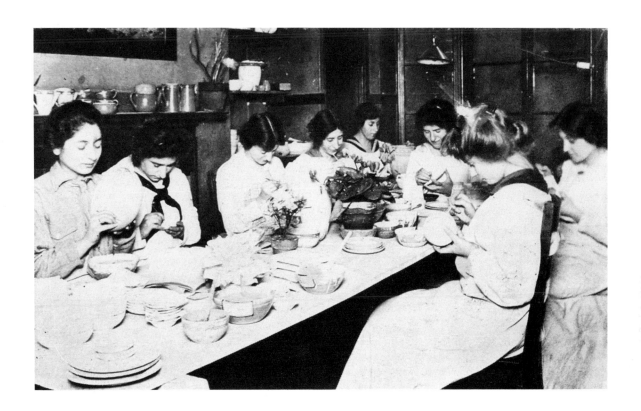

"Girls at work decorating Paul Revere Pottery." *Art and Archaeology*, May 1923.

produce utilitarian wares for the home and industry. They were rarely equipped for artistic production, which required highly refined bodies, delicate colors, unique glazes, and precisely controlled firings. To meet the new demands of art production, constant and rigorous experimentation was necessary.

From its inception, the art pottery movement was characterized by great diversity. The search for suitable and marketable wares produced a rich variety of forms, clays, glazes, and decorative subjects and treatments drawn from myriad sources. Although the movement strove to elevate design in clay from the status of craft to that of art, it nevertheless perpetuated the "vessel" tradition. That is, while most art pottery objects—vases, tablewares, lamps— were created as ornaments, their forms nonetheless implied function. Yet few could actually withstand heavy use because their earthenware bodies, fired at low temperatures and covered with soft glazes, were easily chipped and

cracked. Not until the twentieth century did artists carry clay design to full abstraction, totally divorcing art from function.

The earliest decorative subjects, treatments, and shapes that issued from novice American art pottery companies and the hands of artist-potters reveal, not surprisingly, a determined imitation of the more sophisticated design work of foreign cultures, specifically that of Japan and France. A romantically inspired historicism additionally marked the first phase of the art pottery movement. The Victorian sensibility gloried in conventional decorations and pictorial representations, often at the expense of form. Staunch advocates of design reform railed against naturalistic decoration, but their admonitions were largely ignored. Shapes were treated as surfaces for decoration—landscapes, flowers, birds, insects, animals, aquatic life, and conventionalized patterns. These subjects were often worked in strong colors, enriched with metallic accents, and sculpted in high relief. The spirit of the

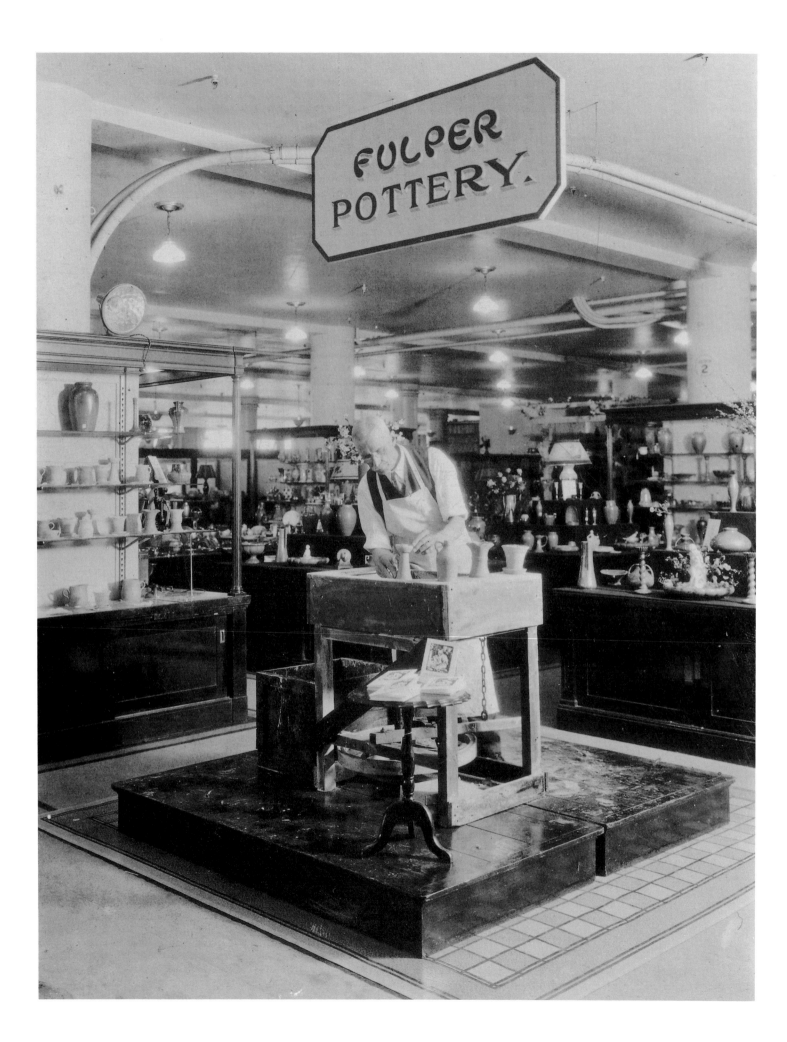

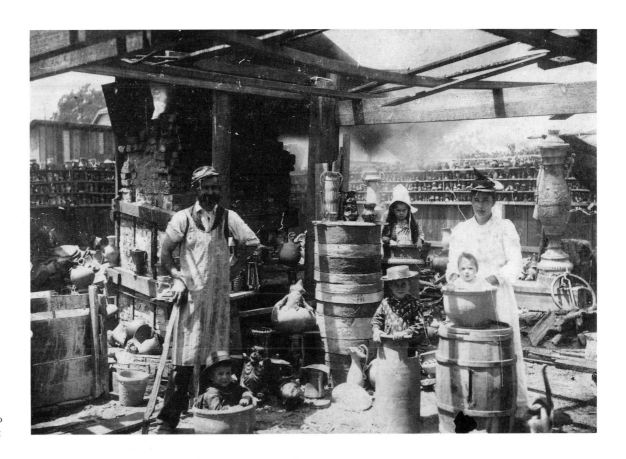

George E. Ohr and family in their pottery yard, Biloxi, Mississippi, no date. Collection of Robert Blasberg

"John Kunsman, Master Potter, demonstrating his skills at the wheel," c.1915. Courtesy of Todd Michael Volpe, New York

times celebrated the distant past and exotic cultures, images from which were freely employed by the potteries. Ancient Greek, Roman, and Etruscan models were reinterpreted by Robertson's CKAW, the Rookwood Pottery, and by firms such as Galloway and Graff of Philadelphia. Forms were inspired by Near and Far Eastern bronzes, earthenwares, porcelains, glasswares, and lacquers, and by Western objects made of silver, glass, and clay. Much Victorian art pottery seems humorous to late-twentieth-century sensibilities, mingling cultural influences as it did, but we should not be misled into thinking of it as an isolated aberration. The choice of motifs—whether historical or exotic—was part of a continuing effort by designers to establish an artistic identity within the context of nineteenth-century aesthetics.

This search for identity is well exemplified by Rookwood's efforts. Although founded expressly to produce art wares of distinction, Rookwood only achieved its goals slowly. Its first products were exuberantly crude, giving no hint of the

pottery's future technical proficiency and refined elegance. This early awkwardness was due both to the inexperience of the decorators and to the limitations imposed by the available materials, equipment, and techniques. Clays were limited to a modest range of qualities and colors—white, cream, yellow, ginger, sage green, and common red. In turn, these clays limited the colors and glazes that could be applied to them, and the temperatures at which they could be fired. Although colors in early Rookwood wares are often vivid, they are cold and hard because delicate hues were destroyed by the high heat.

Under the influence of Maria Longworth Nichols, *Japonisme* shaped the character of Rookwood's decorated pottery and paved the way for the first line of wares identifiable with the company. In Rookwood's first years, its motifs and shapes never attained the lyrical elegance of the Japanese-inspired silver and copper wares of Tiffany or Gorham. Despite Nichols's avidity for the grotesque and comic in Japanese art, the motifs and forms selected by other Rookwood

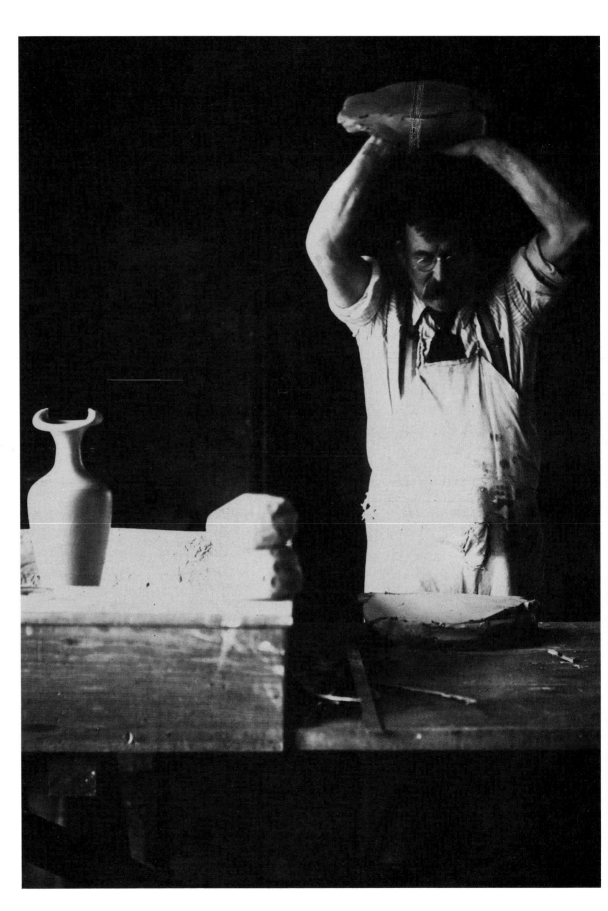

artists soon displayed more conservative tastes. Flying birds, owls perched on branches, spiders in their webs, bats, prunus sprays, chrysanthemums, and leafy bamboo rendered calligraphically were among the most prevalent Japanese decorative motifs in use at Rookwood in the early to mid-1880s. Painted in a subdued palette, these subjects were usually depicted against a ground of white or pale slip, painted in vigorous cloudlike swirls evocative of *ukiyo-e* woodblock prints. Yet while these motifs were strongly marked by their Japanese influence, for Americans they retained an air of familiarity through their reliance on images from nature.

In September of 1881, Nichols hired the youthful Albert Robert Valentien (born Valentine) as the pottery's first full-time decorator. He was soon joined by other artists, among them Matthew Andrew Daly, Laura Anne Fry, and William Purcell McDonald. These four artists, all trained at the School of Design of the University of Cincinnati (later the Art Academy of Cincinnati), possessed some experience in ceramic decoration before entering Rookwood. But their first work at the pottery is often almost impossible to distinguish from that of Nichols, so strong was her influence.

In hiring skilled decorators, Nichols took an important step in making Rookwood a full-fledged art pottery company. She was fortunate to be able to choose from locally trained talent, still young and uncommitted to doctrinaire artistic notions. As much as Nichols hoped to elevate public taste with Rookwood's wares, she first needed to determine just what the public would buy. This determination could come only through a lengthy process of trial and error, for no established market for American art pottery existed to give her direction.

By 1883 Nichols could no longer both decorate the firm's wares and attend to its pressing business matters. If the fledgling enterprise were to succeed it needed the firm hand of an experienced business manager and, accordingly, William Watts Taylor was hired in June of 1883. Time proved Taylor a brilliant choice, for his business acumen was complemented by a

cultured and refined sensibility, both prerequisites for success in an art industry.

Taylor moved decisively with a much-needed analysis of the pottery's sales. Shapes and decorations that sold poorly were discontinued. Tests were made to determine which shapes could be fired easily; those that cracked, warped, blistered, or exploded in the kiln were dead loss. Rigorous experimentation was conducted to perfect clays, colors, glazes, techniques, and kiln conditions.

Of the technical advances that combined to allow the infant pottery to produce distinctively artistic lines, none was so crucial as the development of the atomizer technique, which permitted colors to be sprayed on wares in delicate gradations. By September of 1884, Laura Fry had developed a process by which colors could be sprayed onto still-moist or bisque-fired forms, or onto the glaze itself before firing. Rookwood immediately adopted this process, which revolutionized the pottery's decoration by resolving the problem of how to treat the ground around the underglaze slip painting. Rich colors could now be laid in subtle gradations, to create soft and dramatic effects. The atomizer opened the way for Rookwood's first two artistic lines—Cameo and Standard. Of these, Standard remained a principal ware for some twenty years, from the late 1880s to about 1910.

Decorated primarily with floral subjects, Standard ware evidenced Rookwood's assimilation of the lessons of Japanese art. Nature was depicted in botanical detail, with subjects rendered in apparently casual, asymmetrical arrangements. Standard's yellow-tinted high-gloss glaze, warm, golden colors, and low relief decorations bring to mind Japanese lacquers, while the subtle gradations of the atomized grounds suggest the soft transitions of color seen in Japanese woodblock prints.

To reinforce the acceptance of Rookwood pottery as art, Taylor placed the wares in highly prestigious retail stores in larger metropolitan centers, and in the local shops of smaller cities and towns as well. Although some time passed

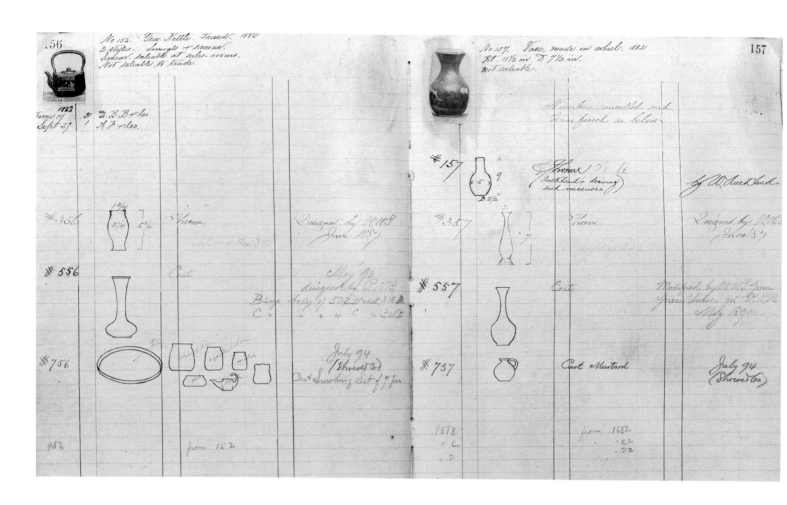

Two pages from the *Rookwood Pottery Shape Record Book*, 1882–83. Courtesy of the Cincinnati Historical Society

before Rookwood began to advertise extensively in popular periodicals, Taylor encouraged the publication of articles about the pottery. But most important, he sent exhibits of Rookwood to a variety of expositions, where thousands of people viewing the pottery displays accomplished what no number of black-and-white illustrations could do.

In May of 1887 Nichols (now Mrs. Storer, having married Bellamy Storer in 1886 following the 1885 death of George Ward Nichols) realized a long-cherished dream: a youthful Japanese pottery decorator arrived at Rookwood. Kataro Shirayamadani remained for decades a principal artist at Rookwood, his work attaining the highest artistic and technical perfection.

Confident now with their artistic direction, Rookwood sent a display of their wares to Paris to the 1889 Exposition Universelle. Included were examples of Standard ware and a new finish called

Tiger Eye—in which a crystalline effect was achieved through a glaze that held glittering golden flecks in suspension. Only thirteen years after the American art manufacturers suffered embarrassment at the Centennial Exhibition, Rookwood captured the prestigious gold medal in Paris. This recognition, by the French no less, brought great publicity, and the prestige that assured financial success.

In 1890 Rookwood became incorporated, with Taylor as president. Two years later the company left its cramped quarters on the banks of the unpredictable Ohio River and moved to a spacious Tudor Revival workshop situated dramatically on Mt. Adams, above the city's thriving downtown and on the edge of lush Eden Park.

Just as Rookwood had dominated the art pottery movement in the 1880s, it reigned supreme in the following decade. At the World's Columbian Exposition in Chicago in 1893, the company made a grand show and again won high honors.

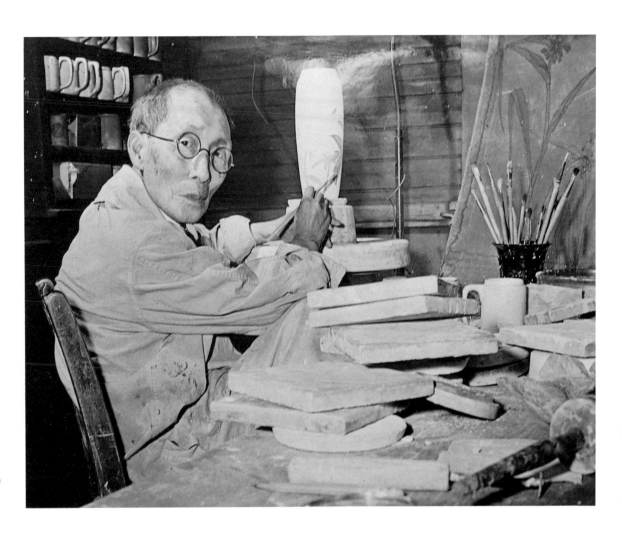

Kataro Shirayamadani at eighty-three years of age, 1945. Courtesy of the Cincinnati Historical Society

Rookwood's rigorous experimentation and zeal for perfection led to greater technical proficiency and artistic sophistication throughout the 1890s. In that decade, the decorating staff attained its fullest complement; never again would so many new decorators be hired in so short a time. The company began to publish its own promotional literature, while continuing to exhibit its wares widely in major expositions.

Rookwood introduced three new artistic wares in quick succession in 1894—Iris, Sea Green, and Aerial Blue, pastel ceramics as cool in palette as Standard ware was warm. In technique, however, they differed in no way from the Standard: all three were painted in slips on white bodies under high-gloss glazes. Standard was varied at this time by the introduction of silver overlay designs applied by the Gorham Manufacturing Company in Providence, Rhode Island, and by the introduction of portraits of noted stage performers, young blacks, Native Americans,

and faces copied from the works of old masters such as Hals, Rembrandt, and Van Dyck. However, blossoms and plants remained the dominant decorative subjects at Rookwood in the 1890s, the firm's artists depicting some two hundred cultivated and wild varieties.

In the 1890s Rookwood evolved a formulaic approach to decoration that facilitated production. While the company proudly proclaimed that no restraints were imposed on the creativity of its artists, this claim was misleading. As employees, Rookwood's decorators attended carefully to the company's close monitoring of the market. The demand for certain forms, subjects, colors, and glazes inevitably imposed artistic limitations.

Rookwood celebrated its twentieth anniversary in 1900, a happy occasion made triumphant by the award of a grand prize in Paris at the Exposition Universelle. Museums in England,

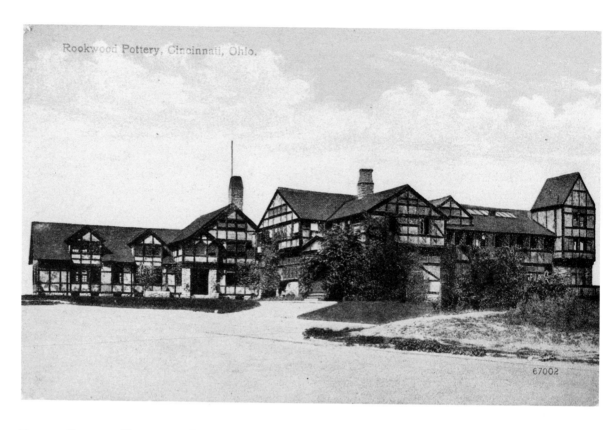

France, Germany, Norway, and Russia purchased pieces for their collections, the most convincing testament that Rookwood had entered a select circle of international art manufactures.

The Paris Exposition of 1900 marked a turning point in the stylistic concerns of American art ceramics. That year Rookwood began the limited production of mat-glazed wares. These dull finishes were no doubt a bow to European and recent American ceramic developments, in particular to the work that the Grueby Faience Company of Boston had exhibited at the Paris show, which had won one silver and two gold medals. The mat glazes and the stylized patterns used at Grueby spoke to a new national preoccupation with simplicity. Simplicity was advocated as an all-encompassing philosophy in domestic life, household decoration, and in architecture. Influenced by this attitude, arbiters of taste judged Rookwood's underglaze-painted decoration self-conscious and overly precious.

By 1904 Rookwood's Standard ware was clearly falling out of fashion, and by 1910, the year of the pottery's thirtieth anniversary, underglaze slip-painted wares had become relics of the past. The move to dull finishes meant not merely the replacement of one glaze with another; the opacity, tactility, and softened color effects made possible through mat glazes required a drastically altered approach to decoration and form as well.

Rookwood's status as America's premier art pottery received serious challenges in the years between the World's Columbian Exposition of 1893 and the outbreak of the First World War. During this period many noteworthy art pottery companies, small pottery studios, and artist-potters entered the field. Some of this new activity came from well-established firms venturing into the production of art wares, while some was generated by wholly new enterprises: the Grueby Faience Company in Boston began operation in 1894; in 1895, the Newcomb and Dedham potteries were founded in New Orleans and Dedham, Massachusetts, respectively; Samuel A. Weller began the production of art pottery under his own name in 1896 in Zanesville, Ohio; and that same year the Stockton Art Pottery Company was incorporated in Stockton, California.

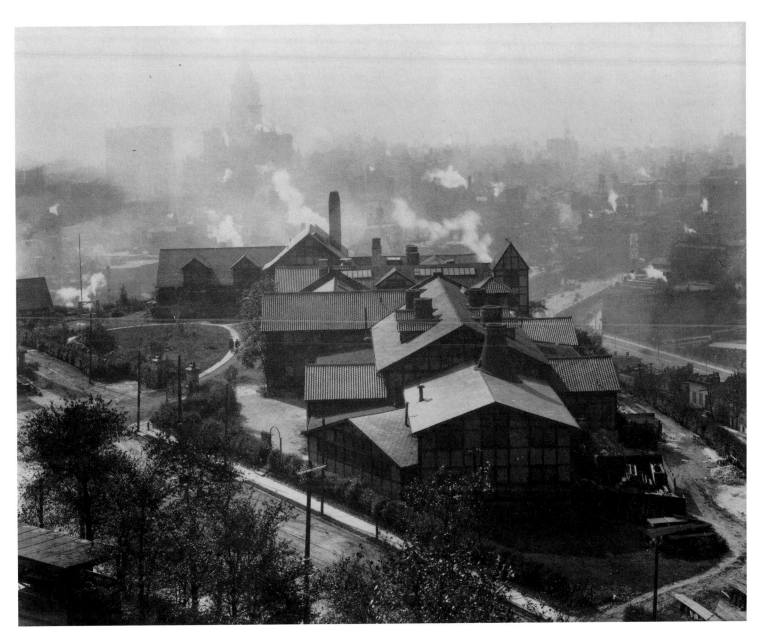

"View of the smoke filled basin from
the monastery on top of Mt. Adams
with the Rookwood Pottery Building
in the foreground," c.1915. Courtesy
of the Cincinnati Historical Society

Advertisement for the University City Pottery, *Keramic Studio,* March 1910. Courtesy of the Virginia Museum of Fine Arts

In 1898, M. Louise McLaughlin took a monumental step when she produced Losanti, a glazed single-fired artistic porcelain. The following year the decorator Artus Van Briggle left Rookwood for reasons of health and settled in Colorado Springs, where he opened his own company in 1902.

Other important art potteries that emerged in the early years of this century include Gates Potteries in Terra Cotta, Illinois (1901), and the Pewabic Pottery in Detroit (1903). Adelaide Alsop Robineau of Syracuse, New York, introduced her studio porcelain at the Louisiana Purchase Exposition in St. Louis in 1904, where the Tiffany Pottery of Corona, New York, also first exhibited. That same year the Marblehead Pottery was founded in Marblehead, Massachusetts. And in 1909, the year in which the

University City Pottery began production in the St. Louis suburb of the same name, the Fulper Pottery of Flemington, New Jersey, added art wares to its production.

The assignment of these dates cannot be so certain as we would wish. To study the art pottery movement is to be struck by the number of companies with tangled histories complicated by the formation and dissolution of partnerships and the problems inherent in entrepreneurship. The realization of a decision to produce art wares often required many months of preparation and experimentation. Yet despite the difficulties the movement grew energetically.

Why did so many and such a variety of art potteries appear within so short a period? Naturally, profit was a strong motive behind the introduction of new art wares. Certainly profit accounts for the willingness of some companies, especially the Ohio imitators of Rookwood, to ape that which was most successful. But to explain the proliferation of art potteries as mere economic opportunism is to deny more significant cultural forces.

Newcomb Pottery, to cite an important example, was not even founded as an industry, but as an educational enterprise for young women. Newcomb developed neither from an established ceramic manufactory nor from a coterie of amateur china painters, but within the context of a university art school. Operated by Newcomb College, the women's school of Tulane University, the Newcomb manufactory had a clearly defined goal in training women for artistic employment, mainly during the years between the completion of their formal training and marriage.

The Marblehead and Arequipa potteries, the latter opening in 1911 in Fairfax, California, grew from similar beginnings. Convalescence programs provided patients with occupational therapy in crafts classes, including pottery decoration. But these two ventures soon encountered a common dilemma—how to reconcile production requirements with the skills of patients in the convalescent therapy program. It

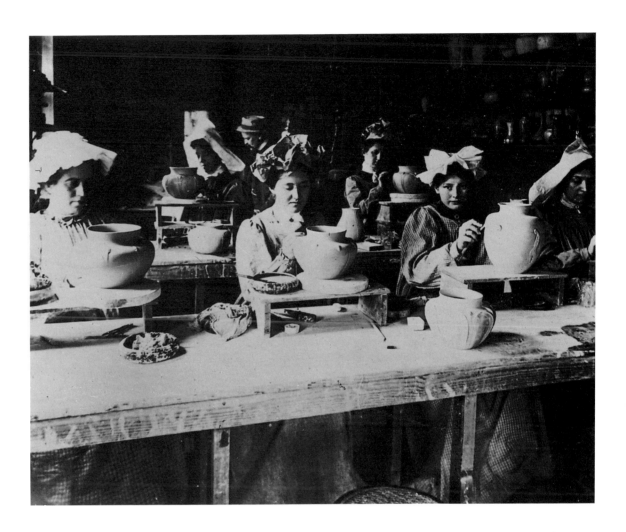

was not long before the directors of each program favored more professional standards.

Whether art pottery was produced in a major manufactory such as Rookwood or Grueby, in a university art school, or in a handicraft class, the ultimate impulse was the same—to produce objects of beauty. And to countless Americans the possession of a piece of art pottery demonstrated that they themselves possessed a refined sensibility and that they were participating in the mainstream of culture.

Maintaining a high public profile remained a constant problem for art pottery producers. In the late nineteenth and early twentieth centuries, national and international expositions provided great exposure to large audiences in a very short period of time. Awards entailed far

more than medals or certificates of recognition for excellence—they also brought widespread free publicity and new customers. Yet the increasing frequency of major expositions, with the time and money they required, soon became as much a burden as a boon for the participants.

In addition to expositions, arts and crafts societies were established, and these organizations provided significant exposure for artists. The first of these was founded in Boston in 1897, while others sprang up across the country in cities such as Detroit, Chicago, Minneapolis, San Francisco, and Cincinnati. These societies and others, such as the Society of Western Artists (which was actually located in the Midwest), promoted local craft artists, but provided exhibition space for the work of nationally known individuals, clubs, and companies.

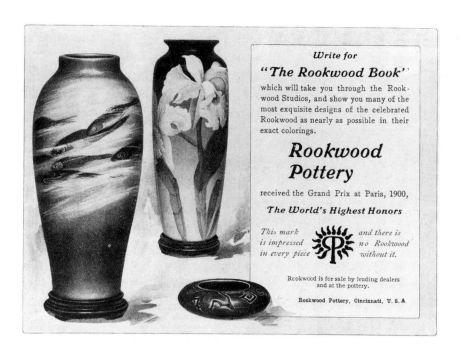

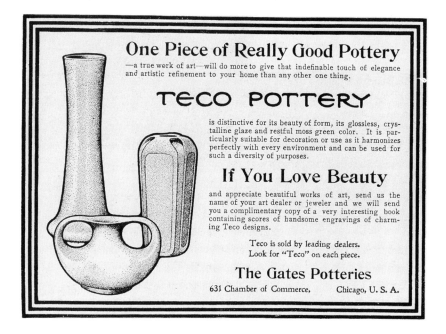

Advertisement for Rookwood pottery, *House Beautiful*, June 1904. Cooper-Hewitt Museum, New York. Library

Advertisement for Teco pottery, *House Beautiful*, September 1905. Cooper-Hewitt Museum, New York. Library

Advertisements and "arranged" articles by supportive and clearly partisan writers afforded the art potteries further access to the public eye. Such important home magazines as *Art Amateur, Art Interchange, House and Garden*, and *House Beautiful* were all aimed at affluent readers and regularly featured articles on art pottery. Additionally, journals arose that specifically addressed ceramics and their role in the Arts and Crafts movement. Adelaide Alsop Robineau founded *Keramic Studio* in 1899, which was followed by Gustav Stickley's *Craftsman* in 1901. These two periodicals soon became the most important arbiters of taste in the American Arts and Crafts movement.

The art pottery companies also published their own brochures and catalogues. It is important to remember that the techniques of national advertising matured concurrently with the rise of the art pottery movement. A major development in marketing art pottery came in 1904 when Rookwood began mail-order sales, making its wares easily available to a much wider audience.

The appearance of so many new potteries between the mid-1890s and the end of the First World War enriched the art pottery movement considerably. Yet amidst the diversity of art pottery production in the early twentieth century, certain signficant shifts in artistic emphasis are apparent. Of these, none was more important than the transition from an overriding concern with decoration to an emphasis upon glazes and the synthesis of form, decoration, and glaze into a total aesthetic statement. No longer regarded simply as the equivalent of varnish—a shining protective finish—glazes became a vital part of the artistic work, exploited for their tactile qualities and richness of color.

By far, the most famous mat glaze developed during the art pottery movement was a rich apple green, introduced by Grueby in 1898 and shown in Paris in 1900. Thick and opaque, Grueby's mat glaze covered the firm's heavily potted, architectonic forms with a texture suggesting finely-grained bark. "Grueby green" quickly became synonymous with any mat green glaze, and grew so popular that it was imitated

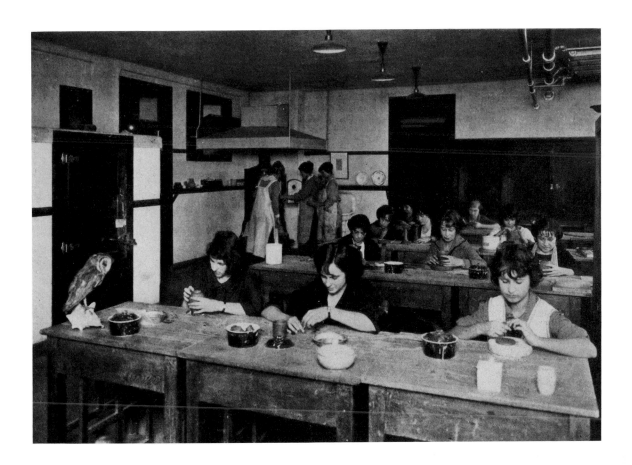

widely at Hampshire, Denver, Merrimac, Pewabic, Teco, Van Briggle—and even at Rookwood.

With the move toward mat glazes, forms themselves became simpler in order to provide expanses of uninterrupted surface. The generous shapes of Native American pottery from the Southwest were adopted, especially at Rookwood, and often covered with solid-colored mat finishes in dark blues, greens, reds, browns, and yellows. Because mat glazes softened contours and blurred lines or fine detail, designs were rendered broadly. Decoration was reduced to stylized designs and patterns applied in flat color. Their graphic equivalent was poster design, an international art form that emphasized bold outlines, flat bright colors, and powerful design in order to heighten visual impact and create immediate response. The ceramic wares of Marblehead, Paul Revere, and Rookwood exploited the poster style fully, some in subtle renderings and others in bolder statements.

One of the high points in the art pottery movement came with the development of the Vellum glaze at Rookwood. Introduced at the Louisiana Purchase Exposition in St. Louis in 1904, Vellum was neither fully mat nor high gloss. It had been developed by the ceramic chemist Stanley Burt after many months of experimentation, and its filmy, soft sheen and inviting tactile qualities suggested the character of parchment.

Although Vellum-glazed wares were often decorated with stylized floral designs, ships sailing the lagoons of Venice, swimming fish, and birds, the glaze came to be identified most strongly with landscape motifs. Scenic Vellum wares, as they were called, depicted pastoral meadows, snowy winter forests, lazy streams, and majestic mountains. These landscapes employed the soft, hazy effects of the Vellum glaze to celebrate atmospheric light, especially the haunting moods of sunrise and twilight.

Mat glazes were but one of the new developments in surface covering of the period. Dramatic crystalline glazes were developed by Fulper, Pewabic, Robineau, University City, and Grand Feu. Unlike Rookwood's Tiger Eye, these glazes exhibited pronounced crystal growths on the surface, often intermingled with or

surrounded by vivid colors. Another rich glaze effect that appeared around this time was the iridescent metallic sheen brought to perfection by Jacques Sicard at Weller—although iridescent glazes were also produced by Theophilus A. Brouwer, Jr., and by Pewabic.

Accident was very much a part of the charm of these glazes and surface treatments. As the glazes matured in the fire, their development could never be predicted accurately. Crystals formed over and around crystals, and as colors separated and flowed one into the other, unique and dramatic results occurred.

The period also witnessed a synthesis of form, decoration, and glaze in art pottery. In the most successful creations, no single element was dominant. This synthesis was often promoted by incorporating the design into the mold, either in relief or in intaglio. At other times the design was integrated with the form by modeling. The plastic qualities of clay easily accommodated the stylized interpretations of organic forms—artichoke and squash blossoms, gourds, insects, fish, birds, and reptiles. Exquisite examples of decorative synthesis were achieved by Rookwood, Tiffany, University City, Van Briggle, Fulper, and Weller.

By 1916, the date commonly accepted as marking the end of the Arts and Crafts movement in America, art pottery seemed adrift; even Rookwood's course appeared unclear. While the company embarked on new decorations and introduced new colors and glazes, it began to produce greater and greater quantities of unsigned, mass-produced wares. Public tastes were changing rapidly, and those few art pot-

teries that still survived seemed incapable of responding to these changes without artistic compromise.

During the economic misery of the 1930s, most art potteries vanished with little notice. The few that managed to survive the lingering Depression could not withstand the traumatic impact upon the luxury trades brought on by another global war. The effect of these severe external pressures on an industry already struggling to survive was ultimately disastrous. During this period, the art pottery movement is considered to have ended.

One can argue that the American art pottery movement was both a disappointment and a creative success. Fine art pottery remained generally beyond the economic reach of most people, although it was always far more affordable than paintings or sculpture. To the extent that this is true, the movement failed to live up to its frequently stated goal of creating a popular art at a reasonable cost. And clearly it failed to provide the stable field of employment for women initially envisioned by feminists and social reformers.

But the movement had its successes as well, producing magnificent works of art—objects that brought credit to their creators and to their country. Moreover, art pottery provided employment for many hundreds of talented decorators and skilled craftsmen, and to thousands more engaged in marketing these wares. And of course we cannot forget what is perhaps the movement's greatest success—the pleasure that art pottery has brought and continues to bring to the millions who have touched and held and admired its rich and subtle forms.

Kenneth R. Trapp

Rookwood Pottery

The first pottery fired at Rookwood was drawn from the kiln on Thanksgiving Day 1880, an event that marked both the culmination of the Cincinnati women's art movement and the beginning of the American art pottery movement. Cincinnati had grown to be a vital industrial city and an important art center during the period following the Civil War, and it offered an ideal setting for the reforming zeal of the awakening Arts and Crafts movement.

Benn Pitman, who had come from England to promote his brother's shorthand method of writing, became an important spokesman for Arts and Crafts ideas in Cincinnati. He established woodcarving classes in 1873 at the University of Cincinnati's School of Design (later the Art Academy of Cincinnati) and encouraged a group of women to pursue practical design in the applied arts. It was these eager followers whom Pitman introduced to the fashionable pastime of china painting in 1874. Their interest was such that he hired a young German woman named Marie Eggers to instruct them in the basic principles of overglaze decoration. Among Pitman's students was M. Louise McLaughlin, who soon became one of the most visible figures among Cincinnati women. Inspired by the ceramics exhibits at the 1876 Centennial Exhibition in Philadelphia, as were so many early pottery enthusiasts, McLaughlin shifted her attention from overglaze china painting, and began working in the *procès barbotine* (later referred to as the "Cincinnati Limoges" technique). The barbotine technique involved painting colored liquid clays, or "slips," onto the ceramic body while the body was still "green," days before firing, and allowed for especially painterly effects that were permanently preserved under the glaze. Her accomplishments and her influence on the decorative style of Rookwood pottery have been well chronicled,[1] but it was her founding of the Cincinnati Pottery Club that most strongly prompted Maria Longworth Nichols to establish the Rookwood Pottery.

McLaughlin organized the Pottery Club in April 1879, with herself as president and Clara Chipman Newton as secretary. A select group of twelve regular and three honorary members were invited to join, including Nichols. However, Nichols's invitation to the first meeting of the Pottery Club supposedly failed to reach her, and in spite of a second invitation being issued, she felt she had been snubbed and decided to work on her own. Up to that time, Nichols's ceramic activities were limited to overglaze china painting, to which she had been introduced in 1873 by Karl Langenbeck, a neighbor and ceramic chemist who had been sent a set of china-painting colors from Germany. Lacking formal art training, Nichols's painted ceramics were nevertheless skilled.

The following month Nichols approached Frederick Dallas, a local commercial potter, about renting a small room at his factory on Hamilton Road, with the intention of setting up a studio for decorating unfired clay vessels. When she realized that the high-firing graniteware kilns used by Dallas for his commercial wares destroyed much of her delicate underglaze decoration, Joseph Bailey, Sr., the superintendent of Dallas's pottery, helped her overcome the problems created by the harsh temperatures. In the fall of that year, the Pottery Club also moved to the Hamilton Road Pottery, and McLaughlin even had a kiln built at her own expense that served the needs of special firing.

Although Nichols had a special kiln installed for firing overglaze decorated wares, she continued to use the high-firing kilns at the commercial pottery for her underglaze work, and found the results to be discouraging and inconsistent. Her father, Joseph Longworth, one of Cincinnati's wealthiest citizens, suggested to his daughter that she start her own pottery where she could have complete control of the creative process. He had recently bought an abandoned schoolhouse at 207 Eastern Avenue, and during the spring and early summer of 1880, Nichols transformed the building into a pottery.

The newly renovated building, complete with equipment purchased upon the advice of Bailey, was named Rookwood because, as she later recalled, "in its length and last syllabe [sic] it reminded one of Wedgewood [sic], and because the word had pleasant associations in my

memory, since it was the name of my father's country place on Walnut Hills, where I lived from one year old to twenty years."[2]

The early years at Rookwood were experimental ones, as Nichols and a group of associates struggled to establish the pottery as a viable enterprise. Essentially, the pottery had been created as an outlet for Nichols's creative energies. It was, in her own words, "at first an expensive luxury which I, luckily, could afford to pay for."[3] But the pottery grew to be more than this; along with her own decorated pieces, the first kiln fired at Rookwood contained a large number of undecorated commercial tablewares, which the staff hoped to sell to help cover operational costs. "The main object of the Pottery is to advance the manufacture of artistic work," Nichols remarked in a letter of January 29, 1881, "as well as to make cheap ware pretty."[4] Early Rookwood production was characterized by a variety of shapes and involved attempts at many techniques of decoration that reflected English and French ceramic styles, especially those popularized by the English Doulton pottery, and by Emile Gallé of France.

For a few years Rookwood supplied undecorated pieces to local amateur decorators and also fired their works, including those of the Pottery Club, which was allowed to rent studio space from Rookwood after the premises were enlarged in 1881.

The growing success of Rookwood meant that the business of running the pottery absorbed more and more of Nichols's time, and in April 1881, she hired her friend Clara Chipman Newton as secretary and assistant. William Auckland, the English-born and -trained potter, was engaged to throw pots on the wheel, and many of Rookwood's early shapes can be credited to him. Nichols also employed her first full-time decorator, Albert R. Valentien (at this time he still used the Valentine spelling of his name), who had worked at Thomas J. Wheatley's pottery in Cincinnati, one of Rookwood's early competitors. After Valentien began work in September of 1881, several other decorators were hired as well, including Laura Anne Fry, the only Pottery

Club member who became a professional decorator at Rookwood.

Technical problems, including the perfecting of clay mixtures and the control of kiln temperatures, filled the early years of the Pottery, but the continued financial security provided by the Longworth fortune saw Nichols through these difficulties. The first year of full production at Rookwood was 1882, and Nichols realized that a clearly defined financial plan was required. In 1883, she asked her close friend William Watts Taylor to become general manager at Rookwood. While Taylor had little knowledge of ceramics at first, he proved to be not only a brilliant organizer and businessman, but also one sympathetic to the art of pottery, and records indicate that he even designed or had a hand in the designing of seventy of the first five hundred shapes in the early Rookwood repertoire. Most important, he helped to transform Rookwood from an amateur enterprise into a professional commercial concern. Nichols later credited the success of Rookwood to him. "It was only after 1883, when Mr. Taylor took charge as my manager," she admitted, "that things began to assume a 'business' air, and the artistic Pegasus had, to a certain extent, to be harnessed to the commercial cart."[5] One of the first things Taylor did was stop production of the undecorated tablewares to concentrate all efforts fully on art pottery. With Nichols's approval, he halted the practice of firing pieces decorated by non-staff, and he later evicted the Pottery Club. In 1881 the Rookwood School for Pottery Decoration had been set up to train decorators, and this, too, was closed, in 1883, in order that all pottery emanating from Rookwood and bearing its mark be decorated by professional staff members.

By the end of 1883, a sales analysis had been conducted to determine which pieces sold well and which should be eliminated from the line. In the same year Newton, at Taylor's direction, began to keep a record of all shapes developed at Rookwood; the *Shape Record Book* was maintained until 1903, and provides valuable information about early wares and about the designers and decorators.[6] Taylor also hired the firm's first chemist, Karl Langenbeck, in the winter of

1884-85, in an effort to improve the clay bodies and glazes used at the firm.[7]

In 1886, six months after the death of her husband, Col. George Ward Nichols, Maria Longworth Nichols married a prominent Cincinnati politician named Bellamy Storer, Jr. Her new husband's position required much of her attention, and her involvement with the pottery she had founded some six years earlier began to diminish. While Rookwood continued to receive her financial support through the end of the decade, increasingly the firm's creative and financial success depended on the direction of William Watts Taylor.

Rookwood was awarded a gold medal at the Paris Exposition Universelle in 1889, and this award marked a new era for the firm. For the first time since its founding, Rookwood showed a profit, and in 1889 Storer ceded Rookwood to William Watts Taylor, who incorporated the firm as a stock company the following year with himself as president and treasurer.[8] Although Storer moved to Washington, D.C., in 1890, she retained some ties with the pottery and requested that a studio be maintained there for her use whenever she visited Cincinnati.

Not long after Rookwood changed hands, plans were drawn up for the construction of a larger facility to accommodate the growing business. A site was chosen on Cincinnati's picturesque Mt. Adams, with a view that overlooked the city. Ground was broken in 1891, and by 1892 Rookwood's new home was ready for occupancy, complete with a flower garden to lend inspiration to the decorators, who now numbered fifteen. By the end of 1892, the number had increased to twenty-four. With few exceptions (such as Kataro Shirayamadani), the decorators at Rookwood were all trained in Cincinnati.

A full range of Rookwood pottery was exhibited at the Chicago World's Columbian Exposition in 1893, and the Pottery received the "Highest Award" for its efforts. "The Rookwood Pottery was the first in this country," wrote ceramic historian Edwin AtLee Barber, "to demonstrate the fact that a purely American art product, in

which original and conscientious work is made paramount to commercial considerations, can command the appreciation of the American public."[9] Rookwood rode the crest of this success throughout the 1890s and sales continued to accelerate.

Rookwood marked the end of its second decade in 1900 with another success, this time at the Paris Exposition Universelle, where the firm was awarded a Grand Prix, and William Watts Taylor was decorated as a Chevalier of the Legion of Honor. During the following years numerous other national and international awards were bestowed on the Pottery, including a gold medal at the Pan-American Exposition at Buffalo in 1901, a diploma of honor at the Esposizione Internazionale d'Arte Decorativa Moderna in Turin in 1902, the grand prize in St. Louis's Louisiana Purchase Exposition in 1904, another gold medal at the 1907 Jamestown Tercentennial Exposition in Hampton Roads, Virginia, and again, a grand prize at the 1909 Alaska-Yukon Pacific Exposition in Seattle.

These years also saw the increased expansion of the Mt. Adams facility. In 1899 a first addition was made to the main building, and in 1904, studios were erected to house the newly established architectural faience department. Increasing numbers of competitors constantly challenged Rookwood's position as the leading producer of art pottery. Stanley Burt, who came to Rookwood as a chemist in 1892 and eventually succeeded Joseph Bailey as superintendent, encouraged new experiments to improve techniques to keep the pottery abreast of new developments, and an aggressive advertising campaign was launched that included a mail-order catalogue, *The Rookwood Book*, published in 1904. Although production continued to be concentrated on hand-painted pieces during this period, more vases finished with simple mat glazes began to appear, and after 1913, when William Watts Taylor died, this trend picked up considerable momentum.

Upon Taylor's death, Rookwood's management passed into the hands of a board of twelve trustees named in Taylor's will, until Joseph

Henry Gest, the company's vice president since 1902, was made president in early 1914. Throughout his presidency, Gest also served as director of the Cincinnati Art Museum, dividing his daily activities between his two commitments. The manufacture of architectural faience and garden pottery became increasingly important to the company's financial well-being, just as its art ware, now often mechanically made and unsigned, gradually came to be aimed at a wider and more general market.

Rookwood maintained its fiscal stability into the 1920s, but as maintenance costs continued to rise, pottery sales by mid-decade began to drop. Following the stock market crash of 1929, Rookwood found itself operating at a loss, with slim hopes for any improvement. When the fiftieth-year kiln was drawn on Thanksgiving Day 1930, there was little celebrating, even though Clara Chipman Newton returned as the special guest of honor. The following October almost the entire staff was laid off, including many who had worked at Rookwood for three decades. Gest struggled on as the head of the company until 1934, at which time he resigned his presidency.

Rookwood continued to function for another thirty years, although the Depression drained it of much of its vitality. John D. Wareham succeeded Gest as president in 1934, after forty-one years with the company. He had started as a decorator in 1893, later serving as artistic director and as vice president under Gest in 1914. Harold F. Bopp took over the day-to-day operations as superintendent after Stanley Burt retired in 1929, but resigned himself in 1939. Production was at a near standstill by this time and dissolution of the firm appeared inevitable.

In April 1941, Rookwood filed for bankruptcy, but in September of that year, the company was sold to Walter E. Schott, who reopened the pottery by November with Wareham in charge and a staff of many former employees. Schott recalled all the Rookwood pottery consigned to the firm's retailers, as well as the huge collection in the custody of the Cincinnati Art Museum, and proceeded to liquidate it at reduced prices in

order to raise cash.[10] Reclaiming a degree of solvency, Rookwood remained in production through World War II, although necessary supplies were difficult and at times impossible to obtain.

At the end of 1942, Rookwood again changed hands when Schott donated the Pottery to the Institutum Divi Thomae in Cincinnati. The Institutum in turn transferred ownership of Rookwood's equipment and formulae to one of their directors, George S. Sperti, whose company, Sperti, Inc., continued the business. Under this arrangement, Wareham remained in charge of artistic activities, but Sperti, Inc., mananged financial affairs. Wareham and Sperti launched an effort to revive Rookwood, increasing output and hiring and training new decorators. But by 1948 it became evident that the world had changed and that Rookwood could not compete with the flood of inexpensive foreign imports.

The pottery's final years saw much reorganization and many leadership changes in an attempt to make the business succeed. Wareham died in 1954 and Edgar M. Hettman of Sperti, Inc., was appointed director. In January 1956 the firm was sold once again to two Cincinnati businessmen, William F. MacConnell and James M. Smith, who hoped to keep Rookwood alive. By now, however, the individually decorated artwares that had made Rookwood famous had given way to inferior commercial production. In 1959, MacConnell and Smith sold the business to the Herschede Hall Clock Company, retaining the property itself for their own use. In June 1960, Rookwood Pottery was moved to Starkville, Mississippi, where a few pieces were produced with the Rookwood mark until 1966. The Herschede Hall Clock Company was sold in 1967, along with its interest in Rookwood, and pottery production stopped once more. In 1982, interest in Rookwood's former glory prompted Arthur J. Townley of Michigan Center, Michigan, to purchase the remains of the company ("including 1000 master blocks and master molds, 13 medals, 8 shape books, corporate notes, 5000 glaze and clay formulas").[11] Using the traditional mark of the Rookwood Pottery, Townley commenced in 1984 to produce a limited line of

ceramic novelties, such as paperweights, book-ends, and advertising signs, using the original master molds. Although far from its famous building on Mt. Adams, the legacy of the Rookwood Pottery lives on today.

1. The most complete history of Rookwood published to date is Herbert Peck, *The Book of Rookwood Pottery* (New York: Crown Publishers, 1968); see also Deborah D. Long, Carol Macht, Kenneth R. Trapp, *The Ladies, God Bless 'Em: The Women's Art Movement in Cincinnati in the Nineteenth Century* (Cincinnati: Cincinnati Art Museum, 1976).

2. Maria Longworth Nichols, *History of the Cincinnati Musical Festivals and of the Rookwood Pottery* (written in 1895; Paris: by the author, 1919), unpag.

3. Nichols, *History . . . of the Rookwood Pottery*, unpag.

4. Letter to Mrs. Keenan, a member of the Pottery Club, reproduced in Peck, *The Book of Rookwood Pottery*, p. 9.

5. Nichols, *History . . . of the Rookwood Pottery*, unpag.

6. The *Rookwood Pottery Shape Record Book* still exists today in the Rookwood Archives of the Cincinnati Historical Society.

7. After Frederick Dallas's death in June 1881, Joseph Bailey, Sr., was made superintendent of Rookwood. Bailey left for Chicago in 1883 and Langenbeck briefly took over his position in early 1885. By the end of 1885 Langenbeck had also left and by early 1886 had founded the Avon Pottery in Cincinnati. Bailey returned to Rookwood to resume his former position in 1886 and remained there until he died in 1898.

8. Excerpts from an article by W. P. Jervis that appeared in *The Pottery, Glass & Brass Salesmen*, 13 December 1917, have been reprinted in Herbert Peck, *The Second Book of Rookwood Pottery* (published by the author, 1985), p. 19, and indicate that Storer presented Rookwood to Taylor as a gift. No records of the actual transaction are known to survive.

9. Edwin AtLee Barber, *Pottery and Porcelain of the United States* (New York: G. P. Putnam's Sons, 1893), pp. 295-96.

10. See, for example, the advertisement for B. Altman & Co., *New York Times*, Sunday, 22 March 1942 (section L, p. 10). Altman's offered three thousand pieces, including "a special group: now $25.00, values $40.00 to $75.00."

11. Audrey E. Harris, "Rookwood: A Brief Introduction, With Recent Western Auction Values," *West Coast Peddler* 18 (June 1987): 15.

1. VASE, 1879-80

Frederick Dallas's Hamilton Road
Pottery
Cincinnati, Ohio

Decorated by Maria Longworth Nichols (1849-1932)

Molded cream-colored stoneware
body with applied, hand-modeled
dragon encircling the shoulder and
neck in high relief, one leg freestanding; cobalt blue underglaze and red
overglaze decoration; gilded highlights. On reverse, fan-shaped panel
of pale blue underglaze painted in
overglaze brown with birds flying
above cattails and rushes. Allover
highly stylized, partially gilded wave
pattern. Clear glaze.

Height: 26.7 cm.
Diameter: 21 cm.
Marks: Painted overglaze in red: #3

The mold for the body was bought
from Frederick Dallas in 1880 by the
Rookwood Pottery and became their
shape number 173, as listed in the
*Rookwood Pottery Shape Record
Book.*

1984-84-13

Exhibitions

*The Ladies, God Bless 'Em: The
Women's Art Movement in Cincinnati
in the Nineteenth Century,* Cincinnati, 1976.

References

Barber, Edwin A. *Pottery and Porcelain of the United States,* p. 277
(illus.). New York: G.P. Putnam's
Sons, 1893.

Di Noto, Andrea. "A Certain Shade
of Green: The Happy Collaboration
Between Two Collectors and an Art
Dealer," *Connoisseur* 215 (August
l985): 57 (illus.).

Long, Deborah D., Carol Macht, and
Kenneth R. Trapp. *The Ladies, God
Bless 'Em: The Women's Art Movement in Cincinnati in the Nineteenth
Century,* pp. 42-43, no. 64(b) (illus.
p. 25). Cincinnati: Cincinnati Art
Museum, 1976.

Perry, Mrs. Aaron F. "Decorative
Pottery of Cincinnati." *Harper's New
Monthly Magazine* 62 (April 1881):
837 (illus.).

Trapp, Kenneth R. "Rookwood and
the Japanese Mania in Cincinnati."
Cincinnati Historical Society Bulletin
39 (Spring 1981): 57 (illus.).

Maria Longworth Nichols's interest in Japanese art was first sparked after she received "some little Japanese books of designs" brought back to Cincinnati from London by a friend. As she recalled:

It prepared me for the wonderful beauty of the Japanese exhibit at the Philadelphia Centennial Exposition of 1876. It was there that I first felt a desire to have a place of my own where things could be made; and I wanted to import a complete Japanese pottery, workmen and all. My father laughed at the impracticability of this undertaking when I proposed it to him—but the idea of my making pottery interested him.[1]

This bottle-shaped vase, a popular form among Cincinnati's ceramic decorators, makes use of one of Nichols's favorite motifs, the dragon.[2] In an article published in 1880, her decorated pottery was described, without mentioning her by name:

Upon a delicate buff foundation there will be perhaps a panel of blue, shaded with rare nicety, with here and there a dragon in relief, richly gilded, and coiled it may be, around the bottom or near the top, where it is made to form quaint handles, while the introduction of one or two droll figures in human shape, give [sic] these vases a decidedly Japanese appearance.[3]

The treatment of the birds and cattails on the vase suggests a derivation from an Oriental graphic source. Numerous Japanese sketch books, such as Katsushika Hokusai's fifteen-volume *Manga*, were available in Europe and America in the 1870s and 1880s. However, ornament manuals such as Thomas Cutler's *A Grammar of Japanese Ornament* (London, 1880) reproduced similar subjects and also inspired much work in the Japanese manner. M. Louise McLaughlin had used the same motif featuring birds in flight and cattails on a Dallas Pottery plate in 1877, her first success with blue underglaze decoration.[4]

The number "3" on the bottom of this vase probably indicates that it was the third in a series. Another vase, although unmarked, was similarly modeled and decorated by Nichols, but it lacks the freestanding dragon's leg and is composed of red clay.[5]

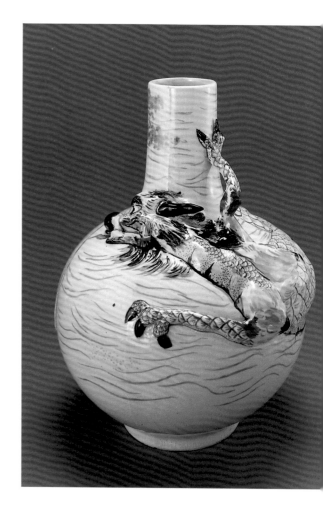

1. Maria L. Nichols, quoted in Rose G. Kingsley, "Rookwood Pottery," *Art Journal* (London), November 1897, p. 342.

2. For another Nichols vase decorated with a relief-modeled dragon, see Wendy Kaplan, ed., *"The Art That Is Life": The Arts & Crafts Movement in America, 1875-1920* (Boston: Museum of Fine Arts, l987), no. 6, pp. 65-67.

3. Alice C. Hall, "Cincinnati Faience," *Potter's American Monthly* 15 (August 1880): 363.

4. Deborah D. Long, Carol Macht, and Kenneth R. Trapp, *The Ladies, God Bless 'Em: The Women's Art Movement in Cincinnati in the Nineteenth Century* (Cincinnati: Cincinnati Art Museum, 1976), pp. 37-38, no. 21 (illus. p. 23).

5. Long, Macht, Trapp, *The Ladies,* pp. 42-43, no. 64(a) (illus. p. 25).

2. VASE, 1882

Rookwood Pottery
Cincinnati, Ohio

Decorated by Maria Longworth Nichols (1849–1932)

Molded ginger-colored earthenware body painted underglaze with groups of black spiders and bats against a background of swirling brush strokes in brown, ocher, blue-gray, cream, and turquoise; various gilded overglaze highlights. Clear glaze. Small hole drilled in bottom, stoppered with cork.

Height: 14.25 cm.
Diameter: 17.2 cm.
Marks: Impressed: ROOKWOOD / 1882 / G [designates ginger clay]; incised vertical artist's monogram: M/L/N

The *Shape Record Book* identifies this shape as Number 129: "Globe Vase, Pressed, 1881. Dec. Limoges; Sales reasonable."

1984–84–12

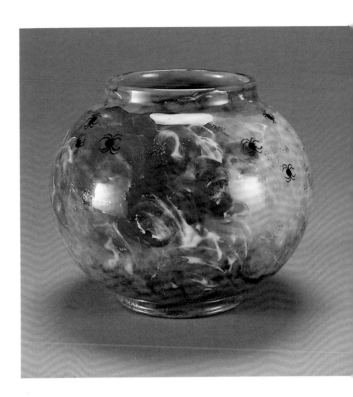

Although M. Louise McLaughlin was not connected with Rookwood, it was she who first developed the "Cincinnati Limoges" technique, or method, of underglaze slip decoration. In this, McLaughlin was indebted to the *procès barbotine*, a manner of painting under the glaze perfected by the French potter Ernest Chaplet while he was working in the 1860s at Laurin's faience factory at Bourg-la-Reine, France.

Following the Centennial, McLaughlin began to experiment with underglaze decorations at the Cincinnati pottery of Patrick L. Coultry and Company. By the beginning of 1878, she had successfully produced the first American pottery in the French manner. After exhibiting examples of her work and receiving an honorable mention at the Paris Exposition Universelle in 1878, McLaughlin won an enthusiastic following among Cincinnati women, who looked to her for guidance in their pottery decoration. Their ranks even included Nichols at first. This strong interest in the production of "beautiful and artistic" pottery led McLaughlin to publish her underglaze technique in a handbook for amateurs, *Pottery Decoration Under the Glaze.* For McLaughlin, a finished piece decorated in this manner

. . . presents the appearance of a painting in oil, to which a brilliant glaze has been applied. This glaze not only renders the colors unchangeable, but gives a beauty and effectiveness which could be acquired in no other way. . . . the glaze is simply the process by which it is finished, and bears the same relation to it as the varnish does to the painting in oil.[1]

Nichols's globular vase, with its asymmetrically grouped spiders and bats against cloudlike swirls, closely recalls her early fascination with Japanese design. In 1878, she had prepared six prints of suggested designs for pottery decoration to illustrate *Pottery: How It Is Made,*[2] a book written by her husband, George Ward Nichols. Most of the prints borrowed details taken from Japanese books of illustrations. The first plate of the Nichols book, for example, includes designs for dragonflies, crabs, and spiders similar to those painted on this vase.

1. M. Louise McLaughlin, *Pottery Decoration Under the Glaze* (Cincinnati: Robert Clarke & Co., 1880), pp. 41–42.

2. George Ward Nichols, *Pottery: How It Is Made, Its Shape and Decoration* (New York: G. P. Putnam's Sons, 1878).

Rookwood Pottery
Cincinnati, Ohio

Possibly decorated by Maria Longworth Nichols (1849–1932)

Thrown red earthenware body with lavalike slips applied around shoulder in turquoise, leaf green, cobalt blue, light blue, and white. Decorated underglaze on front with brown and white birds flying across white full moon, black sky, with random brown, white, and ocher brush strokes. Small cover fitted flush with body, irregular finial. Clear glaze.

Height: 11.4 cm.
Diameter: 7.6 cm.
Marks: Impressed: R O O K W O O D / 1884 / R [designates red clay]

The *Rookwood Shape Record Book* indicates that this jar is Number 92; that it was produced after a model supplied by Nichols; and that it was eventually made in the "B" and "C" sizes, as well as this smaller "E" size.

1984–84–15ab

References

Burt, Stanley Gano. *Mr. S. G. Burt's Record Book of Ware at Art Museum (2,292 Pieces of Early Rookwood in the Cincinnati Art Museum in 1916),* p. 33, nos. 35–43. Cincinnati: Cincinnati Historical Society, 1978 [facsimile].

Much of the work carried out at Rookwood in its first years of operation was of an experimental nature. New glazes and new methods of decoration were tried and often abandoned in an attempt to establish the Pottery's artistic identity. Although this covered jar is not marked as a trial piece, its unusual application of lavalike slip decoration around the shoulder and on the lid certainly was not a regular feature of Rookwood's production. This piece can be identified as one of a group of small jars with lids from the Rookwood Pottery Museum's own collection, which was on loan to the Cincinnati Art Museum from about 1905 to 1942. A description of the group was provided by Stanley G. Burt in 1916:

1884: #35–43—Small jar & lid. Shape #92 (only 1 pc with this stamp). Red clay, clear gl. various slip decorations. Evidently trial pcs.[1]

Although it bears no decorator's mark, this jar is decorated in a style associated with Maria Longworth Nichols's Japanese-inspired work. The handling of the brush strokes is similar to other pieces signed by her or positively known to be from her hand. It should be noted, however, that the early work of Rookwood staff decorators Albert R. Valentien and Matthew A. Daly was highly influenced by Nichols's style and choice of subject matter, so much so that often their early decorated pieces are virtually indistinguishable from hers.

1. Burt, *Mr. S. G. Burt's Record,* p. 33, nos. 35–43.

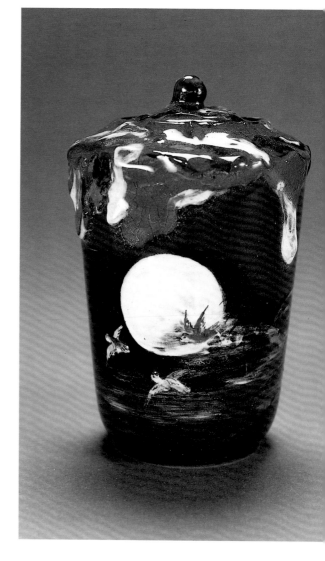

Rookwood Pottery
Cincinnati, Ohio

Decorated by Clara Chipman Newton (1848–1936)

Molded ginger-colored earthenware body decorated underglaze with sprigs of prunus blossoms in white, blue-gray, and brown; underglaze burnt sienna at shoulder and top; various gilded highlights. Clear glaze. Bronze handle with inscription, "Made by Clara Chipman Newton for Maria Longworth Nichols / With deepest appreciation and affection Dec. 25, 1882."

Height: 13 cm. (with handle)
Width: 20 cm.
Depth: 15.9 cm.
Marks: Impressed on central panel of reverse side: R O O K W O O D
1882

A photograph pasted into the *Shape Record Book* identifies this teapot shape as Number 156. It noted: "No. 156, Tea Kettle, Pressed, 1882. 2 styles. Limoges & smear. Smear saleable at sales-rooms, not saleable to trade." Three such teapots were recorded as having been sold in 1883.

1984-84-11ab

Exhibitions

Ode to Nature: Flowers and Landscapes of the Rookwood Pottery, 1880–1940, Jordan-Volpe Gallery, New York, 1980.

Design in the Service of Tea, Cooper-Hewitt Museum, New York, 1984.

References

Schwartzman, Paulette. *A Collector's Guide to European and American Art Pottery with Current Values,* p. 79 (illus.). Paducah, Ky: Collectors Books, 1978.

Trapp, Kenneth R. *Ode to Nature: Flowers and Landscapes of the Rookwood Pottery, 1880–1940,* pp. 64, 74, no.3 (illus. plate 9). New York: Jordan-Volpe Gallery, 1980.

Clara Chipman Newton was a major figure in the development of the Cincinnati art pottery movement. Before entering the School of Design of the University of Cincinnati, she had attended Miss Appleton's School and there became close friends with classmate Maria Longworth. Newton was a member of Benn Pitman's woodcarving class, and, later, his influential china painting class in 1874. She participated in the second Cincinnati Centennial Tea Party in May of 1875, for which she painted cups and saucers in overglaze with patriotic subjects. An original member of Cincinnati's Pottery Club, she was elected its first and only secretary in 1879.

After Rookwood's founding, Newton was hired by Nichols as a secretary in 1881, her capacity actually that of Nichols's general assistant. Although she was never considered a member of the decorating staff, Newton did decorate pottery for distribution. She even gave instructions in overglaze and underglaze painting at the Rookwood School for Pottery Decoration while it was in operation at the firm from 1881 to 1883. When William Watts Taylor was appointed general manager of Rookwood, and established the *Shape Record Book* in 1883, Newton began to record the shape designs and the sales analyses. But Taylor's decision to evict the Pottery Club from the Rookwood premises frustrated her, and when Nichols supported his decision, Newton left the pottery in annoyance. She stayed a faithful member of the Club until it disbanded, and remained herself a vital force in Cincinnati culture the rest of her life.

As a testament of friendship, Newton presented this teapot to Nichols on Christmas Day, 1882. The arrangement of the simple sprays of prunus blossoms that decorate the sides of the octagonal body was derived from Japanese design, but it stands in sharp contrast to Nichols's essays in the Japanese. Newton's decoration is a well-studied interpretation of the Japanese ideals of design, and her restrained and delicate handling of the Cincinnati Limoges technique is inspired. It is likely, since Newton also worked in other

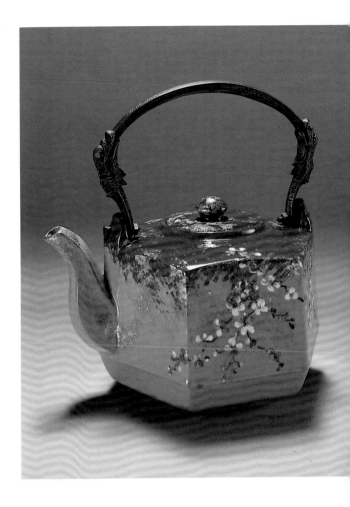

media, that she designed the bronze handle on this piece, as well.

Stanley Burt's 1916 record lists a similar teapot on loan to the Cincinnati Art Museum from about 1905 to 1942:

1882: #5—Tea pot—bronze hdl—yel. clay clear gl.—overgl. dec. Marked on side Rookwood 1882[1]

Nichols would have undoubtedly regarded this teapot created by her close friend as worthy of the collection of the Rookwood Pottery Museum, established in 1885. Burt's notation probably refers to this piece.

1. Stanley Gano Burt, *Mr. S. G. Burt's Record Book of Ware at Art Museum, (2,292 Pieces of Early Rookwood in the Cincinnati Art Museum in 1916)* (Cincinnati: Cincinnati Historical Society, 1978 [facsimile]), p. 14, no.5.

5. EWER, 1884

Rookwood Pottery
Cincinnati, Ohio

Decorated by Laura Anne Fry
(1857–1943)

Thrown red earthenware body with applied handle, decorated with three yellow crabs and dark brown aquatic plants on a mahogany ground. Aventurine effects in the yellow glaze.

Height: 28.6 cm.
Diameter: 17.8 cm.
Marks: Impressed: 64 / R O O K-W O O D / 1884 / R [designates red clay]; incised artist's monogram conjoined: LAF

The *Shape Record Book* notes for Number 64: "Alhambra Pitcher; design furnished by Miss Fry," and indicates that two examples were sold to retailers on April 2, 1884.

1984–84–6

Toward the middle years of the 1880s, Rookwood's production was distinguished by the range of effects that the decorating staff achieved using clay bodies, underglaze slips, and glazes. This is a fine example of the Mahogany ware produced for a brief period. By placing a yellow glaze over a red earthenware body, a deep reddish-brown color was produced, anticipating the rich, earthy tones of Rookwood's Standard ware.

In October of 1884, seven pieces of pottery drawn from one of the Rookwood kilns displayed unexpected and inexplicable gold flecks suspended in their glazes. This crystalline effect was called Tiger Eye, its pieces marked with "mysterious striations, which seem to glow with a golden fire, indefinable in words."[1] When the gold-flecked glazes were less intense, and "rather more limpid," as is the case with this ewer, the term Goldstone was used to describe the effect. In later years Rookwood noted that Tiger Eye was "the earliest of the class of crystalline glazes since so extensively made at Sèvres, Copenhagen and Berlin," and that the effects of the Rookwood glazes were unique.[2] Although this ewer may not have been among the contents of that landmark kiln in the fall of 1884, it remains nevertheless an early and rare example of the glaze phenomenon.

The shape of this ewer was derived from a design furnished by Laura Fry, who also decorated it. Called the "Alhambra Pitcher" in the *Shape Record Book*, its bulbous body, long cylindrical neck, and applied handle evoke a Moorish or Islamic design. Fry decorated the ewer with three crabs in Nichols's Japanese grotesque style. After 1884 this type of decoration diminished at Rookwood, replaced largely by floral decoration.

Like Clara Chipman Newton, Laura Fry was an important leader in the arts movement in Cincinnati. She too had been fully trained in woodcarving, drawing, and china painting at the School of

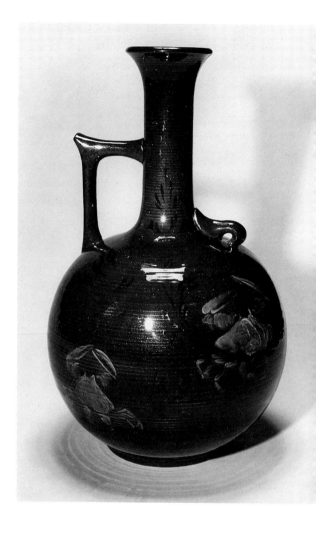

Design. But unlike Newton, she had studied ceramics further in Trenton, New Jersey, and, later, in England and France. Her involvement with the early developments in china painting lead her to become an honorary member of McLaughlin's Pottery Club in 1879. Fry became the only Pottery Club member whom Rookwood employed as a staff decorator, working in that capacity from 1881 to 1887.

1. Rookwood Pottery Company (promotional pamphlet), *Rookwood Pottery* (Cincinnati: Rookwood Pottery Company, c. 1902), pp. 27-28.

2. *Ibid.*, p. 28.

6. COVERED JAR, 1885

Rookwood Pottery
Cincinnati, Ohio

Decorated by Matthew Andrew Daly
(1860–1937)

Thrown sage-green earthenware body decorated underglaze with a depiction of flowing water and two carp incised and modeled in low relief, painted in shades of green against a speckled green ground. Speckled cover. Clear glaze.

Height: 13.3 cm.
Diameter: 8.9 cm.
Marks: Impressed: 47 D / ROOK-WOOD / 1885 / S [designates sage clay]; incised artist's monogram: M A. D

The *Shape Record Book* notes: "No. 47 made on wheel, designed by Mr. [William] Auckland. 1st specimen made Oct, 1883."

1984–84–16ab

One of the most prominent decorators until 1903 was Matthew Andrew (Matt) Daly. He was employed by Nichols in 1884 after having worked for a few months at the short-lived Matt Morgan Art Pottery, one of Rookwood's early Cincinnati competitors.

The form of this jar may have been derived from a Japanese tea jar. The spotty color gradation over the sage-green ground was achieved by using Laura Fry's mouth-atomizer process,[1] with which Daly is said to have experimented in order to blend background colors.[2]

1. In 1884, Laura Fry discovered that the mouth atomizer could be adapted to spray colored slips onto clay bodies, creating even gradations of color. She was granted a patent for this revelatory discovery in 1889.

2. Herbert Peck, *The Book of Rookwood Pottery* (New York: Crown Publishers, 1968), p. 29.

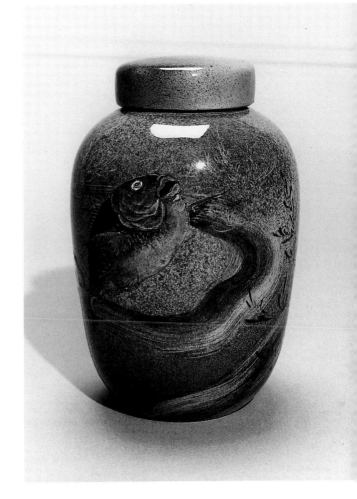

7. EWER, 1887

Rookwood Pottery
Cincinnati, Ohio

Decorated by Kataro Shirayamadani
(1865–1948)

Thrown white stoneware body with applied handle, decorated with prunus blossoms and branches in white, enframing an overglaze-painted field of bright blue and gilded patterning. Upper portion of neck with field of Bristol blue and blue prunus blossoms against gilded patterning. Body painted in graduated tones from peach to pale celadon. Applied handle.

Height: 22.2 cm.
Diameter: 12.25 cm.
Marks: Impressed: RP cipher with one flame / 641S; incised artist's signature in Japanese characters

Number 641 in the *Shape Record Book* is represented by a drawing that is not similar to this piece at all. The "S" following the shape number indicates that it was a special piece, and not a part of the firm's regular production.

The reverse RP cipher became the standardized Rookwood mark in 1886. One flame was added above the mark for each year following until fourteen were reached in 1900. After 1900 a Roman numeral was added designating the year since 1900.

1984-84-14

Since the Centennial Exhibition in Philadelphia in 1876, Nichols had wanted to secure Japanese ceramists to work in America. A local newspaper reported as early as the summer of 1881 that she was seeking to employ Ichidsuka Kenzo, a Japanese pottery decorator, to teach in the Rookwood School for Pottery Decoration.[1] It was not until May 1887, when Kataro Shirayamadani arrived, that she got her wish.

Shirayamadani was born in Kanazawa, Japan, but little is known of his training in the ceramic arts. He had been connected with a company of Japanese craftsmen and artisans who toured America giving public demonstrations of their trades, including pottery and porcelain decoration. Their "Japanese Village" was a popular attraction throughout the United States in the mid-1880s, reaching Cincinnati in 1886. Shirayamadani left the Village while it was in Boston, and after some negotiation, joined the staff of the Rookwood Pottery.[2] By the fall of 1887 examples of his work were displayed at the Piedmont Exposition in Atlanta, Georgia. He was quickly promoted and became one of the company's principal decorators as well as a major designer of shapes and forms. In 1893–94 he visited Japan to study pottery techniques, and returned to his native country again about 1912 for an extended stay. Back in the United States in 1920, Shirayamadani remained at Rookwood as a decorator until his death.

This ewer, dating from his first year in Cincinnati, exemplifies Cameo ware, one of Rookwood's first distinctive pottery lines.[3] Using soft, pastel colors with decoration in slight relief, Cameo stood in sharp contrast to the dark, warm palette of Rookwood's Standard ware. Both lines were introduced between 1884 and 1886, but while Standard received early acclaim and remained in production through the turn of the century, Cameo won only moderate acceptance and was discontinued soon after 1893.

Cameo bisque was developed as a variation on Cameo ware, the two differing only in the application of glazes: Cameo possessed a clear, glossy finish, while Cameo bisque, of which this ewer is an example, had a "slight" glaze on the

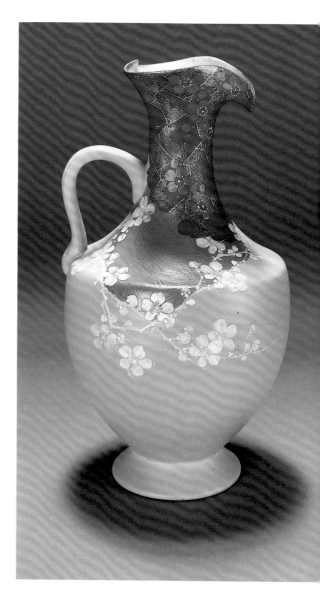

porcelaneous, or refined, stoneware body. This slight, or smear, glaze was an old technique used on some of Rookwood's earliest pieces. It was achieved by placing the piece in a sagger, which is a box made of fire clay, lined internally with an unfired glaze. When fired, the piece absorbs enough glaze from the sagger's surface to give it a dull, semi-glazed appearance.

1. "Mrs. Nichols' Pottery," *Cincinnati Daily Gazette,* 22 August 1881, p. 5. Quoted in Kenneth R. Trapp, "Rookwood and the Japanese Mania in Cincinnati," *Cincinnati Historical Society Bulletin* 39 (Spring 1981): 56.

2. Trapp, "Rookwood and the Japanese Mania," pp. 66-68.

3. A similar but smaller ewer by Shirayamadani is listed in Kenneth R. Trapp, *Ode to Nature: Flowers and Landscapes of the Rookwood Pottery, 1880–1940* (New York: Jordan-Volpe Gallery, 1980), p. 75, no. 9.

8. JUG, 1891

Rookwood Pottery Company
Cincinnati, Ohio

Decorated by Matthew Andrew Daly
(1860–1937)

Thrown gray-green earthenware body, applied handle, decorated with ghostly figure of a skeleton in a shroud, one arm upraised and holding a burning lamp. Figure in shades of ocher, pale brown, dark brown, and green. Background shaded in ochers, browns, and dark green. Yellow glaze with aventurine effects.

Height: 20 cm.
Diameter: 15.2 cm.
Marks: Impressed: R P cipher with five flames / 512 / S; incised artist's monogram: M A D / L [the slash mark is part of the monogram]

The *Shape Record Book* notes that Number 512 was designed by William Watts Taylor in August 1889, and that as many as three handles could be appropriately applied to the form. The incised "/L" on the underside is an unexplained mark. The separate "S" indicates that this piece was thrown as a demonstration piece.
1984–84–8

Laura Fry's innovative adaptation of the mouth atomizer to create subtle gradations of ground colors led to a distinctive Rookwood style. A transparent yellow glaze was used to give the underglaze work a softened, mellow tone. This more restrained, less painterly mode of pottery decoration came to be known as Standard ware; it was this ware that was most closely identified with the name Rookwood.

Evolved around 1884 and in full production by 1886, Standard was the dominant Rookwood line on the market until 1900. It and the crystalline Tiger Eye won a gold medal for the Pottery at the Paris Exposition Universelle in 1889, and placed Rookwood at the forefront of world potteries.

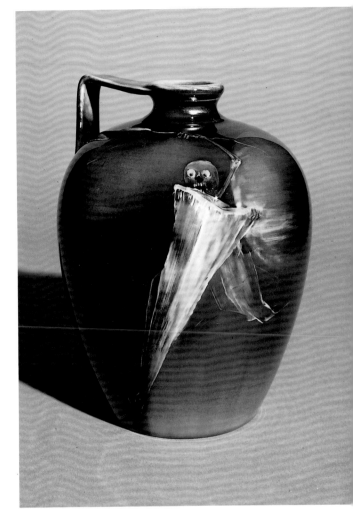

9. VASE, 1894

Rookwood Pottery Company
Cincinnati, Ohio

Decorated by Charles John Dibowski
(1875–1923)

Molded white earthenware body decorated underglaze with two herons flying among rushes, against a shaded background of forest green, willow green, brown, russet, and ocher. Yellow glaze.

Height: 14.6 cm.
Diameter: 7.6 cm.
Marks: Impressed: R P cipher with eight flames / 741 C / W [designates white clay]; incised artist's monogram: C J. D / L [the slash mark is part of the monogram]

Number 741 in the *Shape Record Book* notes that the shape was cast, and that the "C" size (that of this vase) was first designed and made by Joseph Bailey, Sr., in June 1894. The "/L" mark is unexplained.

1984-84-10

References

Di Noto, Andrea. "A Certain Shade of Green: The Happy Collaboration Between Two Collectors and an Art Dealer," *Connoisseur* 215 (August 1985): 52.

This Standard vase exemplifies the romantic naturalism that prevailed at Rookwood in the 1890s. This sort of subject matter, painted against the richly graduated dark tones of Rembrandtesque colors, appealed to late nineteenth-century sensibilities. While early Rookwood work usually included the colored clay of the body in the overall design and color scheme, the adoption of the atomizer technique for applying ground colors encouraged the use of white clay bodies that were used as a "canvas" upon which painted colors were applied.

In 1892, at the age of seventeen, after attending the Art Academy of Cincinnati, Charles John Dibowski became a Rookwood decorator. He remained there until about 1895, when he moved to Zanesville to work for Rookwood's most aggressive competitor, the S. A. Weller Pottery. Dibowski remained there one year, followed by a stint at the Lonhuda Pottery in Steubenville, Ohio, another imitator of Rookwood's Standard ware. Eventually, he found his way to Panama, where he worked on the construction of the Canal. After the beginning of the First World War, Dibowski became an accountant for the Internal Revenue Service.

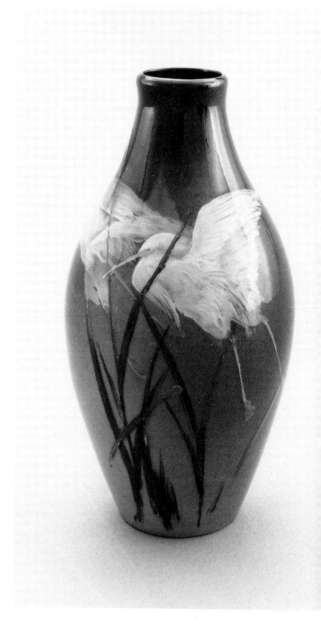

10. VASE, 1898

Rookwood Pottery Company
Cincinnati, Ohio

Decorated by Kataro Shirayamadani
(1865–1948)

Molded white earthenware body
decorated underglaze with three
stalks of golden yellow foxglove,
green leaves and stems. Background
shaded from green at the base to
yellow-orange at the shoulder. Yellow
glaze.

Height: 33 cm.
Diameter: 11.8 cm.
Marks: Impressed: R P cipher with
twelve flames / 856 C; incised artist's
signature in Japanese characters

This vase is a version of shape
Number 786, which was an adapta-
tion of a Coalport vase. Shape
Number 856 was designed in May,
1898.

1983–88–2

Although new glazes and underglaze effects
were developed and marketed in the 1890s,
Rookwood's conservative Standard ware re-
mained popular and widely celebrated. Rook-
wood decorators occasionally painted directly
from nature, but most often they worked from
drawings, watercolor sketches, photographs, or
from any one of the hundreds of books, journals,
or ornament manuals in the Rookwood library.
Organized Saturday outings into the nearby
woods and fields allowed the artists to make
their own studies from nature.

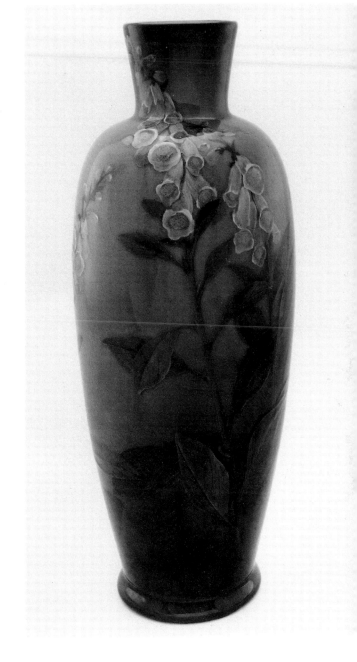

Rookwood Pottery Company
Cincinnati, Ohio

Decorated by Matthew Andrew Daly
(1860–1937)

Thrown white earthenware body
with applied handle, decorated un-
derglaze on front and back with large
yellow and orange roses and green
leaves. Background shaded in gold,
green, and brown. Yellow glaze. Sil-
ver openwork overlay engraved with
flowers, leaves, and scrolls. Handle
and lip sheathed in undecorated sil-
ver.

Height: 54.6 cm.
Diameter: 21.3 cm.
Marks: Impressed: R P cipher with
eight flames / 496 X X / W [desig-
nates white clay] / R P cipher with
eight flames; incised artist's mono-
gram: M A D; silver stamped on
bottom rim: 999 / 1000 F I N E
G O R H A M M F G C O.

Shape Number 496 was designed by
Pitts Harrison Burt in April 1889.
The "X X" indicates that this was
larger than the normal "A" size.

1984–84–9

In 1892 Rookwood introduced a new type of
decoration that involved electrodepositing silver,
primarily on certain Standard ware pieces. This
process, which had been used in the United
States in the 1880s to decorate glass and
ceramics, grew in popularity between 1890 and
1910. Rookwood supplied the Gorham Manufac-
turing Company of Providence, Rhode Island,
with decorated pottery, which was shipped to
Gorham's factory, embellished with silver, and
then sent directly to Rookwood's agents through-
out the country.

The technique involved the electrical deposit of
silver in predetermined patterns on the glazed
bodies of the Rookwood wares. The surfaces
were coated with a conductive substance and
immersed in a plating bath. The silver adhered
to the conductor upon the application of elec-
tricity and was subsequently etched, engraved,
and polished to create a virtuoso effect. The
finished product was well suited to Victorian
tastes and was especially admired for its tech-
nical and artistic skill. Gorham proudly displayed
examples of this work at the Chicago World's
Columbian Exposition in 1893. Electrodeposited
silver was used on Rookwood pieces at least
until 1900, but its high cost limited the market,
and its aesthetic merit was dubious to the
critics.[1]

1. Pieces decorated in this manner are known to have been acquired
for European museum collections and collectors. The
Kunstgewerbemuseum in Berlin purchased a ewer at the World's
Columbian Exposition in Chicago in 1893. See Herbert Peck,
"Rookwood Pottery and Foreign Museum Collections," *Connoisseur*
172 (September 1969): 44 (illus.). In 1901, Rookwood's silver-
decorated pieces were described as ". . . dreadful Gorham open
work, silver decorations which suggest defects to be covered up." W.
P. McDonald, "Rookwood at the Pan-American," *Keramic Studio* 3
(November 1901): 148.

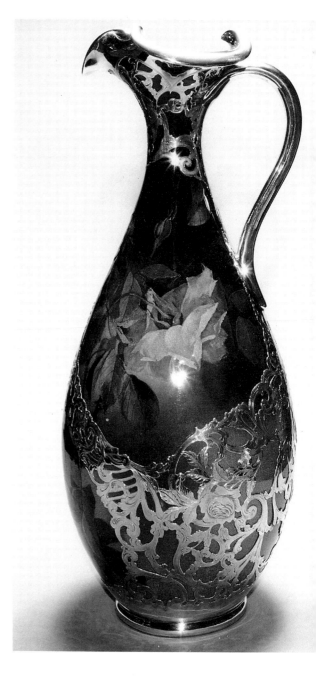

12. VASE, 1898

Rookwood Pottery Company
Cincinnati, Ohio

Decorated by Kataro Shirayamadani
(1865–1948)

Thrown white earthenware body decorated underglaze with dark green lily pads and yellow water lilies in various stages of bloom, against a mahogany red ground. Around the shoulder and neck, three stalactitic shapes in electrodeposited copper, with green patina. Yellow glaze.

Height: 31.3 cm.
Diameter: 15.9 cm.
Marks: Impressed: R P cipher with twelve flames / 614 C; incised artist's signature in Japanese characters

The *Shape Record Book* notes that this shape was designed by Joseph Bailey, Sr., in May 1891.

1984–84–5

Exhibitions

Ode to Nature: Flowers and Landscapes of the Rookwood Pottery, 1880–1940, New York: Jordan-Volpe Gallery, 1980.

References

Trapp, Kenneth R. *Ode to Nature: Flowers and Landscapes of the Rookwood Pottery, 1880–1940*, p. 77. New York: Jordan-Volpe Gallery, 1980.

Rookwood's involvement with silver overlay work may have encouraged the firm to establish its metalworking department in 1894. Kataro Shirayamadani returned from Japan that year, bringing with him a friend named E. H. Asano, who had been a metalworker in Japan. Asano's experiments with metal mounts for Rookwood vases, lamps, jugs, and pitchers proved to be commercially unsuccessful, and after three years this department was discontinued.

Further experimentation with metals continued, however, and a technique was developed whereby copper was electrodeposited onto pottery. According to the company's own promotional literature:

Metals applied appropriately to reliefs modeled by the artists in connection with painted decorations characterize another type of Rookwood. This method gives the piece a variety and richness of texture and color, while retaining the unity of design lost in metal mounting.[1]

1. Rookwood Pottery Company (promotional pamphlet), *Rookwood Pottery* (Cincinnati: Rookwood Pottery Company, c. 1902), p. 36.

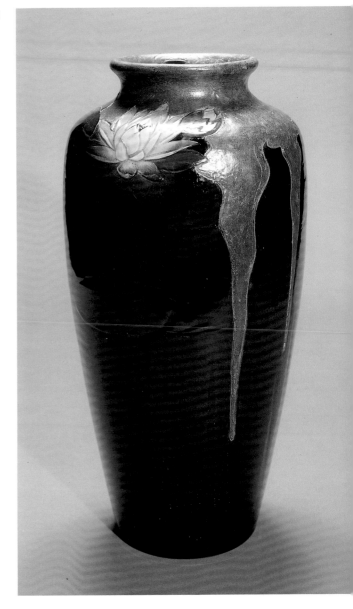

13. VASE, 1899

Rookwood Pottery Company
Cincinnati, Ohio

Decorated by Matthew Andrew Daly
(1860–1937)

Molded red earthenware body with
incised, upright peacock feathers
with green "eyes" extending from
shoulder to base. Orange glaze with
slight aventurine effects.

Height: 19.7 cm.
Diameter: 8.25 cm.
Marks: Impressed: R P cipher with
thirteen flames / S 1478 E; incised
artist's monogram: M A D

The letter "S" of the mark identifies
it as a special piece; in this case, it
was made from a sketch numbered
1478.

1984–84–7

In 1895 Rookwood sent Matthew Daly on a study
trip to Europe for three months. There he had
the opportunity to view the latest developments
in ceramic decoration, particularly in France and
Germany. The peacock feather was a popular
motif among art nouveau designers, and it is not
surprising that it also appears in Rookwood
pottery in the latter years of the century.

This vase also represents some of the results of
Rookwood's ongoing glaze experiments. Stanley
Burt, superintendent after Joseph Bailey's death
in 1898, was a trained chemist who devoted most
of his energies to improving the artistic sophis-
tication of the pottery's work. He developed
many new glazes and colors, though few were
put into full production. Here, a special orange
glaze with suspended particles of aventurine has
been applied over the red body.

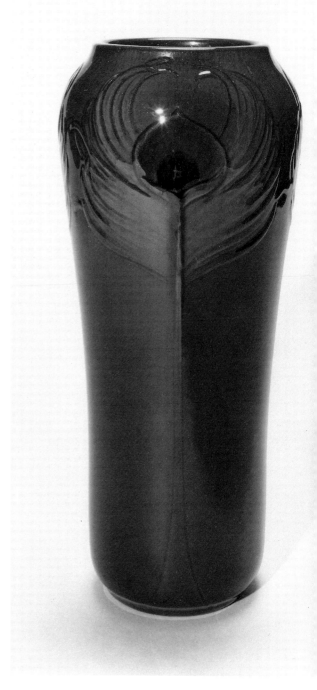

14. VASE, 1894

Rookwood Pottery Company
Cincinnati, Ohio

Probably glazed by Joseph Bailey, Sr.
(c.1826–1898)

Molded refined white earthenware
body with bright red aventurine
glaze.

Height: 14 cm.
Diameter: 10.15 cm.
Marks: Impressed: R P cipher with
eight flames / 750 C / 279 within
facing crescents

The *Shape Record Book* notes that
Number 750 was cast from a Japa-
nese vase brought to the United
States by Kataro Shirayamadani. It
was first made in July, 1894. The
facing crescents are identified as trial
marks used by Joseph Bailey, super-
intendent of Rookwood, who carried
out most of the glaze experiments.

1984–84–23

References

Di Noto, Andrea. "A Certain Shade
of Green: The Happy Collaboration
Between Two Collectors and an Art
Dealer," *Connoisseur* 215 (August
1985): 54.

One of the most sought-after and widely imitated glazes among European and American ceramists in the 1880s was a deep red developed in imitation of the Oriental *sang de boeuf,* or ox-blood. Working independently of French potters such as Ernest Chaplet and Auguste De-laherche, who had already achieved this effect, Hugh C. Robertson of Chelsea, Massachusetts, became in the 1880s the first American potter to produce the rich, red glaze (see No. 29). As America's premier pottery at the time, Rook-wood followed Robertson's lead and began experiments to achieve similar results. The pottery finally developed several varieties of red glazes, including the brilliant shade used on this vase dating from 1894. Rookwood promotional material described the results:

The Solid Color pieces comprise many of the richest and deepest reds and browns, some so intense that only actual sunshine will reveal the elusive hue. . . . There have also been a few small pieces of brilliant red, some of the "Sang de Boeuf" quality, others lighter.[1]

The experimental glaze on Number 279 was described by Stanley Burt as ". . . red from copper reduction, so called oxblood red made by Mr. Bailey."[2]

This vase came from the Clark Collection in Cincinnati and by tradition is said to have been displayed at the Exposition Universelle in Paris in 1900.

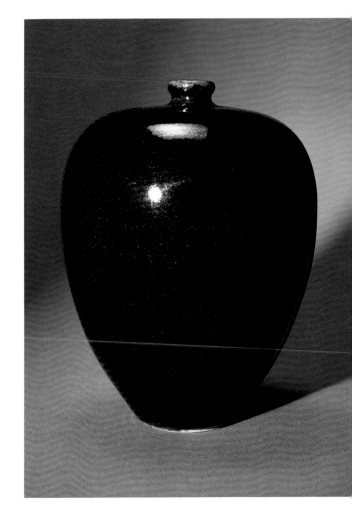

1. Rookwood Pottery Company (promotional pamphlet), *Rookwood Pottery* (Cincinnati: Rookwood Pottery Company, c. 1898), pp. 20–21.

2. Stanley Gano Burt, *Mr. S. G. Burt's Record of Ware at Art Museum (2,292 Pieces of Early Rookwood in the Cincinnati Art Museum in 1916)* (Cincinnati: Cincinnati Historical Society, 1978), p. 110, nos. 57–59. For Number 120, produced the same year, Burt also noted, "Vase—Bailey Oxblood red," and for Number 121, "Vase, same as 120 but different result. Shows brassy look of too complete reduction."

15. VASE, 1906

Rookwood Pottery Company
Cincinnati, Ohio

Decorated by Lenore Asbury
(1866–1933)

Molded white earthenware body decorated underglaze with pastel pink lotus blossoms and pale green leaves. Background shades from dark blue at base to light green at shoulder. Clear glaze.

Height: 24.2 cm.
Diameter: 14 cm.
Marks: Impressed: R P cipher with fourteen flames / VI / 905 C; incised artist's monogram: *L.A.* / W [designates clear glaze]

According to the *Shape Record Book*, Number 905 was first made in the "E" size in June 1900; the larger "C" size was not cast until July 1901.

1983–88–3

After nearly a decade of success with Standard ware, Rookwood introduced three new pottery lines—Iris, Sea Green, and Aerial Blue—within three months during 1894. Aerial Blue, a blue ware with a gray-white ground, was discontinued within a few months, but the Iris and Sea Green wares proved to be quite popular.

Although Iris ware was said to represent a glazing innovation, its effect is dependent upon underglaze painting rather than on the clear glaze itself. Slips were applied in the same manner as for Standard ware, but cool pastels predominated instead of the rich, dark colors. Pearl grays, pale blues, yellow, greens, and pinks were combined with the gray-white grounds, or subtly shaded into darker colors. Naturalistic floral subjects remained the favored motifs, such as the lotus blossoms on this vase decorated by Lenore Asbury, one of Rookwood's most accomplished decorators.

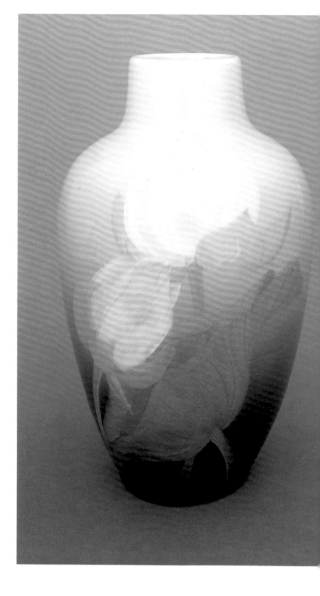

16. VASE, 1900

Rookwood Pottery Company
Cincinnati, Ohio

Decorated by Frederick Daniel
Henry Rothenbusch (dates unknown)

Thrown white earthenware body
decorated underglaze with gray-
green bamboo stalks and leaves ex-
tending the length of the body, two
pale blue butterflies behind the
stalks. Black background. Clear
glaze.

Height: 18.7 cm.
Diameter: 7.3 cm.
Marks: Impressed: RP cipher with
fourteen flames / 589 F; incised
artist's monogram, conjoined: FR /
W [designates clear glaze]

This shape was originally designed
by Kataro Shirayamadani in De-
cember 1890, in the "C" size. The
smaller "F" size was introduced on
December 30, 1893.

1984–84–19

Dark or Black Iris ware, represented by this
vase, was developed as a variation on Rook-
wood's successful Iris ware, from which it differs
in its much darker palette, "the ground some-
times being a rich luminous black."[1] Often, pastel
colors were chosen to contrast with the back-
ground and decoration was selected to comple-
ment the form. Fred Rothenbusch, the nephew
of Albert R. Valentien, was a Rookwood deco-
rator from 1876 until 1931.

1. W. P. McDonald, "Rookwood at the Pan-American," *Keramic Studio*
3 (November 1901): 146.

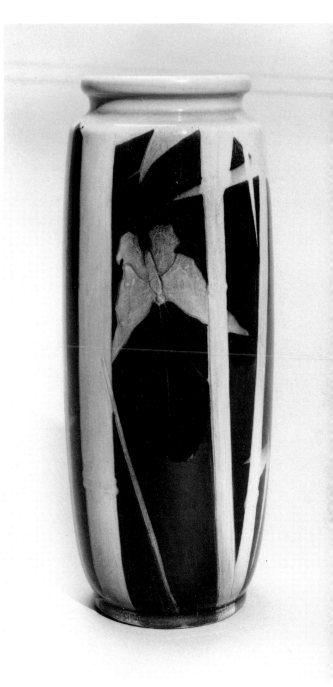

Rookwood Pottery Company
Cincinnati, Ohio

Decorated by Edward Timothy
Hurley (1869–1950)

Thrown white earthenware body
decorated underglaze with two fish
above three shallow relief waves in
shades of green and blue-green
against green background. Light
green glaze.

Height: 18.75 cm.
Diameter: 7.3 cm.
Marks: Impressed: RP cipher with
fourteen flames / I / 589 F; incised
artist's monogram: E.T.H. / G
[designates green glaze]

See No. 16 for comments on shape
589.

1984-84-18

References

Di Noto, Andrea. "A Certain Shade
of Green: The Happy Collaboration
Between Two Collectors and an Art
Dealer," *Connoisseur* 215 (August
1985): 56.

Introduced in 1894, Rookwood's Sea Green, like
Iris, contrasts markedly with the dark, relatively
somber character of Standard ware. As its name
implies, Sea Green was typically decorated with
underwater motifs, its cool, opalescent greens
and blue-greens ideally suited to aquatic images.
Bands of foam-crested waves animate the lower
portion of this vase, utilizing the color of the clay
body, but augmenting it with thickly applied slip.
A lightly tinted green glaze covers the entire
vase.

In 1904 a similarly decorated Sea Green vase
was offered by Rookwood through their mail
order catalogue for about $10.00.[1]

1. Rookwood Pottery Company, *The Rookwood Book. Rookwood, An
American Art* (Cincinnati: Rookwood Pottery Company, 1904), unpag.

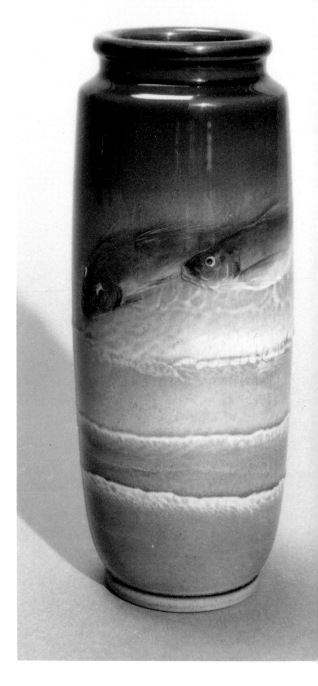

18. VASE, 1901

Rookwood Pottery Company
Cincinnati, Ohio

Decorated by Sarah Alice Toohey
(1872–1941)

Thrown white earthenware body decorated underglaze with light green branches of dogwood blossoms and leaves against light blue background. Light green glaze.

Height: 24.8 cm.
Diameter: 11.45 cm.
Marks: Impressed: RP cipher with fourteen flames / I / 888 C; incised artist's monogram, conjoined: ST / G [designates green glaze]

The *Shape Record Book* notes that the "C" size of Number 888 was first made in October 1899.

1984–84–17

Naturalistically depicted flowers, in this case dogwood blossoms native to the Ohio River Valley, remained a popular form of decoration under the tinted glaze of Rookwood's Sea Green ware.

The decorator of this vase, Sarah (Sallie) Toohey, began work at Rookwood in 1887 at the age of fifteen. She was recognized as a gifted painter and through Maria Storer's generosity was given a chance to travel and study in France. In 1908 she took charge of the glazing for Rookwood's new architectural faience department while continuing to design many new pottery shapes. Around 1917, she became head of the glaze room for the vase department. She remained at Rookwood until 1931.

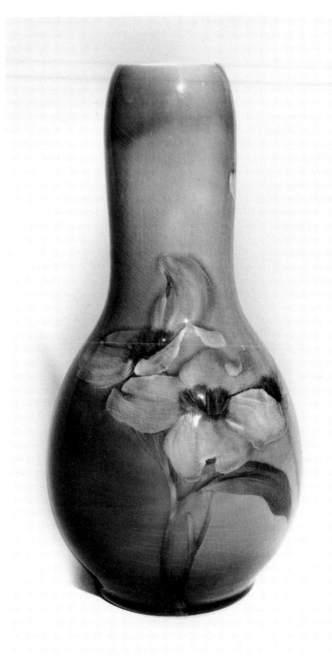

Rookwood Pottery Company
Cincinnati, Ohio

Decorated by Kataro Shirayamadani
(1865–1948)

Molded refined white stoneware
body with carved design of a goose
in relief, its outstretched wings ar-
ranged diagonally. Incised cloud pat-
terns and modeled swirls, diagonal
ridges around body. Gray-green mat
glaze covers goose, and background
is covered with a light to dark gray
slight, or smear, glaze. Pale yellow
mat glaze on interior and bottom.

Height: 10.8 cm.
Diameter: 9 cm.
Marks: Impressed: R P cipher with
fourteen flames / I / T 1195; incised
artist's signature in Japanese charac-
ters

Number 1195 does not appear in the
Shape Record Book; the "T" indi-
cates that this piece was made as a
trial piece.

1984–84–24

The development of mat glazes in the 1890s
marked a dramatic change in the orientation of
art pottery design. Such finishes as the
lusterless smear glazes or the transparent glazes
Rookwood used for its Standard, Iris, and Sea
Green wares concentrated interest on the pot-
tery's underglaze brushwork. Opaque mat
glazes, on the other hand, which could not be
decorated underglaze, focused attention on the
texture of the glaze and on the sculptural clarity
of the forms themselves.

This vase makes limited use of a mat glaze. The
design has been carved in relief; while gray and
pale green mat glazes cover the goose, the
modeled and incised ground is covered with a
smear glaze.

Carved designs were produced very rarely at
Rookwood, generally by Shirayamadani.[1] The
time and cost involved in carving each piece
made this decorative method unproductive, and
it was soon abandoned.

1. For another example of carved ware by Shirayamadani, see Robert
Judson Clark, ed., *The Arts and Crafts Movement in America,
1876–1916* (Princeton, N.J.: Princeton University Press, 1972), p. 151,
no. 217 (illus.). Another vase with the same design as No. 19,
presumably by Shirayamadani but of earlier date, was illustrated in
"The Rockwood [sic] Pottery, " *Die Kunst* 2 (1899-1900): 71.

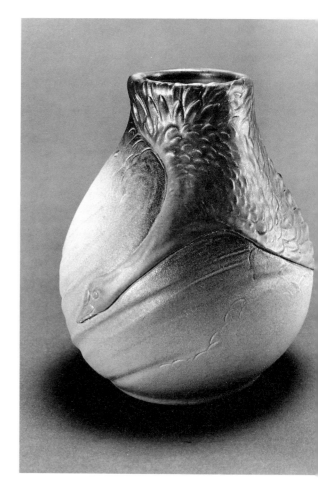

20. PLAQUE, c.1910

Rookwood Pottery Company
Cincinnati, Ohio

Designed by Sarah Alice Toohey
(1872–1941)

Molded coarse white earthenware
body with relief design of landscape
with trees and winding river, and two
rooks. ROOKWOOD across front of
plaque. Covered with colored mat
glazes in light and dark green,
brown, tan, pale sea green, fuchsia,
and black.

Height: 37.8 cm.
Width: 20 cm.
Depth: 3.2 cm.
Marks: Impressed: R O O K W O O D
F A I E N C E 66 / .1288. / 1359 Y;
artist's monogram, conjoined, in high
relief on front, lower left corner: S T

Number 1359 Y was listed in a
separate book of shapes for faience
tiles, and recorded as "Landscape &
Rook sign."

1984–84–22

Rookwood became a leader in American architectural faience, producing between 1902 and 1930 a wide range of fireplace mantels, fountains, and wall tiles. Mat glazes were particularly well suited to architectural tiles, their dull finish considered appropriate for interiors.

This plaque, used as an advertising sign in Rookwood showrooms, shows a range of colors and textures that could be achieved in mat glazed tiles. "They tempt the touch almost as much as the eye," declared William Watts Taylor, "and through both they suggest the most varying qualities, such as jade, or leather, or old ivory, or the delicate bloom of ripe fruit."[1] Though the pieces were often not hand decorated, Rookwood hoped to achieve a distinctive and individual effect through the quality of the glazes.[2] In this regard, the firm was strongly influenced by the Grueby Faience Company.

Sarah (Sallie) Toohey designed this plaque with two large rooks, the company's namesake, soon after she took charge of glazing for the architectural department in 1908. In 1898 Toohey had designed the cover for the Rookwood reprint of Rose G. Kingsley's *London Art Journal* article about the pottery. This cover included a large raven with outstretched wings in black silhouette, quite similar to the one she placed at the top of this plaque.

1. William Watts Taylor, "The Rookwood Pottery," *Forensic Quarterly* 1 (September 1910): 211–12.

2. Other examples of this advertising plaque are known, but with different combinations of colored glazes; see, for example, Kenneth R. Trapp, *Ode to Nature: Flowers and Landscapes of the Rookwood Pottery, 1880–1940* (New York: Jordan-Volpe Gallery, 1980), p. 89, no. 117.

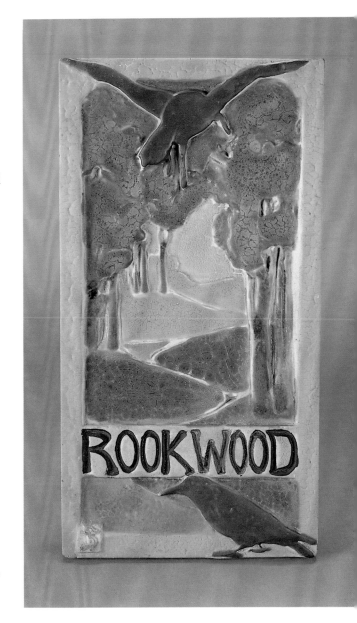

Rookwood Pottery Company
Cincinnati, Ohio

Decorated by Edward Timothy
Hurley (1869–1950)

Thrown refined white stoneware
body decorated underglaze with tall,
slender trees and branches encircling
the body, in gray-brown against an
ivory ground. Transparent mat glaze.

Height: 32.4 cm.
Diameter: 15.2 cm.
Marks: Impressed: R P cipher with
fourteen flames / IX / 925 B / V
[designates vellum glaze]; incised
artist's monogram: E T H. / V

The *Shape Record Book* notes that
Number 925 was first thrown in May
1901 and that the "B" size preceded
the smaller "D," "C," and "CC"
sizes.

1984–84–3

Exhibitions

*A Century of Ceramics in the United
States, 1878–1978,* Everson Museum
of Art, Syracuse, N.Y., 1979, with
national tour.

*Ode to Nature: Flowers and Land-
scapes of the Rookwood Pottery,
1880–1940,* Jordan-Volpe Gallery,
New York, 1980.

References

Clark, Garth, and Margie Hughto. *A
Century of Ceramics in the United
States, 1878–1978,* p. 52, fig. 51.
New York: E. P. Dutton, in assoc.
with the Everson Museum of Art,
1979.

Maloney, John. "The Ruckus Over
Rookwood." *Antiques U.S.A.* (July/
August 1981), p. 12 (illus.).

Trapp, Kenneth R. *Ode to Nature:
Flowers and Landscapes of the Rook-
wood Pottery,1880–1940,* p. 83. New
York: Jordan-Volpe Gallery, 1980.

Rookwood introduced its Vellum ware for the
first time in 1904 at the Louisiana Purchase
Exposition in St. Louis. Characterized by a
transparent mat glaze, derived after long experi-
mentation by Stanley G. Burt, the name Vellum
was chosen because in the firm's words "it
partakes both to the touch and to the eye of the
qualities of old parchment."[1] While Rookwood
artists continued to decorate pottery under the
glaze, the Vellum glaze's soft, waxen texture
veiled their pictorial work, presenting them with
a whole new series of design issues. Vellum
stood as the connecting link between the paint-
erly tradition of pottery decoration and the more
abstract, formalist trend towards colored mat
glazes. Rookwood's popular Standard ware was
eclipsed by its own mat-glazed ceramics.

1. Rookwood Pottery Company, *The Rookwood Book. Rookwood: An
American Art* (Cincinnati: Rookwood Pottery Company, 1904), unpag.

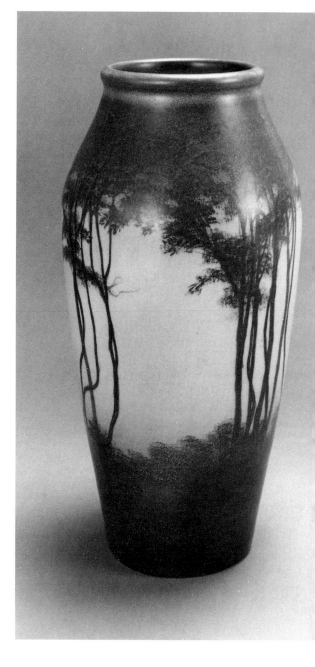

Rookwood Pottery Company
Cincinnati, Ohio

Decorated by Edward Timothy
Hurley (1869–1950)

Thrown refined white stoneware
body decorated underglaze with
scenes of an Indian encampment
along a river bank. Design executed
as a pale gray silhouette against a
background of orange to pale yellow,
shading into blue-green at top.
Transparent mat glaze.

Height: 34.7 cm.
Diameter: 16.5 cm.
Marks: Impressed: R P cipher with
fourteen flames / IX / 1659 B / V
[designates vellum glaze]; incised
artist's monogram: E. T. H. / V
[designates vellum glaze]

This shape was first made about
1908.

1984–84–1

References

Sotheby, Parke Bernet, N.Y., *American Arts and Crafts*, 19 November
1981, lot 144.

Edward T. Hurley, working at the pottery from
1896 until his retirement in 1948, established
himself as a master of Vellum underglaze decoration at Rookwood. In addition, Hurley was a
printmaker, painter, and photographer. He often
carried his camera into the countryside to make
photographic studies of trees and of the qualities
of natural light, studies he used as aids in his
decorative work.

Hurley's use of the American Indian motif can be
seen as part of a romantic fascination among
turn-of-the-century artists with a sentimentalized vision of the American frontier.

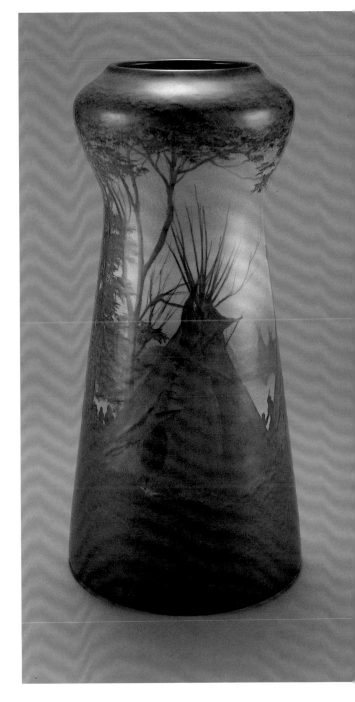

Rookwood Pottery Company
Cincinnati, Ohio

Decorated by Charles (Carl) Schmidt
(1875–1959)

Molded refined white stoneware
body decorated underglaze with sce-
nic landscape; birch trees clustered
in foreground, and lake and trees in
background. Colors range from blues
to greens to grays, with brown
accents in trees. Clear high glaze.

Height: 14.7 cm.
Diameter: 14.9 cm.
Marks: Impressed: RP cipher with
fourteen flames / XII / 2000 / V
[designates vellum glaze]; impressed
artist's monogram, conjoined within
circle: CS; incised V [designates
vellum glaze]

Shape Number 2000, first made in
October 1911, was produced in only
one size. With a mat glaze it origi-
nally sold for $5.00.

1984–84–2

Any attempt to represent spatial depth on a
rounded vase has to overcome the problems
posed by the lack of a focal point. Rookwood
decorators devised a formula for painting land-
scapes that divided scenes into bands with a
well-defined foreground, middle ground, and
background.

Although this piece has a brilliant clear glaze, it
should be considered Vellum rather than Iris
ware. The incised and impressed "V" marks on
the bottom imply that the decorator and the kiln
master originally intended it to be finished with
the transparent mat Vellum glaze. Why that was
changed before the final firing is unknown.

Decorator Carl Schmidt, a German by birth,
worked with Rookwood for thirty-one years,
from 1896 to 1927. Like Hurley, he was a master
of the Vellum technique and became best known
for the Venetian scenes he depicted on vases
and plaques.

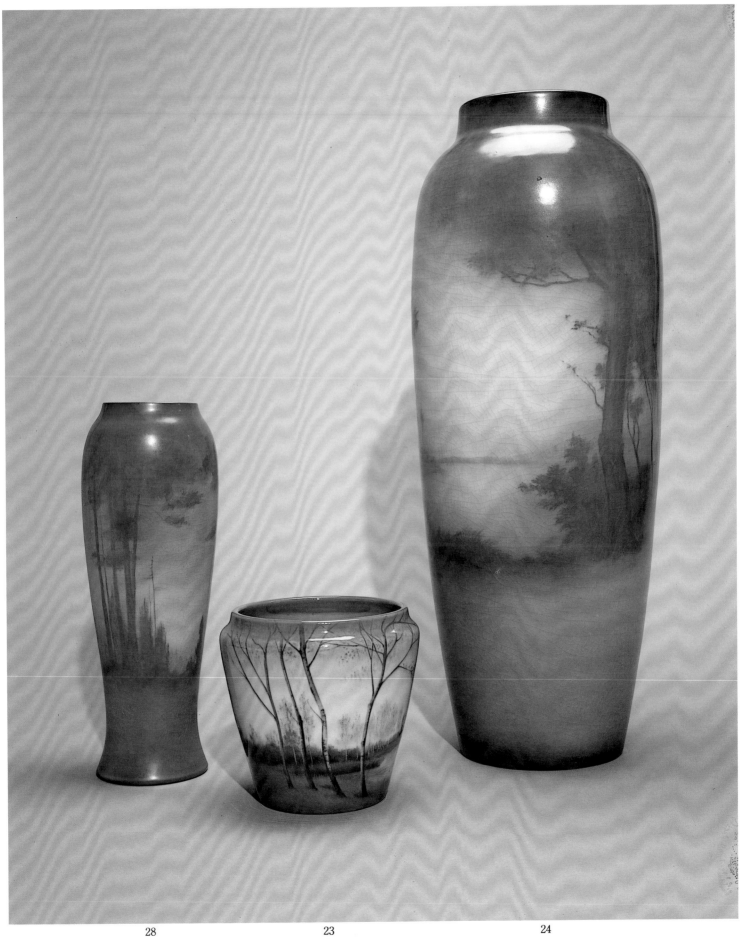

28 23 24

24. VASE, 1917

Rookwood Pottery Company
Cincinnati, Ohio

Decorated by Lenore Asbury
(1866–1933)

Thrown refined white stoneware body decorated underglaze with a continuous landscape: lake, trees, and low hills in middle ground, and trees and brush in foreground. Decorated predominantly in blues and greens, shading to pale yellow and peach in sky. Transparent mat glaze.

Height: 54.6 cm.
Diameter: 17.8 cm.
Marks: Impressed: RP cipher with fourteen flames / XVII / 907 A / V [designates vellum glaze]; incised artist's monogram: *L.A.*; X cut through glaze on bottom

The *Shape Record Book* indicates that this shape was first introduced in June 1900 and that this was the largest size created. The "X" may mean that the piece was offered for sale at a reduced price.

1984–84–4

This piece, compared with the landscape vases made at the Newcomb Pottery (see No. 54), suggests certain aesthetic interests held in common by the two firms. Trees and landscapes depicted in shades of blue and green under the veil of transparent mat glaze characterized the output of both potteries during the years around 1917. Newcomb had gained widespread praise for its own variation on this style, and Rookwood was well aware of Newcomb's success. Although the Cincinnati pottery was producing Scenic Vellums prior to 1910—the year Newcomb first produced its mat glaze—they only shifted to this cooler palette after Newcomb's entry into the market.

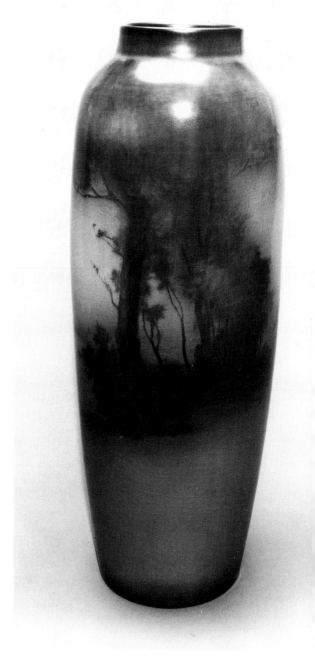

Rookwood Pottery Company
Cincinnati, Ohio

Decorated by Edward George Diers
(1870–1947)

Molded refined white stoneware
body decorated underglaze with
misty tropical scene: Spanish moss-
covered tree in foreground with palm
trees along the banks of a still river;
palm trees and foliage in background.
Predominantly shaded in greens,
blues, and blue-grays. Transparent
mat glaze.

Height: 21.6 cm.
Width: 27.3 cm.
Depth: 2.25 cm.
Marks: Impressed: RP cipher with
fourteen flames / XIII / V [desig-
nates vellum glaze] above three
lozenges; some pencil notations on
back, including 35 in upper right
corner; painted underglaze on front,
lower right: E. Diers

1984–84–21

Exhibitions

*Ode to Nature: Flowers and Land-
scapes of the Rookwood Pottery,
1880–1940*, Jordan-Volpe Gallery,
New York, 1980.

References

Trapp, Kenneth R. *Ode to Nature:
Flowers and Landscapes of the Rook-
wood Pottery, 1880–1940*, p. 84, no.
109a. New York: Jordan-Volpe Gal-
lery, 1980.

Vellum ware plaques, which could be framed for
wall display, often depicted scenes of the Cincin-
nati countryside. In this instance, the decorator
depicted a tropical landscape unlike anything in
the Ohio River Valley.

A title, "Willows Along a Silent Stream," is
marked on the back of this plaque's frame.
Rookwood is known to have fitted each plaque
with a frame labeled with the artist's name, the
date, and the title of the composition.[1] While the
frame associated with this plaque may not be the
original, the characteristically sentimental title
may be a Rookwood designation.

Like easel paintings, most of these picture tiles,
which make no pretense of utility, bear the
artist-decorator's signature or monogram on the
front, generally in the lower right-hand corner.
Edward Diers, who joined Rookwood in 1896
after a period of study at the Art Academy of
Cincinnati, has spelled out his last name on the
front of the plaque. On the back of this piece,
the number "35" probably indicates that it
originally sold for thirty-five dollars; the meaning
of the three lozenge-shaped devices impressed
on the back is unknown.

1. Kenneth R. Trapp. *Ode to Nature: Flowers and Landscapes of the
Rookwood Pottery, 1880–1940* (New York: Jordan-Volpe Gallery, 1980),
p. 61.

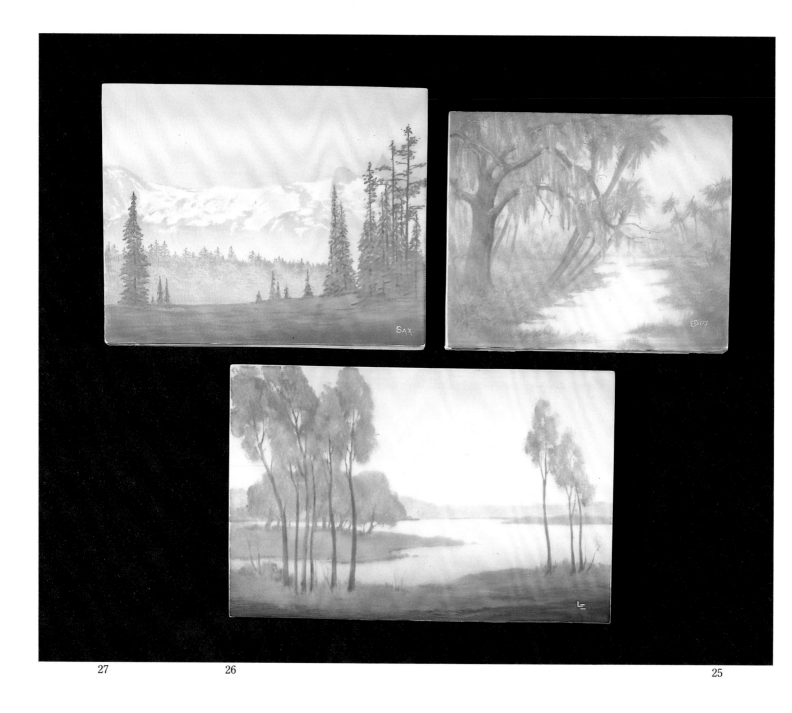

27 26 25

58

26. PLAQUE, 1916

Rookwood Pottery Company
Cincinnati, Ohio

Decorated by Lorinda Epply
(1874–1951)

Molded refined white stoneware
body decorated underglaze with
clusters of tall, slender trees beside
a wide and winding river, low hills in
background. Predominantly shaded
in blue and green, with ivory tones in
sky and water. Transparent mat
glaze.

Height: 23.8 cm.
Width: 37.4 cm.
Depth: 1.9 cm.
Marks: Impressed: R P cipher with
fourteen flames / X V I / V [desig-
nates Vellum glaze]; incised on left
edge: 36 / X V I / artist's monogram,
conjoined: L E; incised artist's mono-
gram, conjoined, right edge, bottom:
L E; pencil notations on back, includ-
ing 60— in upper right corner;
painted underglaze on front, lower
right, artist's monogram, conjoined:
L E

1983–88–4

Like Edward Diers and most of Rookwood's
decorating staff during this period, Lorinda
Epply was a native of Cincinnati who had
attended the Art Academy of Cincinnati. She had
also studied ceramics at Columbia University
before joining Rookwood in 1904. Once there she
remained through the financially troubled years
of the 1930s and 1940s, retiring in 1948.

27. PLAQUE, 1918

Rookwood Pottery Company
Cincinnati, Ohio

Decorated by Sara Sax (1870–1949)

Molded refined white stoneware body decorated underglaze with snow-covered mountains in background and clusters of tall pine trees in middle ground. Trees in shades of green and brown, mountains in gray and white. Sky shades from peach to blue-green. Transparent mat glaze.

Height: 23.8 cm.
Width: 31.4 cm.
Depth: 1.9 cm.
Marks: Impressed: R P cipher with fourteen flames / X V I I I; incised on right edge, bottom: 130; incised on bottom edge, right, artist's monogram, conjoined: S A X; pencil notations on back, including 35 in upper right corner; painted underglaze on front, lower right, artist's monogram: S A X

1984–84–20

Usually, Rookwood plaques depicted familiar but unspecific landscapes (see No. 26), but in this instance, a typewritten label attached to the plaque's frame identifies this snow-capped mountain scene as "Cascade Range, Washington . . .," the northernmost section of the Sierra Nevada Mountains. Sara Sax, one of Rookwood's most skilled floral decorators, may have based the composition on firsthand observation, but no documentation exists to indicate that she visited Washington, and it is more likely that she used a photograph or a painted image for inspiration. The popularity of such plaques, which evoked poetic sentiments, continued well into the 1940s.

This plaque, which still retains its original frame and label, bears the number "35" on the back, which probably indicates that the piece originally sold for thirty-five dollars.

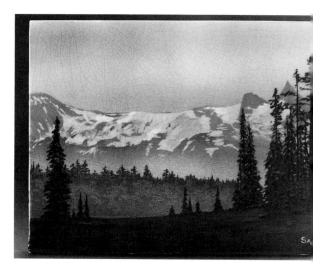

28. VASE, 1922

Rookwood Pottery Company
Cincinnati, Ohio

Decorated by Lenore Asbury
(1866–1933)

Thrown refined white stoneware body decorated underglaze with trees and landscape. Shaded predominantly in dark green and blue. Transparent mat glaze.

Height: 30.2 cm.
Diameter: 10.8 cm.
Marks: Impressed: RP cipher with fourteen flames / XXII / 2040 C / V [designates Vellum glaze]; incised artist's monogram: *L.A.*

This shape was developed in about 1912 and sold for $5 with a mat glaze, or $20 with decoration and the Vellum finish.

1983–88–1

By 1922, the year this vase was produced, translucent mat glazes had been in use at Rookwood for nearly twenty years. The cool blue palette and the sketchy, almost impressionistic treatment of trees and landscape found here are typical of the Rookwood Vellum style—a style that, at this point, had passed its artistic height, although it remained popular with a wide market.

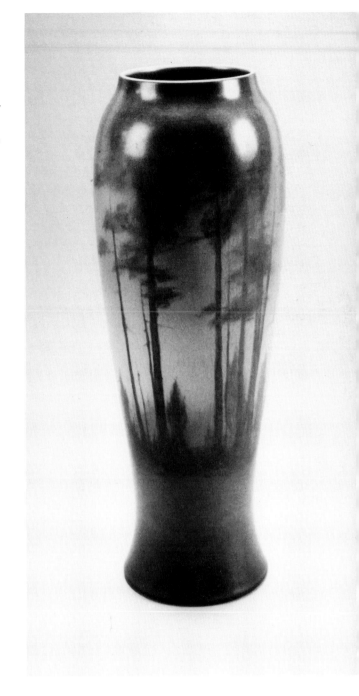

Chelsea
Keramic
Art
Works

Dedham
Pottery

In 1866, Alexander William Robertson started a small pottery in an abandoned varnish factory at the corner of Willow and Marginal Streets in Chelsea, Massachusetts, where he manufactured brownware from the fine red clay obtained nearby. Hugh Cornwall Robertson, who had served a brief apprenticeship at the Jersey City Pottery in 1860, joined his older brother in this venture around 1868, and the enterprise became known as A.W. & H.C. Robertson. Production shifted to plain redware flowerpots, some of which were decorated, but none glazed.

Family involvement in the pottery grew further when James Robertson, father of Alexander and Hugh, retired from another local pottery in 1872 and joined his sons' firm, bringing with him his eldest son, George. James Robertson had brought his family to the United States from England in 1853, first settling in New Jersey and moving to the Boston area in 1859. When he joined his sons' pottery concern, the firm became known as James Robertson & Sons. By 1875, Chelsea Keramic Art Works had been added to the name. The company became increasingly involved in the creation of art wares around this time, successfully marketing an art pottery line in 1875. Notable among the Robertsons' smooth, fine-textured redwares was a group of classically inspired vases in imitation of ancient terra-cottas, some with Greek-style figures against polished black grounds. Along with the Robertsons, the pottery called on a few capable local artists as designers and decorators, among them John Gardner Low[1] and the sculptor Franz Xavier Dengler.

By 1877 most redware manufacture had ceased at the Chelsea Keramic Art Works. A new line called Chelsea Faience dominated production into the 1880s. Buff-colored clay bodies noted for their simple shapes were thrown or molded and covered with a variety of monochromatic, transparent glazes. Pieces were often decorated with applied or carved sprigs of flowers and leaves, and at times the surfaces imitated hammered metal, creating an interesting allover honeycomb pattern. Chelsea Faience "soon attracted the attention of connoisseurs and carried the firm to

the front rank of American potteries.[2] Bourg-la-Reine of Chelsea was introduced the following year, a variety of Chelsea Faience highly influenced by the Haviland technique of painting under the glaze with colored clays. But it remained in production only a few years, never achieving the popularity of McLaughlin's similar work in Cincinnati.

With his father's death in 1880 and Alexander's move to California in 1884, Hugh C. Robertson was left as sole owner of the pottery. Abandoning the rather elaborate decorative style of his earlier work, Robertson turned his attention to the Chinese and Japanese ceramics he had seen at Philadelphia's Centennial Exhibition in 1876 and in growing numbers of Boston collections. In particular he endeavored to capture the secret of the elusive *sang de boeuf,* or oxblood, glaze. His attempts produced wonderful glazes in sea green, mustard yellow, blue-green, apple green, purple, and in a delicately shaded, yellow-to-red glaze called "peachblow." An especially noteworthy, rich oxblood red was first obtained in 1885 and perfected in 1888. Another important discovery during this period was the Japanese crackle glaze, which later became the Dedham Pottery's specialty.

Robertson struggled alone with his work, assisted only occasionally by his son, William. His preoccupation with his art, and his lack of concern for the commercial success that could have financed fuel for the kiln, forced him to close the pottery in 1889, "its shelves filled with examples of its very finest work."[3]

Two years later the pottery was reopened, considerably reorganized. Supported financially by a group of Boston businessmen headed by Arthur A. Carey, the Chelsea Pottery, U.S., as it was now known, was established with Robertson as superintendent and his son William as kiln master. The directors encouraged Robertson to continue his art pottery, but insisted that he concentrate additional efforts on the development of a commercial ware that could support the business. Robertson began experimenting with the crackle glaze he had first

obtained in 1886. By the end of 1891, he had achieved favorable results on flat objects, and began to produce "Cracqule ware," tableware formed of white stoneware that required high firing, and was decorated with an underglaze border of blue rabbits. Cracqule ware proved to be highly successful and numerous other borders followed, about fifty in all, each executed by hand with a stylized design in cobalt blue.

In 1893 the location of the pottery was discovered to be unsuitable, since local dampness often permeated the kilns and caused steam to form during the firing. Land was purchased in nearby Dedham, and in 1895 the company and most of its Chelsea staff moved to the new site. The name was changed as well, "owing to the fact," the company explained, "that the old name of 'Chelsea Pottery, U.S.' was frequently confounded with that of the English Chelsea Potteries, and that it also led some people to suppose that the American Chelsea Ware was an imitation of the English product";[4] so Robertson's firm became the Dedham Pottery Company.

Work continued much as before, and Dedham's wares proved to be very popular. Until his death in 1908 Hugh Robertson pursued his glaze experiments, now concentrating on mixing different glazes. He developed an important variation of the flambé glaze, as well as "Volcanic ware," so called because the glaze, often pitted with rough craters, flowed over the body like lava. These glazes were highly colorful, but the number of firings and successive coats of glazes required—so much that the form of the pot itself was often lost under the mass of thick, heavy glaze—made the cost prohibitive to most buyers. Dedham Pottery received high honors for this work at Paris in 1900, St. Louis in 1904, and later, in 1915, at San Francisco's Panama-Pacific International Exposition, and was retailed by such stores as Tiffany & Company in New York.

William Robertson assumed the management of the Dedham Pottery after his father's death, but because his hands and arms had been severely burned in a kiln explosion in 1904, he was unable to throw pieces on the wheel. Still, William oversaw production of the now-famous Cracqule ware and the firm continued to prosper through the sale of artistic, commercial tableware, even with a few supply shortages during World War I. At his death in 1929, Dedham's production had reached its highest level. William Robertson's son, J. Milton, took over as superintendent and directed operations through the 1930s. The pottery managed to remain open until 1943 when escalating costs and the lack of skilled artists and craftsmen finally forced its closure.

1. Most of Low's work followed the Greek revival style, an inclination that survived only a short time, due mainly to public indifference. With his father's financial backing, Low left the firm around 1878 to found the Low Art Tile Works, located on Broadway in Chelsea. George Robertson joined him the same year, and together they adapted the technique of mechanically pressing tiles.

2. Edwin AtLee Barber, *Pottery and Porcelain of the United States* (New York: G.P. Putnam's Sons, 1893) p. 262.

3. Mabel M. Swan, "The Dedham Pottery," *Antiques* 10 (August 1926): 120.

4. Dedham Pottery, *Dedham Pottery* (promotional pamphlet) (Boston: Merry Mount Press, 1896), unpag. [p.1].

29. VASE, c.1885–89

Chelsea Keramic Art Works
Chelsea, Massachusetts

Made by Hugh Cornwall Robertson
(1845–1908)

Thrown gray-white stoneware body
with thick, scarlet glaze. Slight
golden luster and some black stria-
tions throughout; textured surface.

Height: 18.4 cm.
Diamater: 9.9 cm.
Marks: Impressed in a diamond pat-
tern: C K A W; painted in black: D P
83 G; pencil notations, including:
300—

1984–84–37

While Rookwood Pottery represented the styl-
istic mainstream of the art pottery movement's
early period, the Chelsea Keramic Art Works
epitomized the avant-garde. Around 1884
Robertson began an intensive exploration of
richly colored glazes on the high-firing stoneware
body he had developed, particularly the *sang de
boeuf*, or oxblood, glaze so admired in Chinese
pottery.

Robertson became the romantic figure of the
zealous potter. He was described in 1896 as
having spent "sixty-two hours watching the
interior of the kiln, while the fire of 3,000
degrees was raging within . . . abandoning for
the time all thought of food and sleep in the
intense concentration and veritable fury of his
enthusiasm."[1]

Barber's general discussion of Robertson's work
can be taken as descriptive of this piece: "The
forms of the vases are simple, with curving
outlines, and entirely devoid of ornamentation
which would tend to impair the beauty of color,
which is that of fresh arterial blood, possessing a
golden lustre, which in the light glistens with all
the varying hues of a sunset sky."[2]
Vases glazed with "sang de Chelsea" were
originally very expensive, a result of their rarity
and the purity of their color. The "300" pencil
notation on this vase may indicate its original
price, considerably less than the $1000 asked for
another example,[3] but still out of the range of
most buyers.

1. Dedham Pottery, *Dedham Pottery* (promotional pamphlet) (Boston:
Merry Mount Press, 1896), unpag. [p. 2].

2. Edwin AtLee Barber, *Pottery and Porcelain of the United States*
(New York: G. P. Putnam's Sons, 1893), p. 265.

3. *New York Times*, 19 September 1943, p. 52; reproduced in Lloyd
E. Hawes, *The Dedham Pottery and the Earlier Robertson's Chelsea
Potteries* (Dedham, Mass.: Dedham Historical Society, 1968), p. 51.

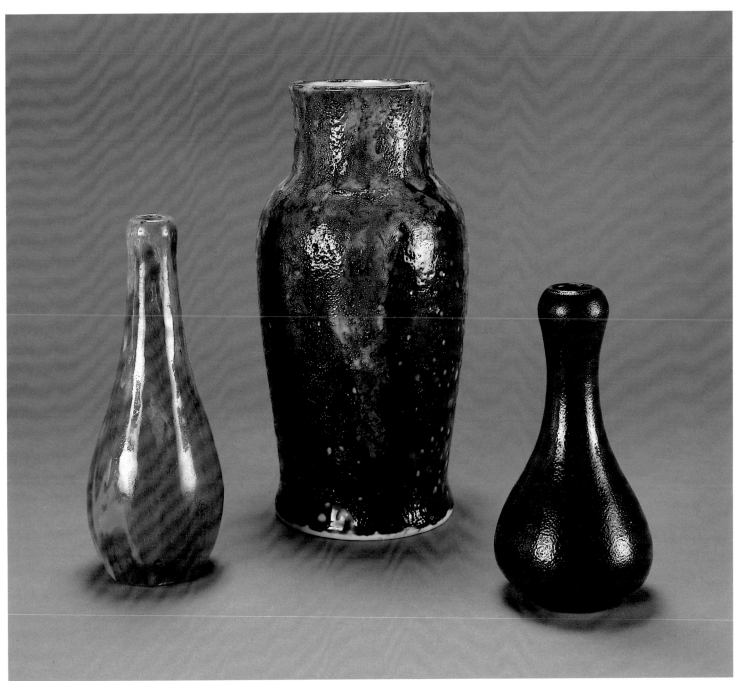

30 31 29

Dedham Pottery
Dedham, Massachusetts

Made by Hugh Cornwall Robertson
(1845–1908)

Thrown gray-white stoneware body
with a thick, flowing coat of orange,
red, gray-green, and blue-green
glazes. Slight luster.

Height: 22.6 cm.
Diameter: 9.2 cm.
Marks: Incised: artist's monogram,
twice: H C R and D E D H A M /
P O T T E R Y; indecipherable pencil
notations

1984–84–38

Exhibitions

American Art Pottery 1875–1930,
Delaware Art Museum, Wilmington,
Del., 1978.

References

Keen, Kirsten Hoving. *American Art
Pottery 1875–1930*, p. 29, no. 43
(illus. p. 30). Wilmington, Del.: Dela-
ware Art Museum, 1978.

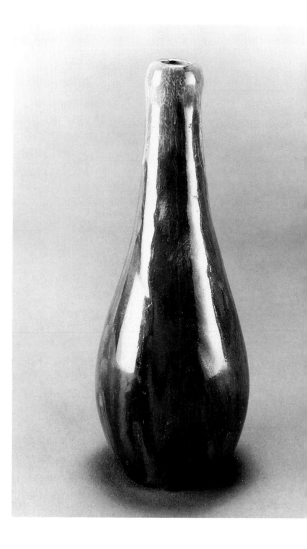

After Dedham's cracqule ware was well into production, Hugh Robertson returned to his experiments with Oriental glazes, and by 1896 he had obtained successful results with flambé glazes. Although these glazes were highly praised, some critics objected that because of their thickness "the forms themselves had not the grace and refinement of the Rookwood examples."[1] Often, as was the case here, the glaze flowed slowly down the body during firing and collected at the base, cementing the pot to the kiln shelf. Afterwards, the piece was forcea-bly removed and the excess glaze ground away. Barber considered the flambé pieces, "after the old Japanese," to be among Robertson's most important achievements.[2]

When the Dedham Pottery closed in April 1943, the firm's remaining stock was disposed of by Gimbels, the New York department store. Hun-dreds of pieces were sold in the fall of that year, including many examples of the earliest pottery made by the Chelsea Keramic Art Works. Many prohibitively expensive *sang de boeuf* vases were offered at half price. A full-page advertisement in the *New York Times* illustrated many of the examples being offered, including a bottle-shaped vase that appears to be identical to this one. It is described in the advertisement as "green and red glaze vase, made in 1896, Dedham's price, $32, Gimbels price, $16."[3]

1. George M. R. Twose, "The Chicago Arts and Crafts Society's Exhibition," *Brush and Pencil* 2 (May 1898): 76.

2. Edwin AtLee Barber, *Marks of American Potters* (Philadelphia: Patterson & White Co., 1904), p. 97.

3. *New York Times*, 19 September 1943, p. 52; reproduced in Lloyd E. Hawes, *The Dedham Pottery and the Earlier Robertson's Chelsea Potteries* (Dedham, Mass.: Dedham Historical Society, 1968), p. 51.

Dedham Pottery
Dedham, Massachusetts

Made by Hugh Cornwall Robertson
(1845–1908)

Thrown gray-white stoneware body
with blue-gray and green flowing
glaze over an olive green volcanic
glaze, with yellow-green "craters."

Height: 29.9 cm.
Diameter: 14.6 cm.
Marks: Incised: Dedham Pottery /
artist's monogram, conjoined: H C R;
painted in black: D P 8.3 F

1984–84–39

Robertson's later ceramic work revolved around
his explorations into the molten qualities of
glazes. Part of a line called Volcanic ware
because of its resemblance to the craterlike
pitted surface of lava, this piece possesses a
striking polychrome effect achieved by placing
one glaze over another. "Their vases as a rule,"
insisted one detractor, "were hideous masses of
glaze and lustre and lumps of clay."[1] Robertson's
work, seen in the context of late nineteenth- and
early twentieth-century ceramic design, has
come to be viewed as an important preface to
the modern period, and one scholar has re-
marked, "the glazes of Robertson's last phase
show the boldest sense of color and texture and,
in a sense, mark the beginning of twentieth-
century developments."[2]

1. "National Arts Club," *Keramic Studio* 1 (February 1900): 212–13.

2. Martin P. Eidelberg, "Art Pottery," in Robert Judson Clark, ed.,
The Arts and Crafts Movement in America 1876–1916 (Princeton,
N.J.: Princeton University Press, 1972), p. 131.

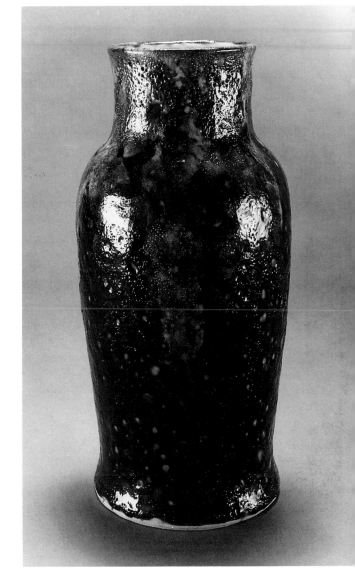

Biloxi Art Pottery

Some of the most inventive and unusual work produced by any American potter was carried out in the small southern town of Biloxi, Mississippi. George E. Ohr had established a pottery there as early as 1882–83, producing a low-firing earthenware characterized by original shapes and glazing effects. His contorted, crushed, folded, dented, and crinkled pots earned him the nickname "the mad potter of Biloxi."

Unlike the Rookwood Pottery or even that of the Robertsons, Ohr's production was essentially a one-man operation, with only occasional assistance with clay preparation provided by his eldest son, Leo.[1] Ohr dug his own clay from the banks of the nearby Tchouticabouffe and Pascagoula rivers and hauled it back to the pottery in a wheelbarrow. There he processed the clay and threw his curious forms on a homemade potter's wheel. He developed his own glazes, fired his own pieces, and, later, even peddled them at fairs and expositions. For the World's Industrial and Cotton Centennial Exhibition of 1884 in New Orleans he prepared over six hundred pieces, "no two alike." But as recounted in his short autobiography, "It cost me my total year's savings to show up, and as I got the wrong man to attend to the taking away of my ware, stand, and fixings, it turned out to be nobody's business and everybody's pottery."[2]

At expositions in New Orleans, Atlanta, and St. Louis, Ohr demonstrated his artistic ability. A showman, Ohr made the act of throwing a pot a theatrical event. On placards he boasted of being the "unequaled—unrivaled—undisputed—greatest art potter on the earth."[3]

While many contemporary critics did not consider his work to be admirable, Ohr did win an award for originality at the 1904 Louisiana Purchase Exposition in St. Louis. He received some favorable criticism and became fairly well known among ceramists and fair-goers. As William A. King commented about Ohr's display at the Arts and Crafts Exhibition held in Buffalo in 1900:

There is art—real art—in the Biloxian's pottery, albeit at times he has a way of torturing the clay into such grotesque shapes that one can well believe it to cry out in anger and anguish against the desecration.[4]

While Biloxi was hardly a major design center, Ohr was not isolated from the ideas of the Arts and Crafts movement, or from developments in the world of ceramics. Before he established his pottery in Mississippi, he "took a zigzag trip for 2 years, and got as far as Dubuque, Milwaukee, Albany, down the Hudson, and, zigzag back home. [He] sized up every potter and pottery in 16 States, and never missed a show window, illustration or literary dab on ceramics since that time, 1881."[5] Ohr's familiarity with the work of contemporary potters does not appear to have altered his own individual style—yet while his forms are unlike those of any other American potter of the time, they do exhibit affinities with certain examples of Christopher Dresser's pottery made from 1879 on at Linthorpe, an English concern near Middlesbrough, Yorkshire.

Ohr abandoned his "pot-OHR-Ree," as he called his workshop, at an uncertain date, and seems to have stopped potting altogether about 1909. He did not want to sell any of his work, convinced as he was that his entire output should be kept intact until the day when the United States government would purchase it all for the national trust. In his heart, Ohr explained:

The potter dreams of fame, not of riches. He cares not that each piece of work will find a ready buyer, that is not his idea. But while he turns that wheel he is dreaming of the day when the whole will be sold intact.[6]

Since no offers were made, Ohr stored 6,000 to 7,000 examples of his life's work in the attic of his sons' Ohr Boys Auto Repair shop. This legacy remained in his family's possession until the early 1970s, when it was sold and subsequently dispersed.

1. J. Harry Proctman, Ohr's foster brother, and Manuel Jalanivich also assisted for a short time.

2. George E. Ohr, "Some Facts in the History of a Unique Personality." *Crockery and Glass Journal* 54 (December 12, 1901): 124.

3. Robert W. Blasberg, *George E. Ohr and His Biloxi Art Pottery* (Port Jervis, N.Y.: J.W. Carpenter, 1973), p. 8 (illus.).

4. W. A. King, Buffalo *Express*, 21 April 1900. Quoted in Paul F. Evans, *Art Pottery of the United States* (New York: Charles Scribner's Sons, 1974), p. 28.

5. Ohr, p. 124.

6. L. M. Bensel, "Biloxi Pottery," *Art Interchange* 46 (January 1901): 8.

32. VASE, c.1893–1909

Biloxi Art Pottery
Biloxi, Mississippi

Made by George E. Ohr (1857–1918)

Thrown buff earthenware body with applied handles. One side covered with a dark blue glaze, the other mottled in shades of purple and green; silver metallic blotches in slight relief.

Height: 25.7 cm.
Diameter: 9.5 cm.
Width: 13.4 cm. (handle to handle)
Marks: Impressed: G.E. OHR, / Biloxi, Miss.

1984–84–33

Ohr's unconventional treatment of traditional forms can be seen in this vase. The body itself is rather simple, reminiscent of a classical baluster shape. But Ohr has imaginatively divided the vase's neck into two separate parts and has pinched a thin ruffle around the edges. The pattern created by the applied double-looped handles on this vase is restrained and elegant, as opposed to the radically asymmetrical handles with which he embellished many of his works.

Although Ohr was making pottery in the early 1880s, none of this early work can now be identified. Nearly all of his surviving pottery dates after 1893, the year a fire totally destroyed his old pottery building along with its contents. He immediately rebuilt after this loss and began potting again. Contemporary photographs of his work in datable exhibitions give no evidence of a stylistic change; he seems to have worked with these idiosyncratic forms throughout his mature career.

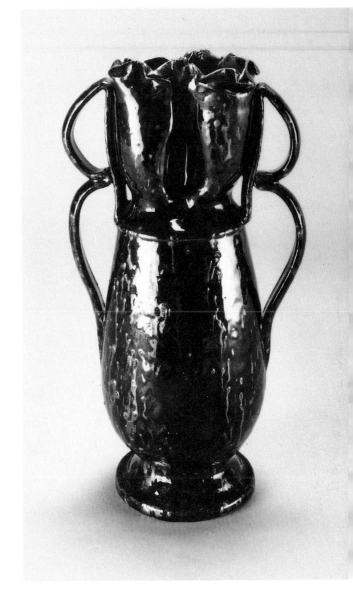

Biloxi Art Pottery
Biloxi, Mississippi

Made by George E. Ohr (1857–1918)

Thrown buff earthenware body covered externally with a variegated rose and pink glaze splotched with dark brown. Interior glazed a light yellow-green with mottled green specks.

Height: 10.8 cm.
Diameter: 15.55 cm.
Marks: Impressed: G.E.OHR, / Biloxi, Miss.

1984–84–34

Ohr's inexhaustible originality found expression through his pottery. This crumpled bowl is a tour-de-force of technical control. Its walls are almost eggshell thin, a particularly difficult accomplishment when one considers the common, unrefined river mud that he used.

Ohr's critics praised his ability to handle glazes "with breadth and artistic boldness,"[1] more than his handling of forms, a fact that he came to regret. "Colors and quality counts [sic] nothing in my creations," Ohr wrote. "God put no color or quality in souls."[2] Like his forms, his glazes seem to have been inspired by organic or natural phenomena, such as the speckling found on marine life or on leaves or rocks.

1. L. M. Bense, "Biloxi Pottery," *Art Interchange* 46 (January 1901): 8.

2. Quoted in Garth Clark, "George E. Ohr," *Antiques* 128 (September 1985): 493.

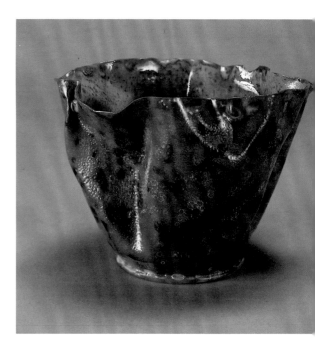

34. BOWL WITH SPOUT, c.1893–1909

Biloxi Art Pottery
Biloxi, Mississippi

Made by George E. Ohr (1857–1918)

Thrown buff-red earthenware body with applied ruffle at mid-body. Variegated dark brown glaze mottled with darker splotches. Interior covered with black glaze.

Height: 10.85 cm.
Width: 11.7 cm.
Marks: Impressed: G.E. OHR, / Biloxi, Miss.

1984–84–35

Function was never one of George Ohr's major concerns. The flattened ruffle around the rim of this bowl makes its purpose somewhat obscure, although a vertical spout on the side does provide a means, however ungainly, of using it.

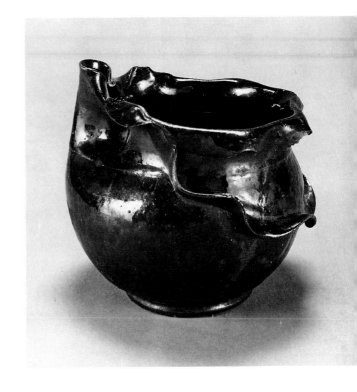

35. BOWL WITH HANDLE AND SPOUT, c.1898–1909

Biloxi Art Pottery
Biloxi, Mississippi

Made by George E. Ohr (1857–1918)

Thrown red earthenware body with folded and deeply dented sides, and applied handle. Exterior covered with variegated rose-colored glaze, with streaks of brilliant green glaze. Interior glazed in mottled dark green with areas of lusterless and high-luster glaze.

Height: 10.15 cm.
Width: 19.4 cm. (handle to spout)
Depth: 11.7 cm.
Marks: Incised, in script: GE Ohr

1984–84–36

This handled-bowl, which resembles a sauce boat, was probably produced some time after 1898, the year Ohr began to incise many of his pieces with hand-script signatures like the one found here. He is presumed to have continued to use this mark for the rest of his pottery career, although he may have retained the earlier impressed block letter mark as well.

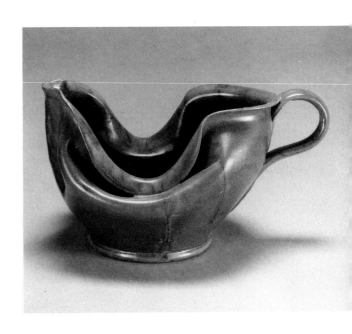

Middle Lane Pottery

After only a single year's experimentation with potting and glazing effects, in 1894 Theophilus Anthony Brouwer, Jr., opened a small workshop he called Middle Lane Pottery, on Middle Lane in East Hampton, New York. In the early studio pottery tradition of which he and George Ohr were a part, Brouwer worked alone in the creation of his pottery, accepting assistance only in laying the fire for his kilns. He threw pieces, turned them, made his own molds, and even developed the glaze technology he needed to achieve his personalized effects. Brouwer's most innovative accomplishment lay in the manipulation of the muffle and open reduction kilns, particularly in setting the glazes.

Brouwer won the acclaim of his ceramist peers for both his luster and lusterless glazes. "Fire Painting," the most famous of his five glazes, was characterized by a surface iridescence and multiple color effects that were achieved by exposing the specially glazed biscuitware almost directly to the heat of the open reduction kiln. The glaze's decorative patterns were determined by the precise placement of the pot in the kiln during firings that took as little as seventeen minutes. Though produced in a similar fashion, "Iridescent Fire Painting" was characterized by a lustrous single-color surface—as opposed to the polychrome of the "Fire Painting" glaze. "Sea-Grass Fire Painting" did not possess this iridescent effect, but was distinguished by designs created in the firing that resembled sea grasses. Brouwer also developed glazes "with surfaces resembling that of kid."[1] By 1900 he had perfected a process whereby a transparent glaze was placed over a layer of gold leaf on the surface of the pots. This "Gold Leaf Underglaze" technique, also produced favorable results.

Brouwer's versatile interests as a painter, woodcarver, plaster model-maker, and metalworker were all employed during the construction of his new pottery in 1903, at a site in Pinewold Park in Westhampton. At the same time he began work nearby on a small castle, which he designed and built in concrete entirely by himself over a period of eight years. The new pottery was simply known as the Brouwer Pottery. While the work he produced in Westhampton was similar to that from Middle Lane, here Brouwer perfected what he called his "Flame" ware. He considered this pottery, which combined elements of all five of his glazes on one piece, to be his crowning achievement, "each example being a carefully studied combination of form, color, and texture."[2] Brouwer seems to have ceased his ceramic work at Westhampton about 1911, although he maintained an active interest in lecturing and in selling his pottery until his death in 1932.

1. Edwin AtLee Barber, *Marks of American Potters* (Philadelphia: Patterson and White Co., 1904), p. 86.

2. Quoted in Paul F. Evans, *Art Pottery of the United States* (New York: Charles Scribner's Sons, 1974), p. 175.

Middle Lane Pottery
East Hampton, New York

Made by Theophilus Anthony
Brouwer, Jr. (1864–1932)

Molded light earthenware body covered with light apple green, ocher, and russet flambé glazes; slightly milky iridescence around shoulder.

Height: 9.2 cm.
Diameter: 7.6 cm.
Marks: Impressed: M within a whale jawbone

1984–84–48

Exhibitions

American Art Pottery 1875–1930, Delaware Art Museum, Wilmington, Del., 1978.

References

Keen, Kirsten Hoving. *American Art Pottery 1875–1930,* p. 46, no. 98 (illus. p. 51). Wilmington, Del.: Delaware Art Museum, 1978.

In 1917 Brouwer described his discovery of the "Fire Painting" method of which this small vase is an example:

With regard to the manner of my discovering this 'Fire Painting,' I am frequently asked if it was accident. It certainly was not, unless one considers the seeing of a bit of iridescent color on the bottom of a little sand crucible an accident. I saw this bit of color and determined to find out how it got there. It took me months of hard work, literally day and night before my muffle furnace door.[1]

Brouwer's process was quite revolutionary compared with traditional pottery techniques. After a short, direct exposure to the kiln's high temperature, the pots were removed and placed directly on a heated iron plate where they were allowed to cool in the normal atmosphere of the studio. According to an article about Brouwer, "The lustre and all effects are completed at this one firing which is often done in the presence of a client and sold while yet red hot."[2]

This vase is incised with an M enclosed by whale jawbones, a mark derived from the actual jawbones that formed the arched entrance to the pottery's East Hampton grounds.

1. Quoted in Frederick H. Rhead, "Theophilus A. Brouwer, Jr., Maker of Iridescent Glazed Faience," *Potter* 1 (January 1917): 47.

2. Rhead, "Theophilus A. Brouwer, Jr.," p. 47.

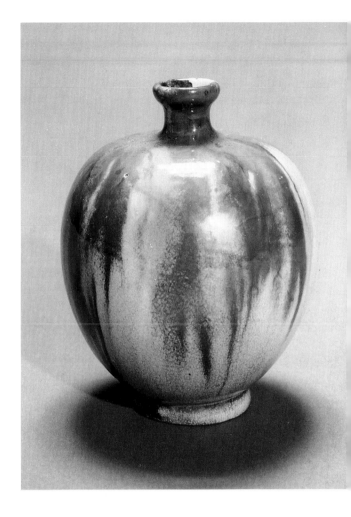

American Encaustic Tiling Company

The desire for simpler, cleaner, and more healthful living environments in the second half of the nineteenth century encouraged the use of tile for architectural adornment on floors and walls. Tiling grew to be immensely popular in Europe during the 1870s, and the fashion spread to the United States, where tiles were imported in great numbers, particularly from England. Following Philadelphia's Centennial Exhibition in 1876, many tile companies were founded in the United States.

Just prior to the Philadelphia Centennial, the American Encaustic Tiling Company was organized in Zanesville, Ohio. F. H. Hall, its founder, had been experimenting with local clays, and with the financial backing of two New Yorkers—Benedict Fischer, later president of the company, and G. R. Lansing—AET was begun in 1875 and incorporated in 1878. Initially the company produced encaustic tiling (with inlaid decoration), but by 1880 it was making glazed tiles, and the following year, embossed or relief tiles. While AET employed a wide range of styles and techniques, its approach remained generally conservative.

AET expanded its facilities and staff throughout the 1880s, successfully convincing American architects that its tiles were equal in quality to European imports. An 1889 plan to move the operation to New Jersey was protested by the citizens of Zanesville, who raised enough money to keep the company and its jobs in their city. Community support allowed a new factory to be organized in 1890 and to be opened in 1892. With thirty-nine kilns in operation, AET claimed that it was the largest tile works in the world.

American Encaustic Tiling continued its success after the turn of the century, eventually opening a sales room and workshop in New York City, where it captured a good part of the market for such commissions as the tiling of the Holland Tunnel. In 1919 the firm purchased a plant in California, which was sold in 1932. AET was forced to close its own doors in 1935, a victim of the Depression.

American Encaustic Tiling Company
Zanesville, Ohio

Modeled by Herman Carl Mueller
(1854–1941)

Molded red earthenware body mod-
eled in low relief, with nude child
pulling on rope around ram's neck;
foliage, trees, and wall in back-
ground. Unglazed.

Height: 14.9 cm.
Width: 45.4 cm.
Depth: 1.6 cm.
Marks:; Impressed in rectangle:
AMERICAN ENCAUSTIC /
TILING Co. Limited / WORKS:
/ Zanesville, O. / NEW YORK;
impressed on front, lower right, art-
ist's monogram, conjoined: HM

1984–84–54

American Encaustic Tiling Company's early
work, done chiefly for commercial installations,
possessed minor artistic merit. To resolve this
problem, Herman Carl Mueller, trained as a
sculptor in Nuremberg and Munich, was hired as
the firm's modeler in 1887. At AET he created
relief tiles in a style that can be termed
"classical," since the designs were based on
Italian Renaissance and ancient Greek and Ro-
man art. Barber, recognizing Mueller's work,
remarked that "some of the most artistic produc-
tions of this factory are the eight, ten, and
fifteen tile facings, with raised designs of classi-
cal female and child figures."[1]

Mueller remained at AET until 1893 when he and
Karl Langenbeck, formerly the ceramic chemist
at the Rookwood Pottery Company, decided to
organize the Mosaic Tile Company in Zanesville,
Ohio.

1. Edwin AtLee Barber, *The Pottery and Porcelain of the United States*
(New York: G. P. Putnam's Sons, 1893), p. 356.

Grueby Pottery

One of the most important achievements to come out of the art pottery movement was an opaque, lusterless enamel, or glaze, created by William Henry Grueby. This mat glaze produced a tremendous impression on the public and on pottery manufacturers when it was introduced around 1897. Naturally produced mat glazes (those not derived by acid bathing or sand blasting) had been developed in this country before that date, but they had met with limited use.[1] Grueby's high standards of craftsmanship, combined with the simple forms, restrained designs, rich, variegated colors, and smooth, satiny surfaces of his pottery, earned him continuous praise from his contemporaries.

Grueby began his career in 1882 at the age of fifteen, when he was hired by the J. and J. G. Low Art Tile Works of Chelsea, Massachusetts, where he remained for about eight years. Grueby ventured out on his own in September 1890 when he organized a short-lived company that produced architectural faience at Revere, Massachusetts.[2] By 1892, he and Eugene R. Atwood had formed a business partnership associated with the larger firm of Fiske, Coleman & Company. As Atwood & Grueby, the two produced architectural ceramics and glazed bricks for interior and exterior decoration.

At the Chicago World's Columbian Exposition in 1893 Grueby encountered the work of many of Europe's most progressive ceramists such as Eugène Chaplet and Auguste Delaherche, the latter of whose work with flambé glazes deeply impressed him. These exhibits inspired him to pursue his own glaze experiments, and in 1894, following the dissolution of Atwood & Grueby in late 1893, he formed the Grueby Faience Company. Located on the same South Boston premises on Devonshire Street that had been used by Atwood & Grueby, the new company produced architectural faience and terra-cotta tiles in historical styles, inspired by Italian ceramics from the Della Robbia workshops, Moorish design, and Chinese ceramics. A limited number of glaze experiments were also conducted. In 1897 the Grueby Faience Company was reorganized and incorporated with Grueby himself as general manager, William Hagerman Graves, a young Boston architect, as business manager, and George Prentiss Kendrick as designer. At first this corporate reorganization signaled no changes in artistic direction, but soon the firm's work began to concentrate on the full development of the mat glazes for which Grueby would become famous.

After 1898, Grueby divided his work between art pottery and the architectural faience production that provided him his first success. Around 1899 a distinction between these two divisions began to be made in the potters' marks. Although inconsistently applied, "Grueby Pottery" was used to identify the bowls, jars, vases, and lamp bases produced after designs by Kendrick, while "Grueby Faience" designated the tiles and other architectural ceramics. All of the company's work was done by hand, either thrown on the potter's wheel or hand built from coarse, heavy clays from New Jersey and Martha's Vineyard. Each vessel was decorated with applied ropes of clay that were modeled into the body of the piece. The decoration itself was done primarily by young women graduates of Boston's School of the Museum of Fine Arts, the Massachusetts Normal Art School, and the Cowles Art School.[3] Designs were based on leaf and flower motifs that fully exploited the potential of Grueby's frequently used green glaze, with its thick, dense texture "like the smooth surface of a leaf, or the bloom of a melon, avoiding the brilliancy of high glazes."[4]

Gustav Stickley, editor of the influential journal *The Craftsman* and a leading furniture maker, exhibited jointly with Grueby in 1901 at Buffalo's Pan-American Exposition, where a large public viewed the Boston potter's work.[5] Grueby captured the highest award for his display, only one year after his triumph at the Paris Exposition Universelle—where he had won a gold medal for enamels and glazes, a silver for pottery design, and another gold medal for his personal accomplishment in creating the dull-finished enamels. Other international awards followed, culminating in St. Louis with a grand prize at the Louisiana Purchase Exposition.

The Grueby Faience Company's use of traditional hand-production methods, combined with the division of labor associated with industry, was much admired by proponents of the Arts and Crafts movement. By 1904 Grueby's glazes and forms were being widely imitated by other producers who were able to make similar wares at considerably lower costs. Financial problems plagued the operations from 1904 to 1907. A new concern called Grueby Pottery Co., with Grueby as president, was legally incorporated as a separate entity from the struggling Grueby Faience Company in 1907. An attempt was made to revitalize the pottery in 1908, during which year Augustus A. Carpenter of Chicago was named president, by hiring Henry W. Belknap of New York as the general manager, and the noted ceramic chemist Karl Langenbeck as superintendent. Nevertheless, the company was forced to declare bankruptcy the same year. After having his name, processes, and designs released by the courts, Grueby incorporated yet another pottery in September of 1909, called the Grueby Faience and Tile Company, and located the new firm in the same factory as the old Grueby Pottery. Operations were limited to architectural faience—vase production seems virtually to have ceased by this date. After a disastrous fire in 1913, which completely destroyed the Grueby Pottery building, the Grueby Faience and Tile Company was rebuilt and continued production until 1919. That year the C. Pardee Works of Perth Amboy, New Jersey, bought the company, transferred its administration a year later to their offices in New York City, and moved production to New Jersey. Grueby himself moved to New York where he died in 1925; the firm survived until the beginning of the Depression.

1. Rookwood had developed a mat glaze as early as 1896 but did not pursue its production until ten years later. The Hampshire Pottery of Keene, New Hampshire, achieved a mat glaze in 1891 but their discovery went unnoticed.

2. Paul F. Evans, *Art Pottery of the United States* (New York: Charles Scribner's Sons, 1974), p. 118.

3. Edwin AtLee Barber, in *Marks of American Potters* (Philadelphia: Patterson and White Co., 1904), p. 100, lists the monograms of twelve decorators, all but one of whom were women.

4. Pendleton Dudley, "The Work of American Potters," *Arts and Decoration* 1 (November 1910): 21.

5. For illustrations of this exhibit, see *Craftsman* 1 (November 1901): following p. 48.

38. VASE, c.1893

Atwood & Grueby, of Fiske, Coleman & Company
Boston, Massachusetts

Produced by William Henry Grueby (1867–1925)

Thrown light buff earthenware body with pronounced concentric rings, body glazed bright green with yellow "flames" near base; cream from shoulder to rim.

Height: 32.1 cm.
Diameter: 21.3 cm.
Marks: Impressed: ATWOOD [& GR]UEBY

1984–84–40

William Grueby's earliest ceramic enterprise, the firm of Atwood & Grueby, was dissolved in 1893 after barely a year in business. The company specialized in architectural faience such as mantels, moldings, tiles (for Philadelphia's Reading Railroad Terminal), and glazed bricks. Until now, little evidence has surfaced to indicate that art pottery was being produced as well. This signed vase from c.1893 appears, therefore, as a landmark in the history of Grueby's art ware.

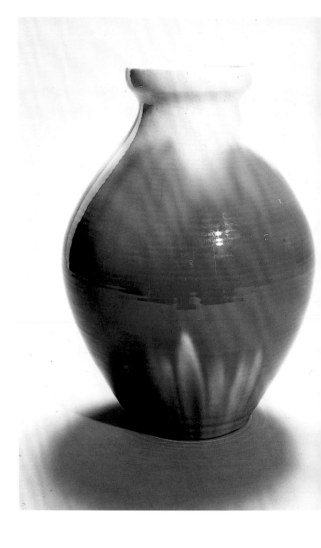

Grueby Faience Company
Boston, Massachusetts

Decoration attributed to
Ruth Erickson (dates unknown)

Thrown buff earthenware body with attenuated leaves and stems applied and modeled in low relief and emerging at foot to form irregular ruffle. Six yellow and ocher daisy groups of four flowers each around the shoulder. Body in dark green mat glaze with silvery veining. Interior covered with ocher high glaze.

Height: 41.6 cm.
Diameter: 19.1 cm.
Marks: Impressed, circular factory mark: GRUEBY POTTERY / BOSTON U.S.A., surrounding lotus blossom; incised artist's monogram, conjoined: R[?]E / 8 31

1983–88–7

Exhibitions

The Ceramics of William H. Grueby, Everson Museum of Art, Syracuse, N.Y., 1981.

References

Anderson, Alexandra. "Collecting." *Vogue* (November 1984): 138.

Blasberg, Robert W. *The Ceramics of William H. Grueby: Catalog of an Exhibition at the Everson Museum of Art,* p. 4, fig. 2. Syracuse, N.Y.: Everson Museum of Art, 1981.

Grueby's development of a line of unique art ware began soon after the incorporation of the Grueby Faience Company in 1897. This vase was probably designed by George Prentiss Kendrick, Grueby's first designer, who established the style of vase decoration the company followed until 1909, although he himself left Grueby in 1901. The dense mat glaze is typical of the "Grueby green," which can best be described as possessing an organic quality: "The surface of Grueby enamels has much the character of a watermelon or cucumber . . . and is full of delicate mottling which gives it an individuality of its own."[1] On this example, the rich green monochrome has been touched with yellow and ocher glazes that highlight the blossoms. Polychrome glazes such as this were in use at least as early as 1899 and continued to be popular throughout the first decade of the twentieth century.[2]

This vase is marked on its base with a decorator's monogram slightly obscured by the glaze, probably that of Ruth Erickson, one of twelve decorators working at Grueby before 1904.[3]

1. Henry W. Belknap, "Another American Pottery," *Pottery and Glass* 2 (January 1909): 14.

2. See, for example, *Brush and Pencil* 4 (May 1899): color frontispiece.

3. Edwin AtLee Barber, *Marks of American Potters* (Philadelphia: Patterson and White, 1904), p. 100. The decoration of this vase was attributed to Erickson when it was exhibited at the Everson Museum of Art's exhibition of Grueby pottery (Blasberg, *Grueby,* p. 4, fig. 2). Another nearly identical vase is in the collection of the Charles Hosmer Morse Foundation at the Morse Gallery of Art, Winter Park, Florida. It is marked with Ruth Erickson's monogram and dated 8/17/05. See Donald L. Stover, *The Art of Louis Comfort Tiffany* (San Francisco: Fine Arts Museums of San Francisco, 1981), p. 120 (illus.).

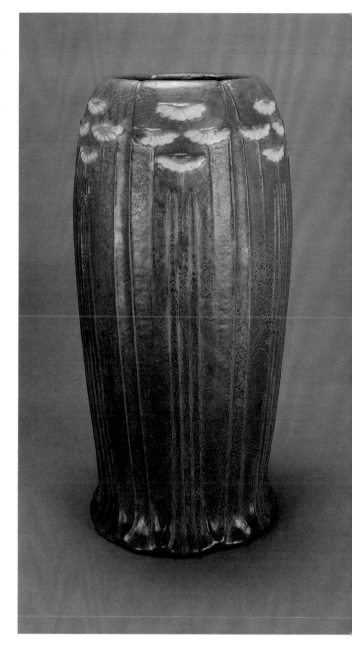

40. TILE, c.1903–04

Grueby Faience Company
Boston, Massachusetts

Red earthenware body with press-molded design of haloed eagle displaying an open book. Allover dark green mat glaze, very dark in recessed background.

Height: 19.7 cm.
Width: 19.7 cm.
Depth: 2.5 cm.
Marks: ; Remnants of Grueby label attached to bottom edge: [G R U E] BY POTTERY/[BOST]ON U.S.A., surrounding a lotus blossom, and remnants of unidentified label; circular label attached to back: George W. Benson / ART SHOP / Buffalo; painted in white: three indecipherable marks

1983–88–10

A major portion of Grueby's output was for such public commissions as the tiling of New York's subway stations. Grueby's tiles were ideally suited as well for decorating the burgeoning number of churches built during the religious revival of the late nineteenth century. This tile depicts the eagle emblematic of St. John. A series of "four tiles forming a square, each holding the symbol of one of the Gospels traced in blue shades,"[1] was exhibited at New York's National Arts Club in December 1906. Based on the George W. Benson Art Shop label attached to the back, this tile may have been made at least two years before this exhibition, since the Benson shop at 656 Main Street in Buffalo, New York, was in existence only during 1904.[2]

1. Eva Lovett, "The Exhibition of the National Society of Craftsmen," *International Studio* 30 (November 1906–February 1907): lxx.

2. Ludwig, Coy L., *The Arts & Crafts Movement in New York State, 1890s–1920s* (Hamilton, N.Y.: Gallery Association of New York State, 1983), p. 51.

41. TILE, c.1902

Grueby Faience Company
Boston, Massachusetts

Decorated by unknown artist(s), initials DC / K.C.

Coarse white earthenware body with press-molded design of a single tulip and leaves. Mat glazes in dark and light green, with butterscotch mat glaze on blossom.

Height: 15.2 cm.
Width: 15.2 cm.
Depth: 2.3 cm.
Marks: Painted in green: DC / K.C.; stamped in blue ink: MADE BY THE / GRUEBY FAIENCE CO. / Boston, Mass.

1983–88–11

This tile was originally part of the decoration of Dreamwold, the Scituate, Massachusetts, country house built for Thomas W. Lawson around 1902 by the architectural firm of Coolidge & Carlson.[1] The Grueby Faience Company supplied the tiling for the conservatory, the fireplaces, and the bathrooms throughout the house.

The tulip blossom is divided symmetrically by thin walls of clay, the raised contours partitioning the inlaid glazes. The satin finish of the glazes "satisfy the eye and invite the touch,"[2] as one critic remarked. The palette here is quite naturalistic, particularly the delicate variations of "Grueby green" between the leaves and the background.

1. "The Interesting Tile Work of 'Dreamwold,'" *Brickbuilder* 11 (October 1902): 205.

2. "Notes on the Crafts," *International Studio* 24 (February 1905): xcv.

Grueby Faience Company
Boston, Massachusetts

Probably designed by Addison B. Le Boutellier (1872–1951)
Decorated by unknown artist, initials A. S.

Light buff earthenware body with press-molded design of trees in a landscape. Various mat glazes in light green, dark green, brown, and blues, defined by raised partitions.

Height: 15.4 cm.
Width: 15.2 cm.
Depth: 2.5 cm.
Marks: Painted in gray, artist's monogram: AS; remnants of original paper label attached to top edge: GRUEBY POTTERY / BOSTON U.S.A., surrounding a lotus blossom

1983–88–12

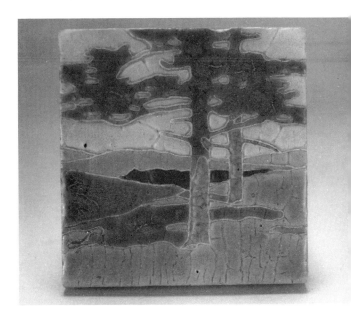

Grueby's tiles embodied the trend toward "welding . . . the artistic with the utilitarian,"[1] and were thus ideally suited to the Arts and Crafts home. They found numerous uses as entry hall pavement, bathroom tiling, fireplace embellishment, and occasionally as insets for furniture or as individual decorative objects set into frames.

The design of this tile is associated with a group of eight different tiles that, when placed together, form a fireplace frieze entitled "The Pines."[2] Addison B. Le Boutellier, an architect who became chief designer of pottery and advertising for Grueby after Kendrick left the firm in 1901, designed this very popular frieze, which was produced numerous times. Each element of the design is segmented by cloisons of clay, the raised contours partitioning the inlaid glazes.

This particular tile, like No. 41, was originally part of the decoration of Dreamwold.

1. "Notes on the Crafts," *International Stuaio* 24 (February 1905): xcii.

2. "The Pines" was illustrated in *Brickbuilder* 15 (1906): 107, where the design is attributed to Le Boutellier, and in Robert W. Blasberg, *The Ceramics of William H. Grueby: Catalog of an Exhibition at the Everson Museum of Art* (Syracuse, N.Y.: Everson Museum of Art, 1981), pp. 14–15. It is not known if an entire frieze was installed at Dreamwold or if tiles were used singly.

43. TILE, c.1905–09, or later

Grueby Faience Company
Boston, Massachusetts

Coarse red earthenware body with press-molded design of lily pads and blossoms, one flower in full bloom and two buds opening. Dark green, blue-green, ivory, and pale yellow mat glazes defined by raised partitions.

Height: 15.4 cm.
Width: 15.4 cm.
Depth: 2.4 cm.
Marks: Impressed: GRUEBY / BOSTON

1983–88–13

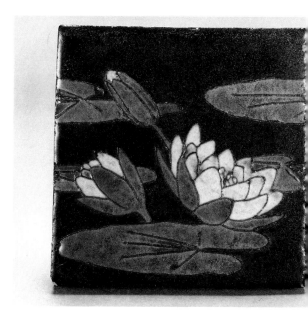

Tiles decorated with pond lilies were evidently among the most popular made by Grueby, judging from the number of examples that are known. This tile was well suited for bathroom decoration, and in one instance it made up the border of a bathroom floor, inspiring one critic to declare, "A more appropriate design for an elaborate bathroom could hardly be imagined and if extravagance is to be shown in house fittings what more delightful than to bathe in a room surrounded by rich-hued flowers in the midst of verdure."[1]

Dating this tile is problematic. It appears to be one of the designs that William H. Grueby brought to his Grueby Faience and Tile Company from the Grueby Pottery after its bankruptcy in 1908. How long these tiles remained in production after 1909 is uncertain, but it is possible that this example dates from the later period. Grueby's usual circular mark surrounding a lotus blossom has not been used on this tile, but rather the words "Grueby Boston" are impressed on the back.

1. "The Potters of America: Examples of the Best Craftsmen's Work for Interior Decoration: Number One," *Craftsman* 27 (December 1914): 297.

44. TILE, c.1902–09

Grueby Faience Company
Boston, Massachusetts

Light buff earthenware body with press-molded design of a turtle below a border of heart-shaped leaves. Mat glazes in dark blue, taupe, dark green, and light green, defined by raised partitions.

Height: 15.4 cm.
Width: 15.4 cm.
Depth: 2.4 cm.
Marks: Indecipherable initials painted in gray

1983–88–16

A photograph of a frieze composed of tiles similar to this was published in 1902, with the observation that this design was suitable for bathroom decoration.[1] The repeating frieze pattern of which this tile is a single element was a procession of turtles. The design continues from one tile to the next; the small turtle tail protruding on the right is carried over from the complete turtle on the tile that follows it.

This tile employs a rich variety of Grueby's colored mat glazes. The pale green background has a prominent crackle effect, which had already received attention from critics: "Mr. Grueby has also succeeded in obtaining a remarkable crackle which is equal to that of the best old Chinese and Japanese crackles. The glaze is strong and fine, and the crackle does not penetrate to the clay."[2]

1. "The Interesting Tile Work of 'Dreamwold,'" *Brickbuilder* 11 (October 1902): 205–6 (illus. 206).

2. C. Howard Walker, "The Grueby Pottery," *Keramic Studio* 1 (March 1900): 237.

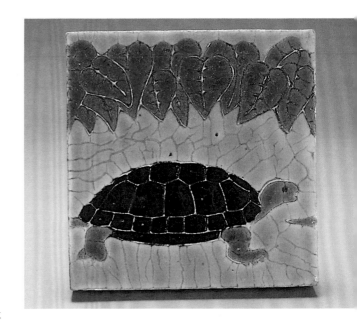

45. TILE, c.1902

Grueby Faience Company
Boston, Massachusetts

Decorated by unknown artist, initials E.R.

Gray-white earthenware body with press-molded design of a rabbit crouching in grass. Light blue, light and dark green, and pale yellow-green mat glazes defined by raised partitions.

Height: 10.4 cm.
Width: 10.4 cm.
Depth: 1.8 cm.
Marks: Painted in green: E. R.

1983–88–14

Exhibitions

American Decorative Tiles, 1870–1930, William Benton Museum of Art, University of Connecticut, Storrs, Conn., 1979.

References

Bruhn, Thomas P. *American Decorative Tiles, 1870–1930,* p. 26, no. 62 (illus. p. 24). Storrs, Conn.: William Benton Museum of Art, University of Connecticut, 1979.

By the turn of the century tiling had become a popular element in American domestic design, and particularly in those areas of the home where hygiene and cleanliness were important. This tile design was first installed in "Dreamwold," Thomas W. Lawson's Scituate, Massachusetts, country house.

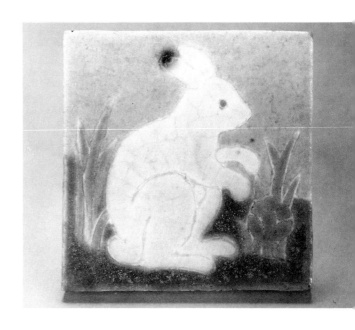

Grueby Faience Company
Boston, Massachusetts

Decorated by unknown artist, initials
A. S.

Light buff earthenware body with
press-molded design of lion on
haunches backed by stylized trees
and landscape. Tan, cream, light
blue, pale blue, and green mat glazes
defined by raised partitions.

Height: 10.2 cm.
Width: 10.2 cm.
Depth: 1.6 cm.
Marks: Remnants of original paper
label attached to top edge:
GR[UE]BY [P]OTTERY
BOSTON [U]S.A., surrounding
a lotus blossom; painted in light blue:
A.S.;

1983–88–15

The unknown decorator, whose initials, A. S.,
are painted on the back of the tile, was also
responsible for the decoration of No. 42 in this
collection. An example of this tile, set into a
fireplace mantel among four other tiles, was
illustrated in a 1908 advertisement for the
Grueby Faience Company.[1] Other tiles in this
series, distinctive for their stylized trees, de-
picted a camel, a bear, and an unidentified
animal. The central tile in the mantel was an
example of the rabbit tile (No. 45).

1. Advertisement for Grueby Faience Co., *Craftsman* 15 (October
1908); xxi.

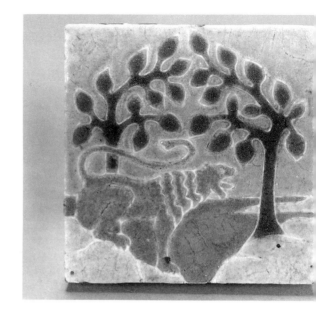

47. PAPERWEIGHT, c. 1904–09

Grueby Faience Company
Boston, Massachusetts

Molded buff earthenware body in the
form of a scarab on a low base.
Allover dark green mat glaze.

Height: 3.2 cm.
Length: 10.2 cm.
Width: 7 cm.
Marks: Impressed: GRUEBY
FAIENCE / BOSTON
U.S.A., surrounding a lotus blossom

1983–88–9

For the St. Louis Louisiana Purchase Exposition
of 1904, at which Grueby won a grand prize, the
firm produced a line of paperweights molded in
the form of scarabs, of which this is one.[1]
Hundreds of these novelties were made for the
fair, both in mat green and in blue.

1. "Louisiana Purchase Exposition Ceramics," *Keramic Studio* 6
(February 1905): 217. Another example is illustrated in Robert Judson
Clark, ed., *The Arts and Crafts Movement in America, 1876-1916*
(Princeton, N. J.: Princeton University Press, 1972), p. 143, no. 199.

48. PAPERWEIGHT, c. 1904–09

Grueby Faience Company
Boston, Massachusetts

Red earthenware body with press-
molded design of winged scarab
pushing a dung ball modeled in low
relief. Ocher and blue mat glazes.

Height: 1.9 cm.
Diameter: 6.4 cm.
Marks: Impressed: GRUEBY
POTTERY / BOSTON, sur-
rounding a lotus blossom

1983–88–8

Exhibitions

The Ceramics of William H. Grueby,
Everson Museum of Art, Syracuse,
N.Y., 1981.

References

Blasberg, Robert W. *The Ceramics of
William H. Grueby: Catalog of an
Exhibition at the Everson Museum of
Art,* p. 26, no. 89. Syracuse, N.Y.:
Everson Museum of Art, 1981.

This small circular paperweight is a variation of
the scarab motif on No. 47 and may date from
the same period, after 1904.

Van Briggle Pottery

Artus Van Briggle's career as a ceramist, first with Rookwood and later as director of his own pottery, was one marked by innovative and refined glaze work. Born in Felicity, Ohio, in 1869, Van Briggle moved to Cincinnati, where he studied painting under Frank Duveneck at the Art Academy of Cincinnati. To support himself, he worked as a decorator at the Avon Pottery, an early Rookwood competitor founded by the influential ceramic chemist Karl Langenbeck. Avon closed in 1887, and the young Van Briggle was hired by Maria Storer to work at her growing Rookwood Pottery.

He progressed quickly and by 1891 stood as one of the firm's senior decorators with a studio of his own in the new building on Mt. Adams. Van Briggle's pottery decoration, not particularly exceptional, although well executed, conformed to the Rookwood factory style. Away from Rookwood he devoted much of his energy to easel painting and became an accomplished portraitist, exhibiting one of his works at the Chicago World's Columbian Exposition in 1893. Storer was captivated by his promising talent and secured him a two-year leave from Rookwood to study in Europe at her own expense. In Paris, he pursued easel and mural painting at the Académie Julian, eventually winning several awards. He also studied sculpture and clay modeling at the Ecole des Beaux-Arts. Not neglecting his interests in ceramics, Van Briggle took note of the great collections of Oriental pottery and porcelain at the Musée des Arts Décoratifs and at the Sèvres Museum. Like the French potters, he became fascinated with Chinese glazes, in particular the "dead," or mat, glazes of the Ming Dynasty.

Rookwood permitted Van Briggle to extend his stay in Paris for an additional year, and he returned to Cincinnati only in 1896. Filled with the inspiration he had found in Europe, he resumed his position at the pottery and continued his painting. In an attempt to recapture the mysterious Chinese "dead" glazes, Van Briggle conducted pottery experiments at home in his spare time with a small kiln that Storer had given him. By 1898 he had achieved some success. Rookwood produced a very limited number of vases with his mat glazes and even exhibited a few in Paris in 1900, where they aroused some interest.

Only three years after returning from Europe, Van Briggle resigned from Rookwood and left Cincinnati. As a child he had contracted tuberculosis and his health was progressively failing. In March 1899 he moved to Colorado Springs, Colorado, in hopes that the climate would restore his health. After a period of enforced idleness, Van Briggle began to experiment with local clays and minerals, working in a small kiln in a laboratory at Colorado College. He remained there for two years, passing the summer months making pottery and painting at Chico Basin Ranch, southeast of Colorado Springs. In 1901 he established a pottery of his own on North Nevada Avenue in Colorado Springs. By Christmas of that year, he and his assistants—a skilled thrower named Harry Bangs and a boy who did odd jobs, as well as his fiancée Anne Lawrence Gregory—had prepared three hundred pieces for exhibition.

Gregory had met Van Briggle in Paris, and in 1895 they were engaged. She followed him to Colorado in 1900 and taught art at a local high school. From the beginning she was very much part of the pottery. In 1902, a few months after the organization of a stock company they called the Van Briggle Pottery Company, Gregory and Van Briggle were married. Among the primary stockholders of the new company was Storer, no longer connected with Rookwood, but still deeply interested in ceramics.

Examples of Van Briggle's new pottery, sent to the Eastern cities in the fall of 1902, were immediately hailed by critics for their exceptional glazes, elegant forms, and simple decoration. This success led to an expansion of the pottery in 1903, the staff increasing to fourteen with Van Briggle himself still directing every aspect of the work. Ambrose Schlegel, a German-born potter, joined the staff at this time as thrower and remained with the company for over twenty-five years. A group of twenty-four pieces was sent

for exhibition to Paris in 1903, and garnered two gold, one silver, and twelve bronze medals in the annual salon. This triumph established an international reputation for the Van Briggle Pottery. Their exhibition was enlarged and sent in 1904 to the Louisiana Purchase Exposition in St. Louis, where it again received important honors.

Van Briggle's health continued to decline, however, and he finally died on July 4, 1904, shortly before the medals were distributed in St. Louis. His wife assumed the presidency of the company, reorganized as the Van Briggle Company, and continued to design many of the pieces. The pottery's consistent success at fairs and in the marketplace resulted in the construction of a new facility at Glen and Uintah Streets, in full operation by the fall of 1908. Frank H. Riddle was appointed superintendent of the plant, and Anne Van Briggle became art director. The art pottery line was expanded to include a variety of tiles and faience for exterior and interior decoration, wall fountains, and garden pottery, but sales began to fall off. In an attempt to produce a more commercially successful line, the company was reorganized again in 1910 as the Van Briggle Pottery and Tile Company. The art pottery line was reduced and commercial wares were expanded in order to shore up decreasing sales. Anne Van Briggle's role in the pottery diminished after she married Etienne Ritter in 1908. In the period from 1900 to 1912, no fewer than 904 patterns for art pottery had been designed by the Van Briggles and their staff, but after 1912, Anne Van Briggle Ritter seems to have made only one new design. Although the company was sold at a sheriff's auction in 1913 due to financial troubles, it went through several periods of reorganization, and the Van Briggle Art Pottery is still in operation today with early designs again in production.

Van Briggle Pottery Company
Colorado Springs, Colorado

Designed by Artus Van Briggle
(1869–1904)

Molded ocher-colored earthenware
body with three groups of lilies
modeled in low relief; central flowers
in full bloom, stems and leaves rising
from base. Pale gray-yellow mat
glaze.

Height: 34.9 cm.
Diameter: 14.3 cm.
Marks: Incised: AA [conjoined in a
rectangle] / VAN BRIGGLE /
1903 / III; impressed: 140

1984–84–49

Artus Van Briggle's "dead," or mat, glazes were described as "similar to the Grueby effect, but showing rather the coloring of Rookwood Iris ware."[1] Besides the "mustard" glaze used on this vase, other colors included green, gray, yellow, blue, and rose. According to a contemporary critic:

The soft tones of the glaze are closely akin to the deep blues and purples of the mountains, to the brilliant turquoise of the skies, to the greens of summer and to the wonderful rosy and tawny tones of the plains in winter. . . . It expressed not only the ideas of its maker, but the spirit of the country as well.[2]

Van Briggle never intended that his pottery be mass produced; although the pieces were cast in molds, they were carefully finished by hand. His process was described by an observer:

The vase being finally completed and accepted as satisfactory, a number of reproductions are made, differing and varying from one another in color-effects alone: the repetition of a fine, slowly-developed model being regarded by Mr. Van Briggle as far preferable to the execution in each case of a new idea which often entails careless and inartistic work.[3]

The clays used by the Van Briggle Pottery were obtained locally and mixed and refined to suit the specific needs of the company. Early pots were marked with a Roman numeral identifying the clay formula. On this piece, the incised "III" denotes a mixture of ground flint and Sherman clay from the quarries at Golden, Colorado. Early pieces were also marked with the year of manufacture. The pattern for this design, model number 140, probably dates no earlier than the year 1903 marked on this piece.[4]

1. "Pottery at the Arts and Crafts Exhibit, Craftsman Building, Syracuse," *Keramic Studio* 5 (June 1903): 37.

2. "Van Briggle Pottery," *Clay-Worker* 43 (May 1905): 645.

3. Irene Sargent, "Chinese Pots and Modern Faience," *Craftsman* 4 (September 1903): 424.

4. An example of this model was illustrated in *Craftsman* 4 (September 1903): facing p. 415, and in *Keramic Studio* 5 (June 1903): 37.

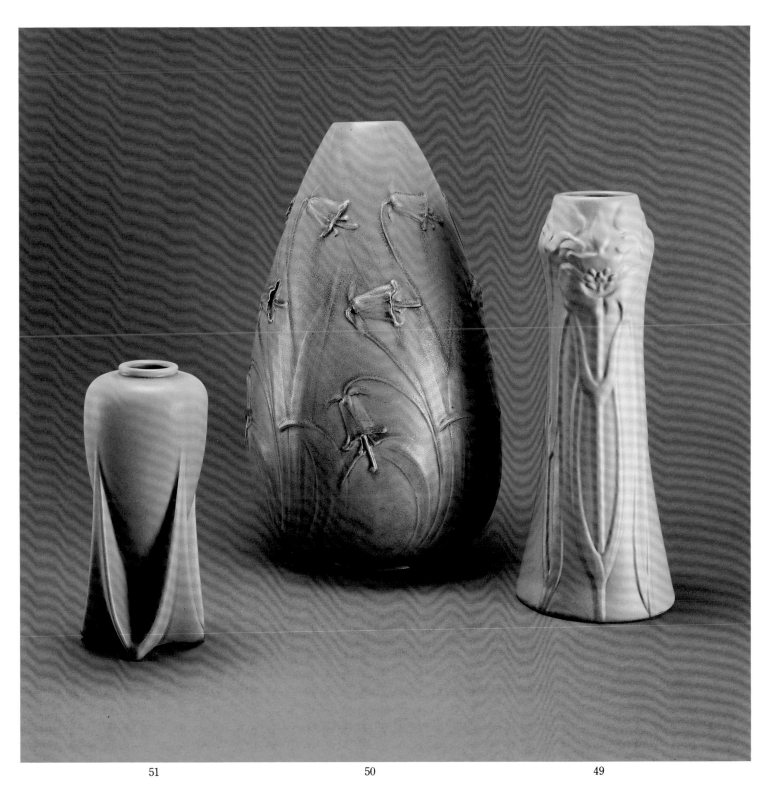

51 50 49

Gates Potteries

William Day Gates founded the American Terra Cotta and Ceramic Company in Terra Cotta, Illinois, in 1881, abandoning a legal practice in Chicago for a chance to supervise the production of architectural terra-cotta, bricks, and drain tiles. The Gates Potteries, developed as a branch of this company, was set up around 1890 to make a plain, undecorated garden pottery, a line that remained in production throughout the existence of the company. After years of experiments, Gates developed an art pottery ware that depended not on surface decoration but on the simple form and color of each piece. The registered trademark of this ware was "Teco," a name derived from the first syllables of the words terra and cotta. The name was in use as early as 1895, although the pottery was not available to the public until 1901. Gates was able to offer his Teco ware at prices lower than the art wares of his competitors because of the economic advantage he had with an already equipped pottery at his disposal, and because his pottery was not handmade.

The first Teco catalogue, from 1904, stated Gates's basic intentions: "In the Teco Art Pottery the constant aim has been to produce an art pottery having originality and true artistic merit, at a comparatively slight cost, and thus make it possible for every lover of art pottery to number among his treasures one or more pieces of this exquisite ware."[1] Many pieces were cast after designs by Gates himself, as well as work by a number of young Chicago architects representing the Prairie School, such as William J. Dodd, Max Dunning, Hugh M. G. Garden, William B. Mundie, and Frank Lloyd Wright.

Displeased with the usual factory squalor associated with the pottery industry, Gates arranged for his employees to work "amid delightful surroundings of wood, field and lake. No half-paid, pinched-faced women; none but men who have the air of being fitted to accomplish what lies before them during the day and of doing the day's work with poise and sincerity."[2] Teco ware was described as "quiet, restful pottery" and "pleasing to the eye and soothing to the nerves,"[3] a sort of antidote to the pressures of modern living. According to one of the firm's advertisements, "Teco tones in green are equally convincing and delightful—and you never tire of them: 'Teco green' is so cool and clean—and such a good friend to live with."[4]

Still, Teco was indeed a factory-oriented pottery, its creations lacking the individuality of Ohr's or Robertson's. Although Teco's designers were identified through material released by the company and are still recognized, the actual craftsmen who made the molds and cast and glazed the pieces remain anonymous, as they have with the majority of the larger American art potteries.

At the 1904 Louisiana Purchase Exposition at St. Louis, Gates was awarded highest honors and took his place along with Rookwood, Grueby, and Van Briggle Potteries. Gates's glazes were instrumental in achieving this recognition. Along with his chief chemist, Elmer Groton, he developed a mat glaze with a lustrous, waxy texture and a silvery, pale to deep moss green color. This was one of their earliest glazes and proved to be their most popular. An art line with crystalline glazes was also introduced in 1904, but was never pursued with the same effort as the "Teco green." To add interest to the line, a variety of colored mat glazes were offered in 1910, including shades of rose, gray, blue, gold, yellow, at least four browns, and several new shades of green. By then the Teco line consisted of over five hundred shapes, sold through the pottery's branch offices and showrooms in Chicago, Minneapolis, and Indianapolis. Business also came through mail-order catalogues and advertisements in progressive home-oriented magazines such as *House Beautiful, The Ladies' Home Journal,* and *The Craftsman.* Other lines of pottery were added: tea sets and tablewares, architectural faience tiles and murals, and a wide variety of garden ornaments.

Teco's art pottery lines were pruned after 1912 because of declining sales. Only the most popular forms remained in production, while most of the company's efforts were directed toward architectural work. By 1922 the art

pottery line was discontinued altogether, though Gates Potteries survived until 1930 through its tile production. With the onset of the Depression, however, the parent American Terra Cotta and Ceramic Company was sold, five years before William Gates's death in 1935.

1. Quoted in Sharon S. Darling, *Chicago Ceramics and Glass: An Illustrated History from 1871 to 1933* (Chicago: Chicago Historical Society, 1979), p. 64.

2. Susan S. Frackelton, "Our American Potteries, Teco Ware," *Sketch Book* 5 (September 1905): 14.

3. Quoted in Darling, *Chicago Ceramics and Glass*, p. 64.

4. Advertisement in *House Beautiful* 22 (September 1907): 42.

Gates Potteries
Terra Cotta, Illinois

Molded buff earthenware body with
three tiers of large daffodils and
leaves modeled in relief. Light and
dark green mat glazes.

Height: 41.25 cm.
Diameter: 23.8 cm.
Marks: Incised: Teco [vertical] / 189
[model number]

1984-84-29

The Teco art line of the Gates Potteries received
wide recognition for its distinctive green mat
glazes and its simple geometric forms. Gates
denied that the mat glaze popularized by Grueby
had influenced the production of "Teco green."
Although one critic found it "a peculiarly pleasing
shade, one that fits in and harmonizes with
nearly all surroundings,"[1] the glaze, in fact, lacks
the depth and richness of the Boston-made
pottery. Many of the early Teco forms used
naturalistic motifs such as plants and flowers as
an integral part of the body.

Like each Teco piece, this example was assigned
a model number, which was incised on the
bottom. Model number 189, which does not
appear in any of the Teco catalogues or promo-
tional material,[2] may have been produced only in
limited quantities.

The fact that this shape seems not to have been
placed in full production suggests that it dates
from before 1910, when Gates turned his atten-
tion to the development of new shapes for
production. The vase's large size and naturalistic
ornament are also typical of early designs,
although Teco art pottery was not discontinued
until 1922.

1. William Harold Edgar, "The Teco Pottery," *International Studio* 36
(November 1908): xxix.

2. Correspondence from Sharon S. Darling, Chicago Historical
Society, to Vance Koehler, Cooper-Hewitt Museum, 29 August 1984.
For another example of this model, see *Architectural Digest* 33 (July/
August 1976): 70.

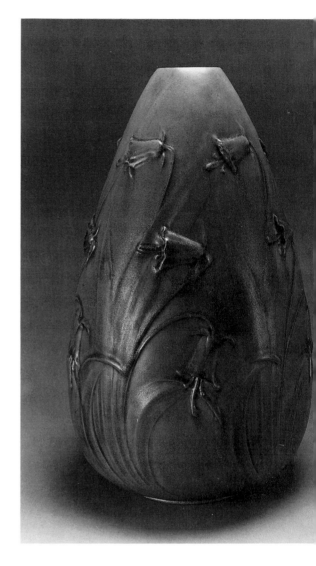

51. VASE, c.1904–20

Gates Potteries
Terra Cotta, Illinois

Designed by Fernand Moreau
(1853–1919)

Molded buff earthenware body supported by four buttress-like feet. Pale silvery-green mat glaze.

Height: 21.9 cm.
Diameter: 9.5 cm.
Marks: Unmarked

1984–84–30

References

Di Noto, Andrea. "A Certain Shade of Green: The Happy Collaboration Between Two Collectors and an Art Dealer," *Connoisseur* 215 (August 1985): 51.

The Gates Potteries warned the public in their promotional material to be wary of imitations of their wares, insisting that the Teco trademark could be found on every genuine piece. Contrary to their claims, this vase is unmarked, but it can nevertheless easily be recognized as a Teco product. The clean silhouette and the distinctive, velvet-textured silvery green mat glaze, which won the company two gold medals at St. Louis in 1904, are inimitable. The first Teco catalogue (c. 1904) also illustrates this shape and identifies it as model number 127.[1] The designer is listed as Fernand Moreau, a French sculptor who first came to Chicago to participate in the World's Columbian Exposition and remained to teach evening classes in clay modeling at the Art Institute. He joined the staff of Gates's terra-cotta company in 1904 and designed several shapes for their art pottery.

One of Gates's basic aims was to offer quality pottery at low prices. From 1904 to at least 1910, this vase sold for four dollars. Teco vases ranged in height from two inches to over seven feet, and sold for amounts ranging between fifty cents to fourteen hundred dollars.

1. For another example of this model, see Sharon S. Darling, *Chicago Ceramics and Glass: An Illustrated History from 1871 to 1933* (Chicago: Chicago Historical Society, 1979), p. 62, fig. 69. The shape also appeared in Teco advertisements. See, for example, *Arts and Decoration* 1 (December 1910): 92.

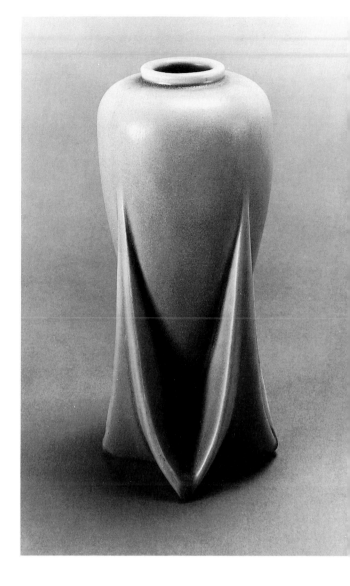

Newcomb Pottery

The establishment of pottery facilities in 1894 at Newcomb College in New Orleans was a direct consequence of the events that stemmed from the World's Industrial and Cotton Centennial Exhibition held in that city between 1884 and 1885. A cultural awakening, particularly among women, began to occur in the South because of this international fair, and attitudes toward art and industry started to change.

A significant contribution to this awakening came in 1884, when Tulane University was founded and the exposition opened. Tulane's first art instructor, William Woodward, had trained at the Massachusetts Normal Art School and later at the Rhode Island School of Design, the faculties of which were highly influenced by the contemporary English movement to improve the quality of production by providing training in the arts of design. Soon after his arrival, Woodward organized evening and Saturday classes in drawing and decorative arts, offering free instruction to both men and women through the university. Response was strong and more teachers were hired, including Ellsworth Woodward, William's younger brother, who came to New Orleans from the Rhode Island School of Design. It was Ellsworth Woodward's guidance that led to the formation of the Tulane Decorative Arts League, a group of about thirty women interested in handicrafts.

In 1886 the H. Sophie Newcomb Memorial College was founded as the women's division of Tulane University. Classes began in a mansion on Washington Avenue in the fall of 1887, with Ellsworth Woodward appointed to head the art program. Along with his brother William and another newly appointed instructor named Gertrude Roberts (later Smith), also a graduate of the Massachusetts Normal Art School, Ellsworth Woodward was responsible for the direction of Newcomb's art department.

William Woodward, who remained on the Tulane faculty, played only a limited role at Newcomb College, but his influence on the art pottery movement in New Orleans was decisive. Around 1887 he and a small group of students from his evening drawing classes organized the New Orleans Art Pottery Company. The company rented a building on Baronne Street and set up a kiln. Joseph Fortune Meyer, employed to make the vessels used for decoration, was joined briefly by his friend George E. Ohr, who had already founded his own pottery in Biloxi, Mississippi. Production was relatively short-lived, the company folding in 1890 because of inadequate capital. Its establishment was, nevertheless, indicative of the sort of lively interest in pottery making in New Orleans that would directly influence the decision to add the craft to the Newcomb College curriculum.

Teaching at Newcomb, Ellsworth Woodward saw the need to provide vocational education for young Southern women in a field in which they could find meaningful, rewarding work and earn an honorable living. To this end, an old building on the college grounds was outfitted in 1894 as a pottery.

That September, Mary Given Sheerer, a china painter of considerable skill, was brought from Cincinnati to serve as Woodward's assistant and to teach the fundamentals of china painting and pottery design. She was a graduate of the Art Academy of Cincinnati, where she had studied drawing under Frank Duveneck. Although she was never formally associated with Cincinnati's Rookwood Pottery, she knew many of the decorators and possessed a keen interest in their work. Sheerer held considerable influence in shaping Newcomb's early aesthetic development, responsible as she was for the selection of all objects for sale and exhibition. For thirty-seven years she remained involved with the pottery, retiring in June 1931, although her influence seems to have diminished before 1910.

The Newcomb College Pottery's first year, 1894–95, was spent testing clays and glazes. Most of the early clays were obtained locally, particularly from Bayou Bogufalaya, across Lake Pontchartrain. Other clays came from throughout the South and were mixed at Newcomb to produce suitable bodies. By 1895 the pottery was in full operation, and a two-year graduate program was begun to give additional training. Jules Gabry, who had been with Clément Mas-

sier's Golfe Juan Pottery in France, was hired to do work considered unsuitable for young women, such as throwing the pots, firing the kiln, and handling the glazing. He remained only until the end of the year, to be succeeded by George Wasmuth, who also left after a brief stay.

In the spring of 1896, Joseph Fortune Meyer, lately of William Woodward's New Orleans Art Pottery Company, took over the potter's job, a position he held until his retirement in 1927. Meyer was a gifted potter, capable of reproducing pottery shapes from the students' drawings. George Ohr is reputed to have joined him at Newcomb Pottery about this time, but no records of his employment survive.[1]

Like Rookwood, Newcomb adopted a division of labor, the women designing and executing their decorations, while the men potted, fired, and glazed the pieces. The aims of the pottery were determined early in its existence: under the guidance of the college, Newcomb Pottery was established to furnish the students of the art school with a means to continue their work after completing their studies there. And it provided financial support for the advanced students, who were able to derive income from the sale of their own pieces. At the start, Newcomb's decorators had been undergraduates, but eventually a staff of about ten women, graduates of the college, was employed. In all, about ninety decorators, or "art craftsmen" as they were called, worked at the pottery during its existence—some for only a year, others for much longer. Many, though not all, became accomplished designers and capable decorators. But even with the variable abilities of the "art craftsmen," the overall quality of those pieces bearing the Newcomb College monogram remained high due to the demanding standards each pot had to fulfill when reviewed by a faculty jury before the final firing.

Sheerer summarized the clearly defined goals and aims of the early pottery:

The fact of its being under the support of a college would make it possible to aim for only the truest and the best, and so it would not be forced to consider too closely the tastes of the public, but to follow honestly and sincerely its own principles. To this end it was decided that the decorator should be given full rein to her fancy. For fear that decoration should become mechanized by repetition, it was also

decreed that no two pieces should be alike and that each should be fresh—inspired by the form demands of that particular vase or cup. The whole thing was to be a Southern product, made of Southern clays, by Southern artists, decorated with Southern subjects.

The first public exhibition and sale of Newcomb's pottery was held in June 1896. By 1897 much of the early experimentation had ended and a distinctive style was developing that was characterized by relatively simple shapes. These forms were decorated with flat, conventionalized designs of Southern flora and fauna, and finished in a cool palette of blues, grays, and greens. This style won immediate success locally, and national recognition came quickly as well. Soon Newcomb was exhibiting with arts and crafts societies around the country. In 1899 the Boston Museum of Fine Arts acquired several pieces, and Arthur W. Dow, while at the Pratt Institute in Brooklyn, declared Newcomb's pottery to be "a serious effort, in the direction of uniting art and handicraft." He added, "The examples which I have seen were beautiful in form and color, simple in design and of excellent workmanship."[2] At the Paris Exposition Universelle in 1900, Newcomb Pottery won a bronze medal.

Tulane's board of administrators decided in May 1901 to appropriate thirty thousand dollars toward the erection of a new art building. The Camp Street structure was ready by October 1902, providing faculty offices, studios, a sales room, and facilities for the pottery. Other crafts became important parts of the art department as well, including needlework, weaving, and metalwork. During this period a new payment procedure for the staff was also instituted. Originally, the women were paid after their pieces were sold, with a deduction made for the cost of materials. After the turn of the century, however, they began to receive payments for the value of each piece decorated, prior to the final firing. This change provided them with a salary even if pieces were broken or cracked in the kiln.

Newcomb Pottery was now entering a new era. Demands for the pottery exceeded production, and decorators were kept continually busy throughout the school months supplying retailers around the country. Next to Rookwood, the

Newcomb Pottery became the largest producer of individually decorated art pottery in the United States. Between 1900 and 1910 the pottery continued to grow and received praise for being a model arts and crafts industry. Many more awards were bestowed for the pottery's distinctive regional character, including medals at international competitions at Buffalo; St. Louis; Portland, Oregon; Hampton Roads, Virginia; and Charleston, South Carolina.

Joseph Meyer handled all the non-decorating tasks at the pottery until about 1905, when failing eyesight forced him to take on an assistant. He continued, nevertheless, to do all the throwing, relying now on "his strong, sensitive fingers, [which] drew up the clay as though it rose of itself."[3] But problems with firing developed about 1908, and Woodward realized the need to hire a professional ceramist. Sheerer tried her best to solve these problems, but because of her sketchy knowledge of ceramic chemistry her success was limited. Years of correspondence with Professor Charles Binns finally resulted in his recommending assistance from a graduate of his program at the New York State School of Clay-Working and Ceramics at Alfred University. Paul Ernest Cox, who received his degree in 1905, arrived in New Orleans during the fall of 1910 to settle the firing difficulties and modernize the pottery's technical operations. He also perfected a new transparent mat glaze, similar to that used by Rookwood for its Vellum ware. Within a year this Vellumlike glaze had replaced the clear, glossy glaze as Newcomb's standard finish. It inspired a slight shift in the Newcomb style, allowing softer textures and subtler underglaze color effects. Floral designs now became more naturalistic and dimensional. A popular demand developed for treescapes modeled in low relief—depictions of "scenic" cypress, palm, and oak trees, usually covered with hanging moss and set against moonlit skies. Sales increased even further. After Newcomb won a grand prize in San Francisco at the 1915 Panama-Pacific International Exposition, plans were begun to move the pottery into a newer and bigger art building on

Newcomb's new campus, adjacent to Tulane University. Cox designed the new kilns, but he left Newcomb in 1918 and never saw them completed.

Frederick E. Walrath, who had studied with Binns and was a well-known ceramist in his own right, succeeded Cox and was responsible for outfitting the new pottery. His stay at Newcomb was brief, however; he left in 1921 due to illness and died shortly thereafter. Two other Alfred alumni followed as ceramists but they soon left, too. In 1929, Kenneth E. Smith was hired and took an active role in guiding the pottery enterprise through the final years. When Meyer himself retired in 1927, the responsibility of potting passed to Jonathan B. Hunt, who remained through 1933. At this point Smith took over potting, continuing in service until 1945. Fewer and fewer decorators were active during this period, almost all work being done by three or four women. Some of the influence of modern abstract design can be seen in their work, but for the most part, naturalistically rendered flowers and treescapes remained Newcomb's mainstay. The pottery sold fairly well, but losses were beginning to show. After forty-seven years, Ellsworth Woodward retired at the end of the 1930-31 academic year, with Mary Sheerer retiring, too. Production during the 1930s was reduced, and the two remaining decorators, Sadie Irvine and Henrietta Bailey, both of whom were now salaried, were teaching more and making fewer pots. By the end of the decade, Newcomb College decided that the pottery department should continue only as an educational program; the sale of pottery virtually ceased by 1940.

1. Jessie Poesch, *Newcomb Pottery: An Enterprise for Southern Women, 1895-1940* (Exton, Pa.: Schiffer Publishing Ltd., 1984), pp. 18, 94.

2. Arthur W. Dow, quoted in Irene Sargent, "An Art Industry of the Bayous: The Pottery of Newcomb College," *Craftsman* 5 (October 1903): 75.

3. Sadie Irvine, quoted in Robert W. Blasberg, "The Sadie Irvine Letters: A Further Note on the Production of Newcomb Pottery," *Antiques* 100 (August 1971): 250.

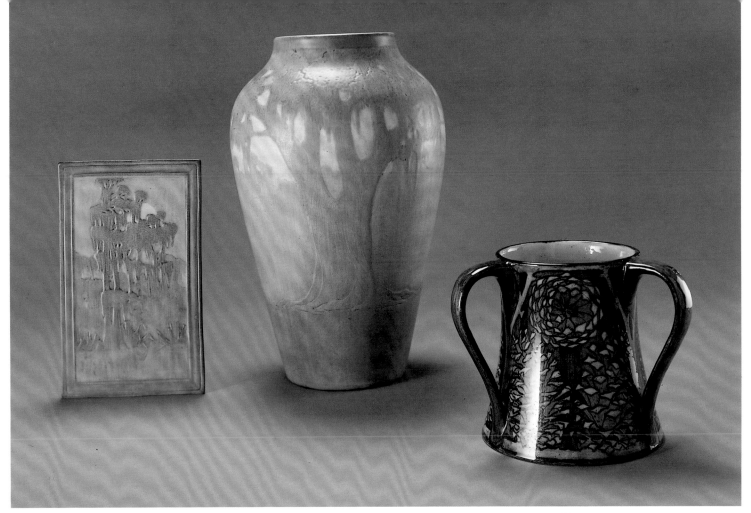

53 54 52

52. TYG, OR THREE-HANDLED CUP, c.1901

Newcomb Pottery
New Orleans, Louisiana

Decorated by Marie de Hoa LeBlanc
(c.1877–1954)
Potted by Joseph Fortune Meyer
(1848–1931)

Thrown buff earthenware body with
three applied handles. Decorated in
underglaze blue with three panels of
pine cones. Clear glaze.

Height: 16.2 cm.
Diameter: 16.2 cm.
Marks: Impressed: N within C
cipher / potter's monogram J M / Q
[designates buff clay]; painted in
blue, decorator's monogram within a
rectangle: M. H. L. and B¹57 [regis-
tration number]; incised underglaze:
very faint early registration mark;
attached to bottom: red and buff
paper label with faint pencil notations

1983–88–21

Exhibitions

*Newcomb College Pottery: A Retro-
spective*, Jordan-Volpe Gallery, New
York, 1984.

During its early years, one of the first types of
decoration adopted by the Newcomb Pottery
was a slip-painting technique resembling that
used for Rookwood's Standard ware. This tech-
nique proved to be too difficult and was soon
abandoned for underglaze painting on low-fired
bodies that were then covered with a simple
clear glaze. Mary Sheerer maintained that "sim-
ple, big designs and firm drawing,"[1] such as
were used in china painting, were needed in this
process and that the colors blue, green, yellow,
and black were most successful under the glaze.
"A corresponding freedom in the choice of color
was at first encouraged; but conditions such as
the composition of the paste and other technical
requisites have established a blue-green tone,
which is not to be regretted as monotonous,
since it unites with the design itself and the
methods of applying the design, in forming the
distinctive character of the Newcomb pottery."[2]

The decoration on this three-handled cup, or
tyg, exemplifies Newcomb's first important

style, which dominated production until about
1910: flat, conventionalized designs based on
local Southern flora, often depicted in profile or
cross section, and carefully rendered in a cool
palette of blues and greens.

Maria de Hoa LeBlanc, who decorated this
example, was one of Newcomb's most accom-
plished early artists. She graduated from New-
comb College in 1898, receiving her diploma in
"Normal Art," and remained to complete her
graduate training in 1901. From 1901 through
1908, LeBlanc was employed as a pottery
worker, and she served as an art craftsman from
1908 to 1914. Her designs were awarded a
bronze medal at the Louisiana Purchase Exposi-
tion of 1904.

1. Mary G. Sheerer, "Newcomb Pottery," *Keramic Studio* 1
(November 1899): 152.

2. Irene Sargent, "An Art Industry of the Bayous: The Pottery of
Newcomb Pottery," *Craftsman* 5 (October 1903): 73.

Newcomb Pottery
New Orleans, Louisiana

Decorated by Sarah Agnes Estelle
Irvine (1887–1970)

Molded buff earthenware plaque with
carved design of cypress trees cov-
ered in moss and set against a
moonlit sky, all within a border.
Painted underglaze in blues, greens,
blue-green, and ivory. Transparent
semi-mat glaze.

Height: 23.8 cm.
Width: 15.0 cm.
Depth: 1.2 cm.
Marks: Impressed and reinforced in
blue: N within C cipher; incised
decorator's monogram, reinforced in
blue: SI; painted in blue: G S 75
[registration number]; incised: 200
[shape number]

1984–84–42

Sarah (Sadie) Irvine was associated with New-
comb College's art program longer than any
other woman, entering as a freshman in 1902.
From 1906 to 1908 she was enrolled in the
graduate school, studying pottery decoration and
embroidery, and later worked as a Newcomb
"art craftsman" from 1908 through 1929. She
remained at Newcomb College until her retire-
ment in 1952, in the capacities of pottery
decorator, assistant, assistant instructor, and
finally instructor of art. Although Irvine was a
proficient embroiderer and watercolorist, and
was recognized in her later years for her
linoleum-block prints, she remains best known
for her pottery decoration.[1] When Sarah
Bernhardt visited Newcomb College in 1911, a
vase by Irvine was selected as the presentation
gift for the celebrated actress. Her work was
often displayed in important exhibitions, includ-
ing San Francisco's Panama-Pacific International
Exposition of 1915, at which Newcomb Pottery
was awarded a grand prize.

This plaque, a relatively rare form for New-
comb,[2] was probably made about 1914, the
landscape scene acknowledged by Irvine as her
own invention:

I was accused of doing the first oak-tree decoration, also the first
moon. I have surely lived to regret it. Our beautiful moss-draped oak
trees appealed to the buying public but nothing is less suited to the
tall graceful vases—no way to convey the true character of the tree.[3]

Although the potter Joseph Meyer had produced
mat glazes earlier at Newcomb, Paul Cox's
development of a transparent, semi-mat glaze
soon after his arrival in 1910 caused a distinct
change in Newcomb's pottery style. A new
decorating technique was adopted that involved
carving the design in low relief in the damp body,
leaving a slightly recessed background; under
the new softer glaze, colors became muted,
misty, and more atmospheric.

1. Robert W. Blasberg, "The Sadie Irvine Letters: A Further Note on
the Production of Newcomb Pottery," *Antiques* 100 (August 1971):
250.

2. Other plaques do exist, including another by Irvine dated c.1914.
See Thomas P. Bruhn, *American Decorative Tiles, 1870–1930* (Storrs,
Conn.: William Benton Museum of Art, University of Connecticut,
1979), p. 38, no. 129 (illus. p. 27).

3. Quoted in Blasberg, "Sadie Irvine Letters," p. 251.

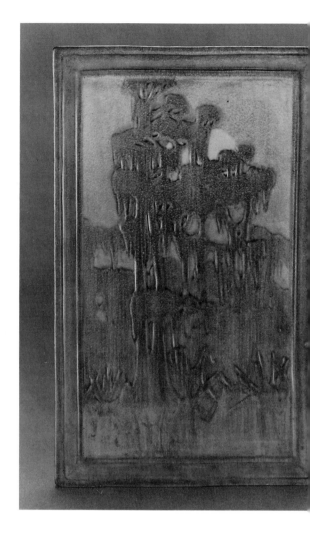

54. VASE, c.1915

Newcomb Pottery
New Orleans, Louisiana

Decorated by Cynthia Pugh Little-
john (c.1885–1959)
Potted by Joseph Fortune Meyer
(1848–1931)

Thrown buff earthenware body
carved with moss-covered oak trees
against underbrush and sky. Painted
underglaze in greens, blues, and
blue-greens. Transparent semi-mat
glaze.

Height: 35.9 cm.
Diameter: 22.6 cm.
Marks: Impressed and reinforced in
blue: potter's monogram J M, con-
joined / C in a circle [designates buff
clay body with semi-mat glaze] / 143
[shape number] / M; incised and
reinforced in blue: decorator's mono-
gram C L, conjoined / 113; painted in
blue: H B 25 [registration number]

1984–84–41

Vases decorated with this familiar landscape
motif met with wide critical and popular approval.
Throughout the 1920s and early 1930s, at a time
when many well-established art potteries were
experiencing serious financial troubles, New-
comb found it difficult to keep up with the
demand for their wares.

Sadie Irvine described the first stages in the
method used to create such vases:

Unless she [the decorator] had been assigned a special order she was
free to choose a piece from the supply in the "damp cellar." Then the
motif was decided, influenced by the form and its size. Each decorator
had her own portfolio, pencil studies of various plant forms, trees,
etc. that she knew well and probably grew in her own garden. . . .
The chosen plant or tree was sketched with a soft drawing pencil, not
"scratched," into a design which the decorator considered suitable.[1]

Cynthia Littlejohn, a classmate of Irvine's and
the decorator of this vase, worked as a New-
comb "art craftsman" from 1908 until 1910, and
again from 1914 to about 1916. She was one of
Newcomb's more accomplished designers, and
examples of her work were included in the
Pottery's 1915 display at the San Francisco
Panama-Pacific International Exposition.

1. Quoted in Robert W. Blasberg, "The Sadie Irvine Letters: A
Further Note on the Production of Newcomb Pottery," *Antiques* 100
(August 1971): 250.

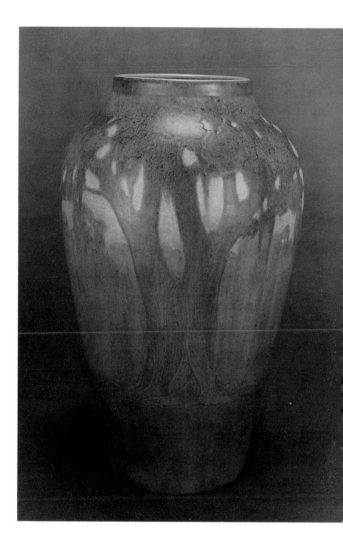

Tiffany Pottery

Louis Comfort Tiffany's self-proclaimed "quest for beauty" led him to expand his work beyond glassmaking to include new fields of artistic expression such as metalwork, enameling, and pottery production. By 1900, he was producing experimental pieces of pottery. A 1902 article reported that "Mr. Tiffany, the maker of the beautiful Favrile glass, is experimenting in pottery, and it is very probable that he is not following beaten paths and that we will see sooner or later some striking and artistic potteries come out of his kilns. But so far nobody knows in what direction his experiments are carried."[1] Not until 1904 was the public finally shown the results of these experiments, when three vases were displayed by Tiffany Studios at St. Louis's Louisiana Purchase Exposition. Pottery did not go into full production at the firm's Corona furnaces until the following year, but by 1906 Tiffany & Company's *Blue Book* was offering "Tiffany Favrile Pottery . . . entirely different from anything heretofore shown in table lamps, vases, jars and other pieces, now in process of manufacture."[2]

Favrile pottery was introduced at a time when other art potteries had already established their reputations for fine, individualized craftsmanship. In the early stages of his pottery's production, Tiffany himself supplied designs, but he did not personally design and make each piece. Unlike other potteries, such as Rookwood, Grueby, and Newcomb College, which required that the names or initials of individual decorators be marked on the bottoms of their pieces, Tiffany's pottery bore only his name or monogram.

The application of the Favrile trademark to Tiffany's pottery implies that it was handmade, but in fact most of the pieces were slip-cast in molds. In some instances the molds were made directly from the copper bodies of his artistic enamels, which were also in production at this time. Each pot was carefully finished by hand, and although many examples were made from the same mold, the glazing and firing made each one singular.

Tiffany experimented with a variety of glazes, including mat, crystalline, and iridescent, but most commonly he used a transparent, yellow-green glaze that gave the appearance of old ivory when placed over the white semi-porcelaneous bodies. A splotchy, pale green mat glaze resembling moss or corroded and patinated bronze was also used, probably in recognition of the popularity of Grueby's green mat glaze, imitated by so many other potteries. For unknown reasons, but presumably for artistic effect, many pieces were left in the biscuit stage with only the interiors glazed. Around 1910, Favrile Bronze pottery was added to the production, made by electroplating metal sheathing over the exterior of the pottery and then patinating it. In their surface finish, these pieces have more in common with metal than they do with traditional pottery.

With Tiffany's retirement from active participation at Tiffany Studios in 1919, pottery production came to an end—although it may have been phased out before then. Certainly after 1914 there appears to have been a cut-back. Several pieces were included in the 1915 Panama-Pacific International Exposition in San Francisco, but these may have been taken from earlier stock. Never a commercial success, the firm's pottery output was always limited.

1. "French Pottery," *Keramic Studio* 4 (June 1902): 30.

2. *Tiffany and Company's Blue Book* (New York: Tiffany and Co., 1906), p. 459. It should be noted, however, that the 1906 *Blue Book* was available as early as the fall of 1905. See Martin P. Eidelberg, "Tiffany Favrile Pottery: A New Study of a Few Known Facts," *Connoisseur* 169 (September 1968): 57, 61.

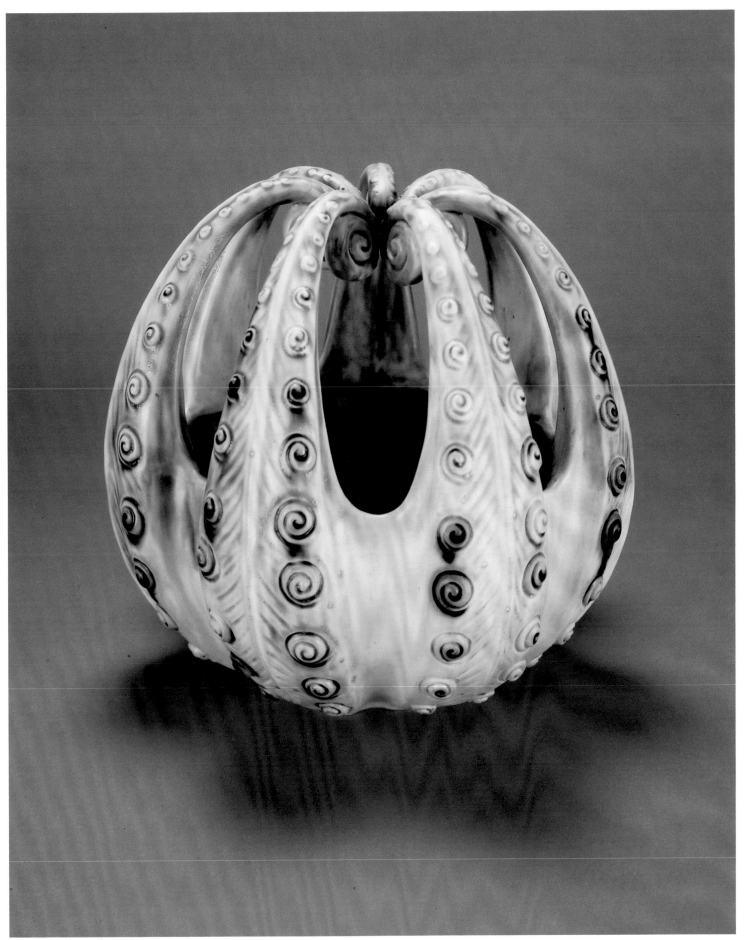

55. VASE, c.1905–14

Tiffany Studios
New York, New York
Made at Tiffany Furnaces, Corona,
New York

Molded, porcelaneous body in the
form of seven stylized fern fronds
rising upward to form the body.
Transparent light green glaze shading
to dark green in recessed areas, with
various small brown flecks in glaze.

Height: 27.7 cm.
Diameter: 29.2 cm.
Marks: Engraved on glazed foot rim:
P345 Tiffany F[av]rile Pottery; in-
cised monogram, conjoined: L C T

1984–84–32

References

Anderson, Alexandra. "American Art
Pottery." *Portfolio* 2 (February/
March 1980): 95 (illus.).

Loring, John. "American Art Pot-
tery." *Connoisseur* 200 (April 1979):
280 (illus.).

Natural forms such as plants and flowers were a
source of inspiration at the Tiffany Studios. An
example of this model was illustrated in *De-
korative Kunst* in 1906,[1] indicating a design date
no later than 1905. This vase may indeed be the
same piece that is pictured in the periodical.

1. Clara Ruge, "Amerikanische Keramik," *Dekorative Kunst* 9 (January
1906): 172. Another version of this model is in the collection of the
Charles Hosmer Morse Foundation at the Morse Gallery of Art,
Winter Park, Florida, but it is glazed only on the interior. See Hugh F.
McKean, *The "Lost" Treasures of Louis Comfort Tiffany* (Garden City,
N.Y.: Doubleday, 1980), p. 207.

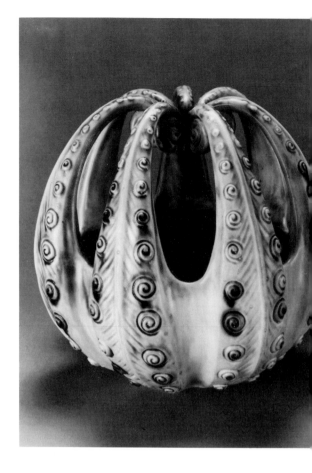

56. VASE, c.1909–10

Tiffany Studios
New York, New York
Made at Tiffany Furnaces, Corona,
New York

Molded porcelaneous body with
raised ribs and six iridescent amber
glass scarabs around the shoulder.
Bronze electro-plating overall, with
dark patina.

Height: 13.35 cm.
Diameter: 7.3 cm.
Marks: Incised artist's monogram,
conjoined: L C T

1984–84–31

This vase is assumed to be an early piece of
"Favrile Bronze" because of the rather experi-
mental handling of the electrodeposited metal,
especially noticeable at the edges. The glass
scarabs, often incorporated into necklaces,
rings, and stickpins, were molded at the Tiffany
Furnaces.

Tiffany Studios was by no means the first to
explore the use of metal-plating in ceramic
production. Charles Walter Clewell of Canton,
Ohio, marketed a bronzed pottery as early as
1906, and several other American potteries,
admiring the rich effects possible through this
technique, produced their own versions.

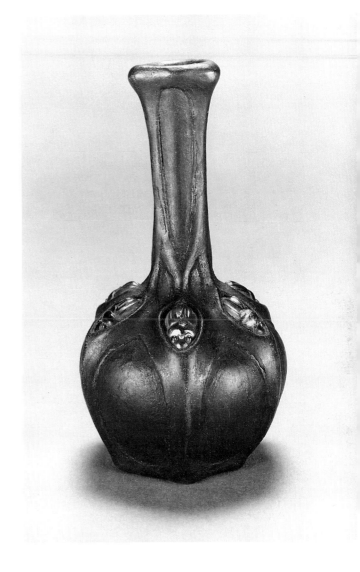

S. A. Weller Pottery

The history of the Ohio-based S.A. Weller Pottery exemplifies the commercial side of the art pottery industry. Weller became one of the largest companies in the country, if not the world, to mass-produce low priced "art pottery." Around 1872 Samuel A. Weller had started a small pottery in Fultonham, Ohio, seven miles from Zanesville, where he made plain and decorated flowerpots and crocks from the common red clay found in the vicinity. Early successes led him to move his operation into a building on Pierce Street in Putnam—now part of Zanesville—and to expand his range of production. By 1890, Weller had built another new pottery in Zanesville between Pierce Street and Cemetery Drive. When the American Encaustic Tiling Company moved into a new factory in 1891, Weller bought their old plant on Sharon Avenue and increased his line to include an assortment of ornamental pottery.

Weller's interest in producing art wares began in 1893 after a visit to the World's Columbian Exposition in Chicago. There he was particularly attracted to the display of William A. Long's Lonhuda Pottery of Steubenville, Ohio. After considerable experimentation, Long had founded a pottery in 1892; by the end of that year, he was regularly producing a decorated pottery with finely shaded brown backgrounds—largely in imitation of Rookwood's Standard ware. Among Long's decorators was Laura A. Fry, who had discovered, while working at Rookwood, the use of the atomizer technique to achieve an even application of background colors. In 1893 Long prompted her to bring a lawsuit against Rookwood for infringing on her process, which had been patented in 1889. The case did not come to trial until 1898 and was decided in Rookwood's favor.

Lonhuda Pottery never became a commercial success, and late in 1894 Weller convinced Long to go into partnership with him and move his pottery operation to the Zanesville plant. By 1895 their Lonhuda Faience Company was in full-scale production, but this firm survived for only one year. Long went to work for the J. B. Owens Company, another Zanesville pottery.

Weller, on his own, continued to produce the popular, high-glazed, brown-shaded ware, which he renamed "Louwelsa," maintaining this successful line in production through 1918.

Rookwood set the artistic standards for other Ohio potteries, and developments there were soon being imitated in Zanesville. Weller's Aurelian, Tourada, and Samantha wares, all executed with solid, brushed grounds rather than by the mouth atomizer, were created to replace Louwelsa ware temporarily while Fry's case against Rookwood over the atomizer technique was pending. Eocean ware, with its blue-gray and pale green backgrounds, was introduced by Weller in imitation of Rookwood's Iris ware. Auroral, or Auroro ware, was derived from Rookwood's Sea Green ware, although Weller's fish and flower decoration was often uninspired and contrived. By 1903, the firm offered an extensive range of art-ware lines. Frederick H. Rhead, an influential art pottery ceramist associated with Weller from 1902 to 1904, developed the Jap Birdimal and L'Art Nouveau lines. And in 1901, Weller hired the French potter Jacques Sicard to produce a line called Sicardo, decorated with metallic lusters on iridescent grounds. Weller employed a large force of skilled workmen, and utilized "every appliance that modern mechanics can supply to facilitate the work of his artist-ceramists."[1] By 1906 his manufactory ran twenty-five kilns, "glowing night and day," to produce a staggering volume of art-ware.

Weller continued to expand the pottery throughout World War I, but after the war most of the art wares were eliminated altogether as more commercial production was increased. Weller's last burst of creative production occurred in the early 1920s, when John Lessell served as art director. Lessell introduced several new art lines, including Lamar ware and LaSa, a lustrous pottery decorated with simple landscapes and trees.

When Samuel Weller died in 1925, the pottery ceased to be run as a sole proprietorship and became the S.A. Weller Company. Demand for pottery dwindled during the Depression, and the

company was forced to consolidate and reduce operations. But it survived, unlike many others that were forced to close, and continued production through World War II. Nevertheless, the onslaught of foreign competition in the American pottery market following the war forced Weller to close its doors in 1948; the company was finally dissolved in 1949.

1. May Elizabeth Cook, "Our American Potteries—Weller Ware," *Sketch Book* 5 (May 1906): 342.

S. A. Weller Pottery
Zanesville, Ohio

Decorated by Jacques Sicard
(1865–1923)

Molded buff-gray earthenware body decorated with honeysuckle blossoms and vines, against a dot pattern painted in gold over an iridescent blue-green, purple, and lustrous copper-red ground.

Height: 14 cm.
Diameter: 11.1 cm.
Marks: Impressed: WELLER [partially indistinct]; incised: 53

1984–84–27

Exhibitions

The Arts and Crafts Movement in America, 1876–1916, Princeton University Art Museum, Princeton, N.J., 1972.

References

Clark, Robert Judson, ed. *The Arts and Crafts Movement in America, 1876–1916,* p. 154, no. 225 (illus.). Princeton, N.J.: Princeton University Art Museum, 1972.

Johnson, Diane Chalmers. *American Art Nouveau,* p. 123, no. 165 (illus.). New York: Harry N. Abrams, 1979.

Kovel, Ralph, and Terry Kovel. *The Kovels' Collector's Guide to American Art Pottery,* p. 303 (illus.). New York: Crown, 1974.

Sicardo Ware became Weller Pottery's most distinctive offering. The popularity of Tiffany's Favrile glass and of European iridescent pottery encouraged Weller to hire the French ceramist Jacques Sicard in 1901. Sicard had been associated with the potter Clément Massier in Golfe-Juan, France, near Cannes. There he became accomplished at the *reflets métalliques* process that had brought Massier success at the 1889 Paris Exposition Universelle.

Sicard and his French assistant Henri Gellie experimented with metallic lusters for about two years after arriving in Zanesville, working in secrecy and, according to legend, speaking only in a French-Swiss dialect to protect their formulae. When they left Weller to return to France in 1907, all production of iridescent pottery ceased at the firm. Until World War I began, Sicard operated a pottery in Amiens, finally returning to Golfe-Juan where he died in 1923.

Sicardo ware appeared on the market by 1903,[1] and was featured in the Weller display at St. Louis's Louisiana Purchase Exposition in 1904.

More than once Weller claimed that Sicardo's shapes were thrown on the wheel.[2] This was not the case with this vase, however. It appears to have been molded, as were the other Sicardo ware examples in this collection, and the shape is known to have been used for other art lines at the company.[3]

1. Tiffany & Company offered Sicardo ware in 1903 and published a brochure to promote it. See Arthur Veel Rose, *S. A. Weller's Sicardo Ware* (New York: Tiffany & Co. [1903]).

2. May Elizabeth Cook, "Our American Potteries—Weller Ware." *Sketch Book* 5 (May 1906): 345–46, for one instance.

3. Martin Eidelberg, "Art Pottery," in Robert Judson Clark, ed., *The Arts and Crafts Movement in America, 1876–1916* (Princeton, N.J.: Princeton University Press, 1972), p. 154.

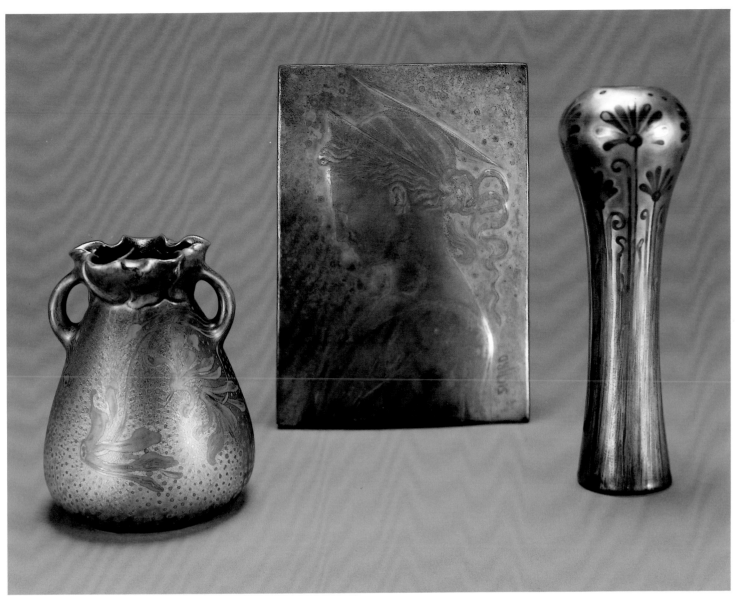

57 60 58

58. VASE, c.1902-07

S. A. Weller Pottery
Zanesville, Ohio

Decorated by Jacques Sicard
(1865–1923)

Molded gray-white earthenware
body decorated with stylized flowers
and leaves, with metallic lusters on
iridescent ground in shades of blue,
lavender, crimson, and green.

Height: 21.9 cm.
Diameter: 7.3 cm.
Marks: Painted in glaze on shoulder:
Sicard / Weller

1984–84–26

The process Sicard followed to obtain his iridescent glazes included, according to a colleague, ". . . painting . . . a metallic-ochreous mixture over a fired copper glaze and then subjecting this to a certain reducing fire."[1] But the firing process and the high temperatures it required proved to be uncontrollable, and many pieces were destroyed in the kiln. "The whole process is an intricate and costly one," a contemporary observed, "and in spite of continual watchfulness, Mr. Sicard is frequently doomed to bitter disappointments."[2] Weller considered his inventory of Sicardo ware a tremendous asset and, after Sicard returned to France in 1907, continued to offer it for sale until after 1912.[3]

1. Frederick H. Rhead, "Theophilus A. Brouwer, Jr., Maker of Iridescent Glazed Faience," *Potter* 1 (January 1917): 44.

2. Arthur Veel Rose, *S. A. Weller's Sicardo Ware* (New York: Tiffany & Co., [1903]), unpag.

3. Paul F. Evans, *Art Pottery of the United States* (New York: Charles Scribner's Sons, 1974), p. 325.

59. VASE, c.1902-03

S. A. Weller Pottery
Zanesville, Ohio

Decorated by Jacques Sicard
(1865–1923)

Molded gray-white earthenware
body decorated with oversize irises
in metallic lusters against a ground of
green, blue, purple, lavender, pink,
and gold.

Height: 63.8 cm.
Diameter: 35.6 cm. (at shoulder)
Diameter: 20.3 cm. (at base)
Marks: Unmarked

1984–84–25

References

Di Noto, Andrea. "A Certain Shade
of Green: The Happy Collaboration
Between Two Collectors and an Art
Dealer." *Connoisseur* 215 (August
1985): cover.

New York Times (New York edition),
17 November 1983, p. C1 (illus.).

A number of monumental vases like this one are known, tradition holding that they were originally made as decorations for the S. A. Weller Theater in Zanesville. The theater, built on North Third Street by Weller's architects, Harry C. Meyer and Frederick Elliott, opened to the public on April 27, 1903. Examples of Weller's architectural faience and art pottery were used throughout the interior,[1] reportedly including twenty of these iridescent vases in the lobby. This vase, while unmarked, is unmistakably the work of Sicard.[2]

1. For three examples of this model with similar decoration, see Louise Purviance, Evan Purviance, and Norris F. Schneider, *Zanesville Art Pottery in Color* (Leon, Iowa: Mid-America Book Co., 1968), cover. These vases are also said to have been made for the Weller Theater (inside front cover). This vase, although not illustrated with the group, originally came from the Purviance collection.

2. A vase of approximately the same shape and size, signed "Weller Sicard," sold at Christie's in New York on 4 December 1981 (lot 30). Tiffany & Company also offered one of these vases, which was illustrated in their 1903 brochure on Sicardo ware. See Arthur Veel Rose, *S. A. Weller's Sicardo Ware* (New York: Tiffany & Co., [1903]), unpag.

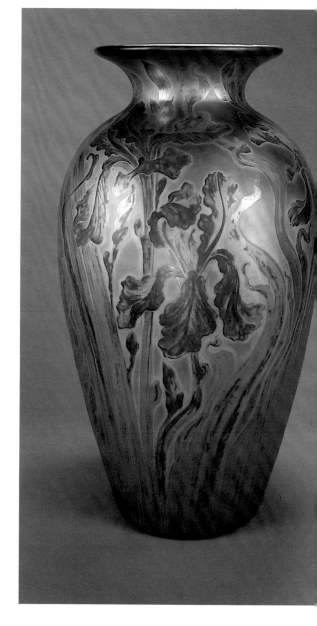

60. PLAQUE, c.1902-07

S. A. Weller Pottery
Zanesville, Ohio

Decorated by Jacques Sicard
(1865–1923)

Molded red earthenware body modeled in low relief with a woman's head in profile, in metallic lusters, primarily purple and green.

Height: 22.85 cm.
Width: 16.8 cm.
Depth: 0.5 cm.
Marks: Painted in glaze on front, lower right corner: S I C A R D ; unexplained monogram incised in recessed area on back

1984–84–28

Sicard's low-relief portrait plaques are rare survivals of his work at the Weller Pottery.[1] Sicard's former master, Clément Massier, produced portrait plaques in a similar style.[2]

1. At least three other plaques decorated with this image are extant. All are much larger than No. 60: the first (now badly damaged) measures 45.7 by 31 cm., the second 42.5 by 33 cm., and the third 52.6 by 40 cm.; see Sharon Huxford and Bob Huxford, *The Collectors Encyclopedia of Weller Pottery* (Paducah, Ky.: Collector Books, 1979), p. 90 (illus.); Brenda Gilchrist, ed., *Pottery*, Smithsonian Illustrated Library of Antiques (New York: Cooper-Hewitt Museum, 1981), p. 117 (illus.);and Christie's, New York, *Important American Architectural Designs and Commissions Including Arts and Crafts,* 13 June 1986 (lot 29).

2. For a circular plaque depicting Dante, and signed by Massier, see Betty Grissom, "Clément Massier—Master Potter," *Spinning Wheel* 27 (September 1971): 23.

61. VASE, c. 1905–10

S. A. Weller Pottery
Zanesville, Ohio

Cast light buff earthenware body modeled in high relief with nude man against a stylized tree. Silvery apple green mat glaze.

Height: 40.6 cm.
Diameter: 21 cm.
Marks: Incised: W E L L E R

1983–88–6

As the leader in mass-produced art pottery, Weller was quick to respond to the popularity of mat glazes. A series of pieces featuring animal and human forms modeled in high relief were finished in a variety of colored mat glazes, such as the apple green on this vase. Introduced at the same time as Sicardo ware, the mat-glazed line never received as much attention.[1]

1. A vase similar to No. 61 was illustrated in a 1906 article concerning the then-current state of American art pottery. See Clara Ruge, "American Ceramics—A Brief Review of Progress," *International Studio* 28 (March 1906): xxviii.

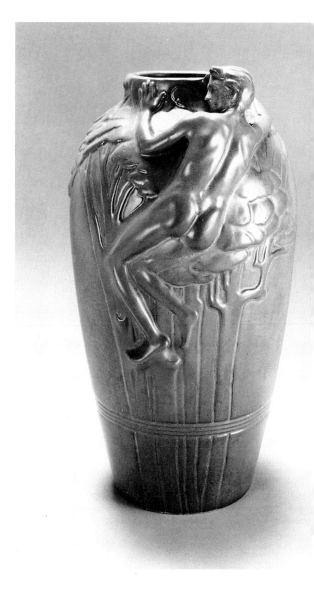

S. A. Weller Pottery
Zanesville, Ohio

Possibly decorated by Charles Walter Clewell (1876–1965), Canton, Ohio

Cast buff earthenware body decorated in high relief with grape clusters and leaves, vines forming the handles. Electrodeposited bronze with greenish patina on surface.

Height: 42.9 cm.
Diameter: 26.7 cm.
Marks: Impressed with partially indistinct circle mark: WELLER

1983–88–5

Although the body was made by Weller,[1] the use of the electrodepositing technique is not generally associated with the Weller Pottery.

Charles Walter Clewell's Clewell Metal Art Company of Canton, Ohio, produced, from around 1906 onward, a pottery covered with metallic coatings of bronze, brass, copper, and silver that resembled corroded metal. Since Clewell was a metalworker rather than a potter, he purchased fired ceramic blanks from several Ohio potteries, such as Roseville, Owens, Cambridge, and Weller. These he would finish at his studio by depositing metal on the surfaces and then chemically inducing colorful patination.

Clewell's work is generally, but not always, inscribed with his name, although some of the Weller blanks he finished do not bear his mark.[2] This vase may be one of that group.

1. The vase itself is an example of Weller's L'Art Nouveau line, designed by Frederick H. Rhead during his brief period with Weller from mid-1903 to 1904. Although this vase does not have the high relief whiplash tendrils and female figures that are characteristic of L'Art Nouveau ware, there is a similar example with a dark, high glaze that is marked "Art Nouveau" within the usual circular Weller mark. See Louise Purviance, Evan Purviance and Norris F. Schneider, *Weller Art Pottery in Color* (Des Moines, Iowa: Wallace-Homestead Book Company, 1971), plate 6.

2. Sharon Huxford and Bob Huxford, *The Collectors Encyclopedia of Weller Pottery* (Paducah, Ky.: Collector Books, 1979), p. 112.

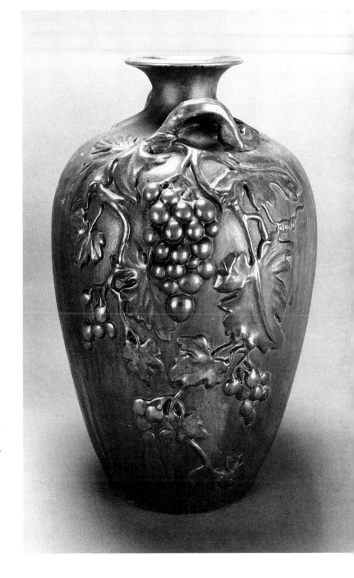

Pewabic Pottery

The founding of the Pewabic Pottery in 1903 initiated the most successful years of Mary Chase Perry's career as a ceramist. Having previously studied art, Perry, like many young women of her day, was soon accomplished at decorating china blanks with naturalistically rendered fruit and flowers. After pursuing clay modeling and sculpture at the Art Academy of Cincinnati from 1887 to 1889, Perry returned to her native Michigan and studied in Detroit with Franz A. Bischoff, a Bohemian painter well known among china decorators. Moving briefly to Asheville, North Carolina, to teach china painting, she returned to Detroit in 1893 and opened a small studio on West Adams Street.

Her neighbor in Detroit, Horace J. Caulkins, founder of a dental supply business, had invented a kiln in 1892 that was suitable for firing porcelain dental materials. With Perry's encouragement, Caulkins adapted his kiln to other uses, including the firing of decorated china. Soon his kiln had revolutionized the craft. Christened the Revelation China Kiln, this kerosene-fueled kiln could be fired at temperatures impossible in previous small kilns. Perry helped Caulkins promote the new kiln, traveling about the country to demonstrate its remarkable economy, portability, and versatility, giving instruction in china painting as she went. By 1898 she was conducting her own experiments with clays and glazes, becoming quite famous through her essays on china painting and watercolor designs, which appeared in leading periodicals. After 1900, Perry began contributing to Adelaide Alsop Robineau's journal *Keramic Studio*.

Influenced by the activities of other women potters such as Robineau, Maria Longworth Nichols, and M. Louise McLaughlin, Perry soon left the field of china painting and prepared to expand into other areas. In 1903 she withdrew her membership from the National League of Mineral Painters and, with the financial backing of her partner Caulkins, founded the Revelation Pottery. Revelation soon came to be called the Pewabic Pottery, a name "taken from the region in upper Michigan associated with Miss Perry's birthplace and childhood."[1]

Originally the pottery was located in an old coach house in Detroit behind the Cornelia S. Fox mansion on Alfred Street. This was a small operation, with Perry conducting the necessary glaze chemistry and designing the forms, and Caulkins mixing the clays and minding the kiln. Joseph Herrick was eventually hired to throw shapes on the wheel. By 1904, Pewabic was able to send twenty-three pieces to the Louisiana Purchase Exposition in St. Louis. Many of these early pieces were clearly influenced by William Grueby and the French potter Auguste Delaherche. Besides a selection of flowing glazes, one of Perry's earliest glazes was inspired by Grueby's famous mat green, although it lacked the depth and richness of his tone. Before the introduction in 1909 of her most famous glaze, the illusive and iridescent "Persian," or "Egyptian," blue, Perry had also perfected a selection of crystalline and volcanic glazes.

Her early success led to the construction of a new pottery in 1906. Designed by the firm of William Buck Stratton—Stratton and Perry were married in 1918—the new building was located at 10125 East Jefferson Avenue. Thanks to the support of Detroit art connoisseur Charles Lang Freer, many artists and architects became familiar with Pewabic's work and many new commissions were secured. In 1908 Ralph Adams Cram, architect of Detroit's St. Paul's Cathedral, chose Pewabic tiles for the interior pavement of the church. Many important architectural jobs were subsequently given to Pewabic Pottery, and most of the company's creative energies were devoted to designing tiles, tile mosaics, and interior fittings.

Although the pottery became quite successful, Pewabic remained relatively unconcerned with marketing its wares and never developed a sense of big business. It continued as a simple operation with a limited staff under the personal control of Mary Chase Perry Stratton. Mary

Stratton taught classes at the pottery from 1924 into the late 1940s. The Depression affected operations drastically, but the firm survived. After 1951, Stratton's health began to fail, and Pewabic's activities were directed more and more by Ella J. Peters. Nevertheless, the pottery remained in Stratton's hands until her death in 1961, and continued to operate as a private pottery until 1965, when it became part of Michigan State University. The pottery was reopened in 1968 and continues to operate as a pottery studio and museum.

1. Helen Plumb, "The Pewabic Pottery, " *Art and Progress* 2 (January 1911): 63–64.

Pewabic Pottery
Detroit, Michigan

Designed and glazed by Mary Chase
Perry (1867–1961)
Probably thrown by Joseph Herrick

Thrown buff composite stoneware
and earthenware body with blue-
green, high-gloss glaze, striated with
yellow-green. Gold and purple irides-
cence at shoulder and neck.

Height: 53.35 cm.
Diameter: 26.7 cm.
Marks: Illegible mark obscured by
glaze; circular paper label attached
to inside rim:
PEWABIC/DETROIT

1983–88–17

Exhibitions

*A Century of Ceramics in the United
States, 1878–1978,* Everson Museum
of Art, Syracuse, N.Y., 1979.

References

Clark, Garth. *A Century of Ceramics
in the United States, 1878–1978,* p.
63, fig. 71. New York: E. P. Dutton,
in association with the Everson Mu-
seum of Art, 1979.

Mary Chase Perry's most notable contribution to art pottery lay in glaze chemistry, specifically in the development of an iridescent glaze that she perfected by 1909. Perry applied her iridescent glaze on bodies composed of an earthenware and stoneware mixture that required high temperature firing, unlike the earthenware employed for Weller's Sicardo ware and for most European luster pottery. Her love of color led to the creation of a variety of radiant iridescent shades that included rose, gold, yellow, copper, purple, green, and her famous "Persian" or "Egyptian" blues—"opalescent, shimmering tints that defy naming, slipping and melting into other tones, now paling, now deeping with every movement of the little vase."[1]

On this vase, surface decoration is abolished in favor of a clean, unadorned shape. This may reflect the influence of Charles Fergus Binns, with whom Perry studied during the summers of 1901 and 1902. Perry also knew the superb collection of ancient and Oriental pottery assembled by Charles Lang Freer, one of the early patrons of the Pewabic Pottery.

What is probably the original impressed Pewabic mark on the bottom of this vase has been obscured by the thick glaze. Perry also identified her pieces by attaching circular labels, and one remains intact on the interior of the rim of this vase.

1. Quoted in *Highlights of Pewabic Pottery* (Ann Arbor, Mich.: Ars Ceramica Ltd., 1977), unpag.

Pewabic Pottery
Detroit, Michigan

Probably designed by Mary Chase
Perry (1867–1961)

Molded buff composite stoneware
and earthenware body with quatrefoil
pattern, both recessed and in relief.
Covered with iridescent gray-brown
glaze; felt backing.

Height: 15.3 cm.
Width: 15.3 cm.
Depth: 1.9 cm.
Marks: Circular paper label attached
to back: PEWABIC / DETROIT

1983–88–18

Exhibitions

American Decorative Tiles,
1870–1930, William Benton Museum
of Art, University of Connecticut,
Storrs, Conn., 1979.

References

Bruhn, Thomas P. *American Deco-*
rative Tiles, 1870–1930, p. 42, no.
142. Storrs, Conn.: William Benton
Museum of Art, University of Con-
necticut, 1979.

After Pewabic's prestigious, one-of-a-kind pot-
tery, the most important of the firm's wares was
its architectural ceramics, particularly its tiles.
When tile-making was added to the production,
Mary Chase Perry visited the American En-
caustic Tiling Company in Zanesville, Ohio, to
research their production methods. As early as
1907, Perry displayed her tiles at an exhibition of
the New York Society of Ceramic Arts.[1] Follow-
ing the critical acclaim awarded Pewabic for the
tiles produced for St. Paul's Cathedral in Detroit,
Pewabic received commissions from around the
country, including installations for the Rice
Institute (Houston, 1913), the National Shrine of
the Immaculate Conception (Washington, D.C.,
1923–31), a ceramic mosaic entitled *The Seven*
Ages of Man, in Detroit's Main Library (1923),
and fountains, alcoves, and stair risers for the
Detroit Institute of Arts (1927). All of these
were designed by Perry.

Dating this tile is problematic, since these glazes
were used continually on tiles until the 1960s.[2]

1. "Exhibition of the New York Society of Ceramic Arts," *Keramic*
Studio 9 (June 1907): 38.

2. An example of this tile can be seen on the wall behind Mrs.
Stratton in a photograph dated 1957, which may indicate that the tile
was still in production at this time. See Lilian Myers Pear, *The*
Pewabic Pottery: A History of Its Products and Its People (Des Moines,
Iowa: Wallace-Homestead Book Company, 1976), p. 262 (illus.).

Fulper Pottery

The Fulper Pottery Company came relatively late to the art pottery movement despite its status as one of the oldest potteries in America. Originally a commercial operation that was established well before Rookwood fired its first pots in 1880, Fulper responded much as the Weller Pottery and the American Terra Cotta Company had to the demand for art wares. By the end of this century's first decade, Fulper had gradually shifted its full attention to supplying the public with relatively inexpensive, well-made art pottery. The company soon became famous for its simple stoneware bodies and its range of glazes.

Originally founded in 1814[1] as the Samuel Hill Pottery, and located at the corner of Mine and Main Streets in Flemington, New Jersey, the company was acquired by Hill's partner Abraham Fulper in 1860. Its initial success came as a producer of drain tiles and utilitarian earthenware and stoneware. But three decades after Abraham Fulper died in 1881, the efforts of his son, William Hill Fulper II, brought fame to the company as a producer of high-quality pottery. Following his initial interest in the technical aspects of ceramic production, William Fulper began designing shapes. Contemporary developments in glaze technology in America and abroad, and the writings of Professor Charles F. Binns of Alfred University, further fueled Fulper's aspiration—to create pottery distinguished by simple shapes and interesting glaze effects, both aesthetically pleasing and affordable. After years of experimentation, the Fulper Pottery Company released its first art line just in time for the holiday season of 1909. The trademark name of Vasekraft (or Vase-kraft) was chosen to promote it, and the line became an immediate success.

With Vasekraft, Fulper did indeed manage to combine high quality with commercial success. The company offered a variety of jardinières, vases, bowls, lamps, candleholders, bookends, and other items. Since the success of each piece's glaze often determined its final cost, some simpler treatments were inexpensive. But others, particularly those glazed with Fulper's rare "famille rose," were prestigious and very expensive. Six general categories of Fulper glazes have been identified, including Mirror, Flambé, Lustre, Matt, Wistaria (pastel colors), and Crystalline. The firm gave specific glaze effects their own names, for example, "elephant's breath," "clair de lune," "café au lait," "blue of the sky," "cat's eye," "violet wistaria," or "mission matte." A wide range of effects could be achieved by combining or overlapping different glazes on the same piece. To produce Vasekraft, Fulper used a glazing technique whereby "the bodies are merely dried by mild heat, after which the glaze is painted on like a wet slip and allowed to dry. Then the firing takes place, bringing both body and glaze to perfection at one operation and amalgamating them in a complete unity impossible of achievement otherwise."[2] The body was made of a combination of stoneware clays from rich New Jersey deposits, the same material used for Fulper's commercial lines. Pieces were commonly cast in molds, which made it possible to produce many examples of each shape. Yet each piece was individually glazed by hand and differed in color and texture.

In 1911, Fulper worked with a staff of about seventy-five. Although he continued to devise some of the designs and glazes, most of this work was done by his employees. John O. W. Kugler designed most of the shapes, and John Kunsman and Edward Wyckoff were the chief potters, developing the master models on the wheel. J. Martin Stangl, superintendent of Fulper's technical division, had studied ceramic engineering at Bunzlau, Germany, and was chiefly responsible for developing the company's unusual glazes.

Business at Fulper was good throughout the 1920s. In 1928, the year of Fulper's death, operations expanded to a branch plant on New York Avenue in Trenton, New Jersey. The next year the original building in Flemington burned to the ground, destroying all the remaining stock and equipment. Still, the plant in Trenton and a second plant in Flemington continued in operation, producing pottery at full capacity. In 1930

Stangl acquired the firm and continued to produce art ware in limited amounts until 1935. After that point he began to use his own name for the line he produced, and in 1955 the company was formally registered as the Stangl Pottery Company.

1. Although the company often claimed to have been founded in 1805, this has been proven to be inaccurate. See Paul F. Evans, *Art Pottery of the United States* (New York: Charles Scribner's Sons, 1974), p. 109.

2. Evelyn Marie Stuart, "Vasekraft—An American Art Pottery," *Fine Arts Journal* 29 (October 1913): 612.

65. VASE, c.1909-15

Fulper Pottery Company
Flemington, New Jersey

Cast buff stoneware body with relief design of cattails. Green mat glaze with ocher highlights.

Height: 32.4 cm.
Diameter: 12.1 cm.
Marks: Printed underglaze in vertical cartouche: FULPER

1984-84-47

Exhibitions

Fulper Art Pottery: An Aesthetic Appreciation, 1909–1929, New York, Jordan-Volpe Gallery, 1979.

References

Blasberg, Robert W. *Fulper Art Pottery: An Aesthetic Appreciation, 1909–1929,* p. 55, fig. 43. New York: Jordan-Volpe Gallery, 1979.

According to a Vasekraft trade catalogue from about 1915, this "cat-tail" vase, model number 443, originally sold for four dollars. It was available in two finishes, either the light brown "café au lait" or the green and ocher "verte antique" of this vase. Fulper was particularly well known for mat glazes.[1] Often Fulper pieces were lined with a color different from the exterior: here, a terra-cotta mat glaze has been applied on the interior. In 1914 a chronicler observed, in reference to Fulper, "bouquets and garlands are becoming more and more a recognized detail of home decoration and it is fortunate that our native potters have supplied us with such ideal backgrounds for these lovely studies in fresh green and living color."[2] At San Francisco's 1915 Panama-Pacific International Exposition, Fulper won a gold medal for his display of pottery, exhibited jointly with Gustav Stickley's Craftsman furniture.

1. "The Potters of America: Examples of the Best Craftsmen's Work for Interior Decorations: Number One," *Craftsman* 27 (December 1914): 299.

2. Evelyn Marie Stuart, "Vasekraft—An American Art Pottery," *Fine Arts Journal* 29 (October 1913): 610.

66 67 65

Fulper Pottery Company
Flemington, New Jersey

Molded buff stoneware; upper two-thirds of body covered with cream, pale blue-gray, and ocher flambé glaze over mustard mat glaze on lower third.

Height: 30.5 cm.
Diameter: 23.5 cm.
Marks: Printed underglaze in vertical cartouche: F U L P E R / incised vertically: F U L P E R; traces of unidentifiable paper label

1984–84–45

Exhibitions

American Art Pottery, 1875–1930, Wilmington, Del., Delaware Art Museum, 1978.

Fulper Art Pottery: An Aesthetic Appreciation, 1909–1929, New York, Jordan-Volpe Gallery, 1979.

References

Blasberg, Robert W. *Fulper Art Pottery: An Aesthetic Appreciation, 1909–1929,* inside front cover, no. 2 (illus. cover). New York: Jordan-Volpe Gallery, 1979.

Keen, Kirsten Hoving. *American Art Pottery, 1875–1930,* p. 69, no. 157 (illus. p. 74). Wilmington, Del.: Delaware Art Museum, 1978.

Loring, John. "American Art Pottery." *Connoisseur* 200 (April 1979): 283, fig. W (illus. p. 285).

The Fulper Pottery's glazes were the most notable aspect of their Vasekraft line. About six glaze categories were developed, and by their combination, limitless variations could be achieved. Frequently, multiple glazes were applied, which resulted in some outstanding effects. On this large vase, a blue-gray flambé glaze was applied over Fulper's unique "mustard matte."

Often Fulper reproduced the same shapes in large quantities, and similar examples of this vase's shape and glaze are known.[1] Still, because of the hand glazing and slight variations in kiln temperatures, each piece remained distinctive. Fulper was particularly sensitive to the importance of the handmade look of its pottery, and even though a piece was cast, great effort was taken to remove all signs of the mold.

1. For example, see Ulysses G. Dietz, *The Newark Museum Collection of American Art Pottery* (Newark, N. J.: Newark Museum, 1984), p. 62, no. 117 (illus. p. 63).

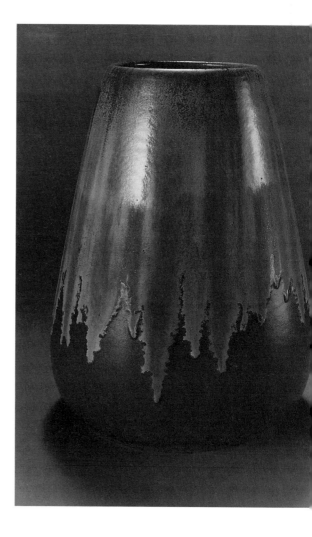

Fulper Pottery Company
Flemington, New Jersey

Molded buff stoneware body covered
with a blue-green crystalline glaze
with subtle flambé striations over a
brown glaze.

Height: 14.6 cm.
Diameter: 22.9 cm.
Marks: Paper label printed in blue
ink: FULPER [in vertical car-
touche]; in pencil: 657 / Vase / and
indecipherable numbers [price?]

1984–84–46

Exhibitions

*Fulper Art Pottery: An Aesthetic Ap-
preciation, 1909–1929,* Jordan-Volpe
Gallery, New York, 1979.

This vase exemplifies Fulper's crystalline glazes.
Numerous effects were achieved with these
sorts of glazes, which were considered some of
the firm's best. In an undated trade catalogue,
Fulper described these glazes as "clear crystals
like the starry Heavens; surface crystals like
hoar frost on window panes and still others like
the surface effect of galvanized iron."[1]

1. Quoted in Kirsten Hoving Keen, *American Art Pottery, 1875–1930*
(Wilmington Del.: Delaware Art Museum, 1978), p. 67.

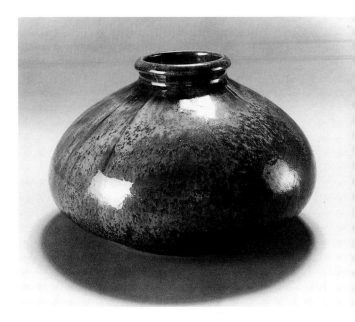

Overbeck Pottery

The Overbeck Pottery was established about 1910 in the family home of Margaret, Mary Frances, Elizabeth, and Hannah Overbeck in Cambridge City, Indiana. With almost no outside help, the four sisters performed every task involved in making their ceramics. They created a studio in a first-floor room of the house and set up a shop in the basement. Margaret, who taught on the art faculty of DePauw University, had worked one summer at a pottery in Zanesville, Ohio, and there developed the ambition to establish a pottery studio of her own. She succeeded, with the help of her sisters, but died soon after, in 1911.

The three remaining women had received some training in art, design, and ceramics themselves, and continued the pottery on their own. Mary Frances, who, like her sister Margaret, had studied with Arthur W. Dow at Columbia University, handled the glazing and some of the designing; Elizabeth, who had studied pottery for a year at Alfred University under Professor Charles F. Binns, was responsible for wheel-thrown shapes and glaze formulae; while Hannah, who had had little formal design training, became an accomplished artist, responsible for most of the designing and decorating.

All of the sisters except Elizabeth had also attended the Art Academy of Cincinnati, though they had not studied ceramics there. Their disparate design training, however, never interfered with their ability to work as a team at their pottery: the finished products were always the result of their group effort. All of them contributed designs and critiques to Adelaide Alsop Robineau's *Keramic Studio*, and through Elizabeth maintained direct contact with the influential Professor Binns. Overbeck pottery received several awards, and the sisters contributed to several traveling exhibitions. Hannah died in 1931, but Mary Frances and Elizabeth continued to work together until 1936, when Elizabeth died. Mary maintained pottery production at the family home until her death in 1955.

68. VASE, c.1915-30

Overbeck Pottery
Cambridge City, Indiana

Designed and decorated by Hannah
B. Overbeck (1870–1931)
Potted by Elizabeth G. Overbeck
(1875–1936)

Thrown buff earthenware body deco-
rated with repeating panels depicting
a man beneath a tree with three
birds among branches; mat glazes in
light brown, cream, green, and
mauve.

Height: 17.5 cm.
Diameter: 10.8 cm.
Marks: Incised monogram: O B K /
E H

1984–84–55

Although the Overbeck sisters produced useful objects—jars, tiles, and dinnerware—they concentrated much of their work on art wares, such as figurines, bowls, and ornamental vases. This vase is typical of this aspect of their production. For the Overbeck's art pottery, Elizabeth Overbeck developed a clay mixture composed of Tennessee ball clay, Pennsylvania feldspar, kaolin from Delaware, and a clay indigenous to Cambridge City. Except for a few molded cups and saucers, each piece was thrown on the wheel, incised or carved, and glazed to produce a satiny, semi-mat surface. The pottery favored such colors as turquoise, creamy yellow, dark green, pink, and a mauve described as "something of the color of a ripe raspberry with lavender shadings,"[1] which the Overbecks called "hyacinth."

1. Lilian H. Crowley, "It's Now the Potter's Turn," *International Studio* 75 (September 1922): 544.

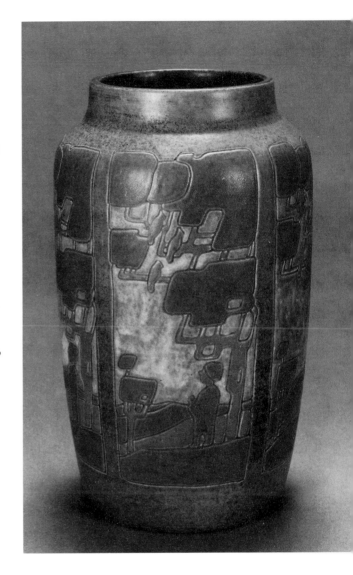

Marblehead Pottery

The Marblehead Pottery was founded by Dr. Herbert J. Hall in 1904 as one of several craft workshops called "handcraft shops," which provided occupational therapy for his "nervously worn out patients."[1] The other crafts around which these shops were organized included handweaving, wood-carving, and metalworking, but the pottery department proved most successful. To assist in the creation of his pottery, Dr. Hall secured the help of Arthur Eugene Baggs, a second year student of Professor Charles Binns at Alfred University's New York State School of Clay-Working and Ceramics. Within a year the pottery workshop was separated from the sanitarium, and three years of experimentation began under Baggs's supervision. By 1908 the Marblehead Pottery had achieved independent commercial success with a weekly output of nearly two hundred pieces, including vases, jardinières, decorated tiles, and other individually designed wares. The staff remained small, consisting at first of Arthur Irwin Hennessey, Maude Milner, Hannah Tutt, an accomplished thrower named John Swallow, and E.J. Lewis, the kiln man. "The designers themselves plan and decorate the individual pieces," one observer remarked, "and personally direct their progress through the various necessary stages."[2]

Marblehead's simple shapes, conventionalized decoration, and subtly colored mat glazes were continually praised. Originally made from a clay found in the vicinity of the town, Marblehead's experimentation resulted in a body made of a mixture of stoneware clay from New Jersey and a brick clay native to Massachusetts.

Marblehead Pottery remained a small operation. In 1916, the year after Baggs took over ownership of the pottery from Dr. Hall, only six staff were employed. Sometime before 1916, the pottery had moved from workrooms at Dr. Hall's Devereux Mansion to a building at 111 Front Street in Marblehead, where numerous tourists stopped by during the summer months. Baggs remained with the pottery, but beginning in the 1920s worked there only in the summer. From 1925 until 1928 he served as a glaze chemist for the Cowan Art Pottery Studio near Cleveland, and also taught at the Cleveland School of Art. In 1928 he became a professor of ceramic arts at Ohio State University in Columbus. The Marblehead Pottery continued operations until 1936, when it could no longer find a market for its handmade pottery. Baggs remained at Ohio State until his death in 1947.

1. Herbert Hall, M.D., "Marblehead Pottery," *Keramic Studio* 10 (June 1908): 30–31.

2. Hall, "Marblehead Pottery," p. 30.

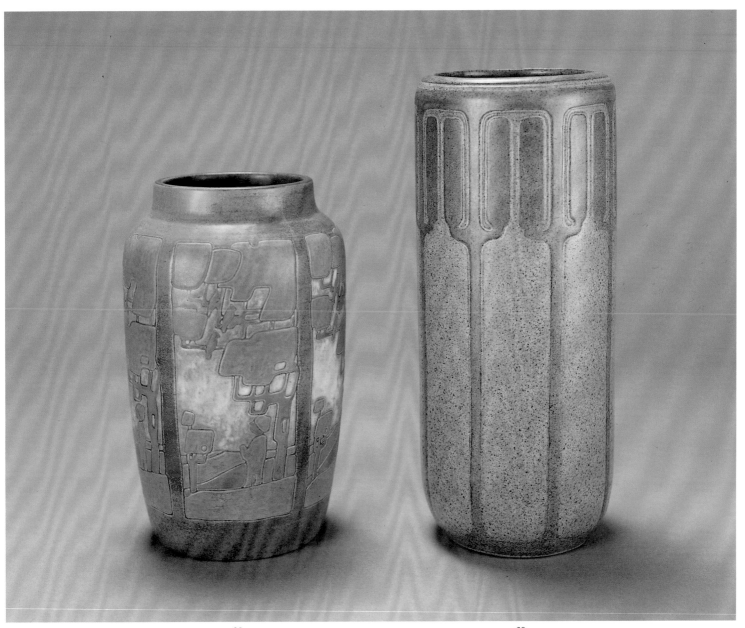

68 69

69. VASE, c.1908–20

Marblehead Pottery
Marblehead, Massachusetts

Probably designed by Arthur Eugene
Baggs (1886–1947)
Decorated by Hannah Tutt (dates
unknown)

Thrown red earthenware body in-
cised with abstract tree motif around
body. Dark green over stippled gray-
green mat glaze. Interior glazed with
dark mustard-colored high glaze.

Height: 22.7 cm.
Diameter: 9.5 cm.
Marks: Incised circular mark: front
end of schooner, between M and P;
incised decorator's monogram: H T

1984–84–43

References

Di Noto, Andrea. "A Certain Shade
of Green: The Happy Collaboration
Between Two Collectors and an Art
Dealer." *Connoisseur* 215 (August
1985): 53.

This vase typifies Marblehead's decorative style. Its sparse decoration relies on simple, flat design that avoids naturalism in favor of the abstract. The flat pattern has been slightly incised into the surface, a common method of decoration at Marblehead, and further defined by simple, subtly contrasting mat glazes. "Although the shapes are conservative and simple, and although the decoration is severely conventionalized and carefully used," a contemporary observer remarked, "it is evident that the uninitiated public approves, for the calls for the product are far in excess of the possible output."[1] Marblehead's more popular designs were often repeated on other pots.[2]

1. Herbert J. Hall, M.D., "Marblehead Pottery," *Keramic Studio* 10 (June 1908): 31.

2. See, for example, Garth Clark, *A Century of Ceramics in the United States, 1878–1978* (New York: E. P. Dutton in association with the Everson Museum of Art, 1979), p. 59, no. 66 (illus.).

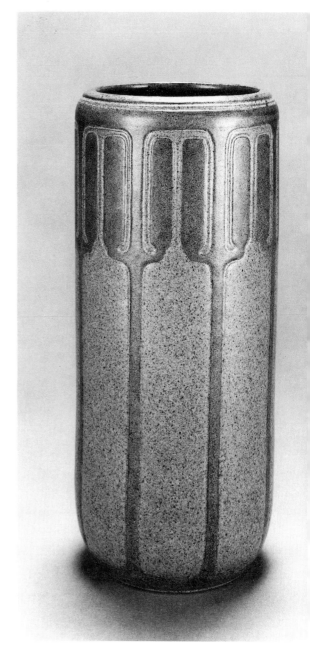

Marblehead Pottery
Marblehead, Massachusetts

Designed by Arthur Eugene Baggs
(1886–1947)

Molded light gray earthenware body
painted in mat glazes with two fish
among seaweed, one fish mustard-
colored, the other gray-brown, with
blue seaweed, all against a stippled,
blue-gray background.

Height: 15.9 cm.
Width: 15.9 cm.
Depth: 2.5 cm.
Marks: Impressed circular mark:
front end of a schooner, between M
and P

1984–84–44

In addition to flowers and plants, sea life inspired
many Marblehead patterns. The town of Marble-
head's location near the sea meant that marine
motifs were quite popular, particularly for tourist
souvenirs. The grays, blues, and yellows of this
tile are "colors that belong to shore places,"[1] and
even the pottery's mark makes reference to its
location.

Other similar tiles are known,[2] but since they
were glazed on all sides, they were probably
made as individual ornaments rather than for an
architectural frieze.

1. Gertrude Emerson, "Marblehead Pottery," *Craftsman* 29 (March
1916): 673.

2. For an almost identical tile, see Thomas P. Bruhn, *American
Decorative Tiles, 1870–1930* (Storrs, Conn.: William Benton Museum
of Art, 1979), p. 35, no. 103. The date for No. 70 is based on an
example illustrated in Herbert J. Hall, M. D., "Marblehead Pottery,"
Keramic Studio 10 (June 1908): 30.

Paul Revere Pottery

The social mission of the arts, a favorite theme of the Arts and Crafts movement, found expression in the activities of Boston's Paul Revere Pottery, as well. The Paul Revere Pottery was established to provide employment opportunities for members of the Saturday Evening Girls Club, a cultural and social organization for poor girls from mainly Italian and Jewish immigrant families in the Boston area. Two women, Edith Brown and Edith Guerrier, suggested that pottery-making be added to the Club's program of lectures, music classes, and glee clubs, to provide a source of income for some of the girls. In the winter of 1906, a small kiln was purchased with money provided by Mrs. James J. Storrow, a prominent patron who subsidized the pottery for a number of years. A ceramist from the Merrimac Pottery in Newburyport, Massachusetts, was hired to handle the technical aspects of glazing and firing, and by 1908 production was underway in the basement of a settlement house in Brookline, Massachusetts.

Aided by Storrow, the pottery soon moved into larger quarters in the Library Club House at 18 Hull Street in Boston. Edith Brown directed the pottery, supplied most of the designs, and even lived on the top floor of the four-story building. The pottery's staff was small at this point, employing about ten decorators, a young helper, a potter, and a kiln man. Brown, convinced that people preferred to buy products made under good working conditions, tried to maintain a cheerful and pleasant atmosphere for the staff.

The close proximity of the pottery to the Old North Church and the historical character of the area provided the inspiration for naming the company, around 1912, the Paul Revere Pottery. The Bowl Shop, as it was also known, developed quickly and soon received acclaim for its line of decorated pottery. Designs were generally based on simple figural and floral patterns outlined in black or incised and filled with flat, naturalistic tones. The pottery included, among other objects, a range of plain and decorated vases, electric lamps, candlesticks, bowls, dinner services, and tea sets. The Paul Revere Pottery was noted for its children's breakfast sets, which were often personally monogrammed with the child's initials. While most of the pottery was of a functional rather than ornamental nature, almost every piece was hand thrown—with the exception of such things as inkwells, paperweights, decorated tiles, and bookends, which were molded. The firm's decorators were all young women who had gone through a one-year training program at the pottery, and worked in the intentionally naive "nursery" style required by the designs.

In 1915 a new building, designed by Brown and paid for by Storrow, was built at 80 Nottingham Road in Brighton, Massachusetts. The staff was increased to as many as twenty in order to keep the four kilns in operation. When the company's mainstay, Edith Brown, died in 1932, Paul Revere Pottery entered a period of sharp financial decline. Never a profit-making enterprise, the pottery managed to survive for nearly ten years, only with the support of Storrow, until it finally closed in January 1942.

71. TILE, 1910

Paul Revere Pottery
Boston, Massachusetts

Probably designed by Edith Brown
(d. 1932)
Decorated by unknown artist, initals
F.L.

Molded buff earthenware body in-
cised and painted with design of two-
story house flanked by buildings.
Incised and painted:
MATHER/ELIO.T/
HOUSE; and
HAN-OVER/&/NORTH/
BENN-/ET/STREETS. Mat
glazes in browns, cream, and green.

Height: 9.3 cm.
Width: 9.3 cm.
Depth: 1.25 cm.
Marks: Painted in black: F. / L.
192-2-10 / S. E. G.

1983–88–20

A small but nevertheless interesting aspect of
the Paul Revere Pottery's production was its
series of tiles. One set of thirteen tiles depicted
the ride of Paul Revere, others the *Mayflower*
and Columbus's ships. The "Boston" set showed
famous old Boston buildings, such as Old South
Church on Washington Street, Paul Revere's
House on North Square, the Schoolmaster's
House, the Mather Eliot House, and the
Hartt House.

The designs for these tiles were incised in
outline upon still-soft clay. A wide variety of soft
colors were developed to decorate the unpreten-
tious and charming designs for these small
ornaments, described by a contemporary ob-
server as "best set up locally upon mantel or
elsewhere in the New England cottage."[1]

Most of these tiles were dated and initialed by
the decorators, who unfortunately remain anony-
mous today.

1. Mira B. Edson, "Paul Revere Pottery of Boston Town," *Arts and
Decoration* 1 (October 1911): 494.

72. TILE, 1913

Paul Revere Pottery
Boston, Massachusetts

Probably designed by Edith Brown
(d. 1932)
Decorated by unknown artist, initials
D.C.

Molded buff earthenware body with
painted design of front view of
house. Incised and painted:
HARTT HOUSE/HULL
STREET. Mat glazes in green,
brown, blue, pink, and cream.

Height: 9.5 cm.
Width: 9.5 cm.
Depth: 1.25 cm.
Marks: Painted in black: D C. / 4.13
/ S.E.G.

1983–88–19

California Faience

The art pottery movement, though initially based in Ohio and Massachusetts, spread quickly to nearly all regions of the country. On the West Coast it was strongly represented by a number of potteries, in most cases founded or staffed by ceramists who received their initial training on the East Coast. The California Faience Company of Berkeley, California, originally grew from a 1916 partnership between William V. Bragdon and Chauncey R. Thomas. Bragdon had graduated in 1908 from the New York State School of Clay-Working and Ceramics at Alfred University, having trained under Professor Charles F. Binns. From 1909 to 1912 he taught ceramics at the University of Chicago, followed by two years under Taxile Doat at the University City Porcelain Works in Missouri. In 1915 he came to Berkeley to teach at the California School of Arts and Crafts (now the California College of Arts and Crafts in Oakland), but ended up establishing a pottery concern with Chauncey Thomas. Originally called simply Thomas & Bragdon, the firm was located in a building at 2336 San Pablo Avenue in Berkeley. Within six years they had changed the name to the Tile Shop and had moved to 1335 Hearst Avenue, where they produced both tiles and a range of art pottery. Although "California Faience" may have been used to designate the art-ware line before 1924, from that year on the firm itself took the name.

Throughout the 1920s the California Faience staff remained small, never exceeding five, including the owners. Tile production made up the greatest part of their work, although vases and bowls were also produced, these generally glazed in a mat monochrome. Thomas was responsible for most of the glaze developments, while Bragdon handled the other technical details including mold-making. Designs were supplied by local artists who were not staff members, most of them now unknown.[1]

California Faience remained in production until the beginning of the Depression. By 1930 all pottery-making at the firm had ceased. Some attempts were made to revive production, but to no avail. Bragdon bought out his partner Thomas a few years into the decade and continued to make pottery on his own, although not for commercial distribution. He sold the manufactory in the early 1950s and died in 1959.

1. Paul Evans has identified one of California Faience's designers as Stella Loveland Towne. See Paul Evans, *Art Pottery of the United States* (New York: Charles Scribner's Sons, 1974), p. 40.

California Faience Company
Berkeley, California

Molded red earthenware body deco-
rated with woman in medieval cos-
tume against architectural and
landscape elements. Design defined
by raised partitions filled with poly-
chrome mat and high glazes.

Height: 26.05 cm.
Width: 17.5 cm.
Depth: 1.3 cm.
Marks: Incised: California / Faience

1984–84–53

Exhibitions

*American Decorative Tiles,
1870–1930,* William Benton Museum
of Art, University of Connecticut,
Storrs, Conn., 1979.

References

Bruhn, Thomas P. *American Deco-
rative Tiles, 1870–1930,* p. 21 (illus.
p. 32). Storrs, Conn.: William Ben-
ton Museum of Art, University of
Connecticut, 1979.

While most of the California Faience Company's
art wares were glazed in a single color, their tiles
were usually boldly polychromatic. Designs were
incised on a plaster mold into which the clay for
each tile was hand pressed, rather than stamped
out mechanically. The mold imprinted the tile
with raised ridges and cloisons that contained
the glazes, often in complicated patterns with
numerous sections and colors.

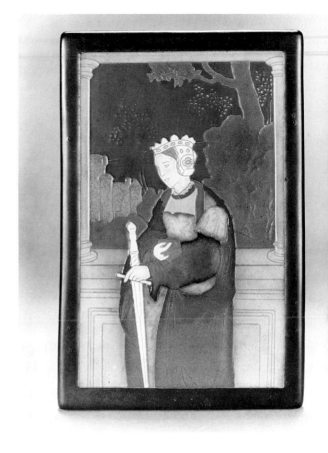

M. Louise McLaughlin

When Rookwood dismissed M. Louise McLaughlin's Pottery Club from its workrooms in 1883, she and her followers returned to their initial involvement with overglaze china painting. Nearly ten years passed before McLaughlin resumed work with wet clay. In 1894 she began experiments at the Brockmann Pottery Company with a process that involved painting decoration onto the interior of the molds with clay slips, and then casting the bodies. She called this work "American faience" and patented her process in 1894, but because the technique was difficult to control and required the assistance of others, she was dissatisfied with the results and soon abandoned it.

Wanting to continue her ceramic work, McLaughlin began a series of experiments aimed at developing a high-firing, hard paste porcelain. Her independent approach to pottery production broke with the relatively passive, traditional role of women potters, following instead the examples of a few self-sufficient, male studio-potters like George E. Ohr and Theophilus A. Brouwer, Jr. By 1898 she was doing all the work at her home in the Cincinnati suburb of Mount Auburn. The situation she described as:

. . . a kiln with small workshop attached having been erected in my garden, where all the processes are executed, from the handling of raw material up to the firing of the vessel; from six to twenty-four pieces being finished at each firing.[1]

Throughout a strenuous period of trial and error, McLaughlin worked with no less than eighteen paste formulae and over forty glazes. "If there was a simple detail of the work where the way was not made hard," she wrote, "memory fails to recall it."[2] Yet through her persistence she developed a satisfactory clay body by 1899, and was able to display twenty pieces of her "Losanti" ware at the spring exhibition of the Cincinnati Art Museum. She chose the name Losanti because of the historic connections it had with the city of Cincinnati, which was originally named Losantiville. McLaughlin further refined her porcelain by 1901, and she displayed twenty-seven pieces at Buffalo's Pan-American Exposition—and won a bronze medal for her work. Throughout, McLaughlin was assisted by Margaret Hickey, who was responsible for casting the porcelain and minding the kiln.

McLaughlin decided to abandon porcelain work in 1904 in favor of other activities (probably also because neighbors complained about her smoking kiln). By 1914 she was involved again in metalwork, which had already won her a silver medal at the 1900 Paris Exposition Universelle, and in jewelry-making, needlework, etching, painting, and sculpture. McLaughlin remained active as an artist in Cincinnati until her death at the age of ninety-two in 1939.

1. Louise M. McLaughlin [sic], "Losanti Ware," *Craftsman* 3 (December 1902): 187.

2. Louise McLaughlin, "Losanti Ware," *Keramic Studio* 3 (December 1901): 178–79.

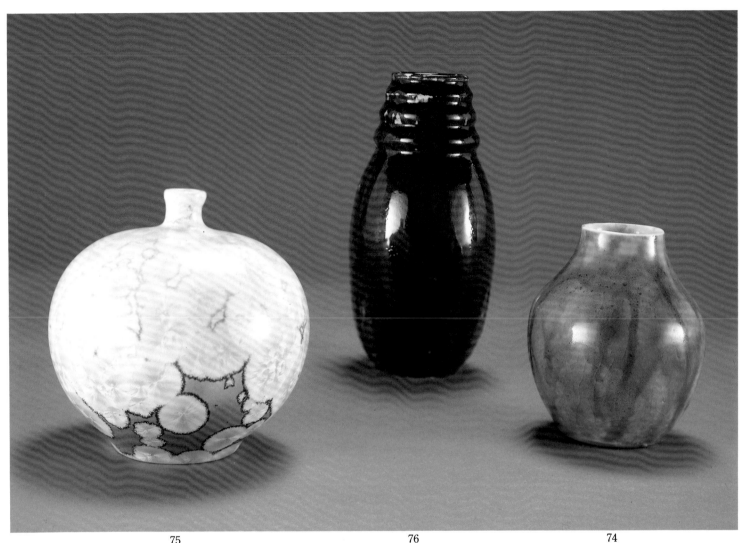

75 76 74

74. VASE, c.1903

Executed by M. Louise McLaughlin
(1847–1939)
Cincinnati, Ohio

Molded porcelain body decorated un-
derglaze with mottled blue and
green. Clear, semi-mat glaze.

Height: 11.45 cm.
Diameter: 9.2 cm.
Marks: Incised: 93 / artist's mono-
gram: McL [conjoined with three
slashes below]; painted vertically in
underglaze blue: LOSANTI

1984–84–51

M. Louise McLaughlin was the first American
studio potter to work with true porcelain as an
artistic medium. At its maturity, her porcelain
was a hard, creamy-white paste that fired to
translucence at high temperature.

McLaughlin decorated many of her porcelains
with carved and pierced decoration, the open-
work sometimes filled with glaze, but because
these pieces collapsed easily in the kiln, this

decorative technique found limited application.
Decorated in a painterly manner, this vase is
unlike most of McLaughlin's porcelain work and
may have been considered an experimental
piece.[1]

1. The date of c.1903 for this piece is based on a statement by
McLaughlin in *Keramic Studio*: "inlaid glazes white and colored, and
trials of varied color effects in decoration is what I am working on";
see "Pottery at the Arts and Crafts Exhibit, Craftsman Building,
Syracuse," *Keramic Studio* 5 (June 1903): 36.

University City Pottery

The roots of University City Pottery lay in the foundation, in 1907, of an organization called the American Woman's League. Established in Missouri by an enterprising publisher and businessman named Edward Gardner Lewis, this organization offered cultural instruction through correspondence courses to women from rural areas. Expanding his ambitions, two years later Lewis bought about one square mile of land adjacent to Forest Park in St. Louis and there he built a commercial, residential, and university district, which he named University City. Not forgetting the League, Lewis invited some of its best students to study at the People's University in University City.

Lewis had a strong interest in the arts and developed the Art Institute of the People's University quickly. He recruited a faculty that included the sculptor George Julian Zolnay as dean and director. Lewis and his wife, Mabel, were both amateur ceramists, and Lewis was determined to establish a ceramics school at University City that would be "the finest in the world." Taxile Doat, one of the most famous French potters of the day, was hired as the director of the School of Ceramic Art. Doat's reputation as a great artist-potter at Sèvres, and his book, *Grand Feu Ceramics*, won him this prominent position in the United States. Doat had been invited to the United States in June 1909 to discuss contractual terms with Lewis and had returned to France to prepare for his position. In December 1909 he arrived in University City, accompanied by his two assistants, Eugène Labarrière and Emile Diffloth, all of his equipment, and his prepared French clays and glaze formulae.

Besides Doat, Lewis sought out the best of American potters for his school. They included Adelaide Alsop Robineau and her husband Samuel Robineau; Frederick H. Rhead, who was recommended as pottery instructor by the Robineaus; Rhead's assistants, Edward Dahlquist and Frank J. Fuhrmann; and Kathryn E. Cherry, instructor of china painting and ceramic design. Rhead arrived first to set up the pottery equipment and begin his manual, *Studio Pottery*, which was published by People's University

Press. The first major kiln was fired on April 2, 1910, under Doat's direction.

Pottery operations at University City were divided between the porcelain work carried out by Doat and Adelaide Robineau, and Rhead's and Cherry's educational work. Separate facilities were installed for each potter. A considerable amount of money backed up the operations, encouraging Doat and Robineau to concentrate their efforts on exhibition pieces rather than concern themselves with marketing. To Robineau's dismay, Doat chose to work independently of the other potters.

Despite its high ambitions, University City's pottery operations only lasted eighteen months. By 1911 the American Woman's League had gone defunct. While both Rhead and the Robineaus left by the end of the year, Doat continued on. His assistants Diffloth and Labarrière having left as well, Doat was now assisted by the ceramic chemist William V. Bragdon, who later founded the California Faience Company. Frank J. Fuhrmann served as decorator, and an English potter named Thomas Parker, as turner. Doat concentrated on his porcelain work and particularly on his flambé, crystalline, and metallic glazes.

The University City Pottery was reorganized in 1912 as the University City Porcelain Works in the hopes of making the operation a commercial success. Edward G. Lewis had moved to California in 1912, where he founded the town of Atascadero, a utopian community for the American Woman's Republic. Porcelain production at University City continued through 1914, and efforts were made to complete work for San Francisco's Panama-Pacific International Exposition the following year, but the pottery closed before then. After Taxile Doat returned to France in 1915, Lewis shipped all of University City's pottery equipment to Atascadero, hoping that the Art Institute once based at the People's University could be established there. This plan, the last vestige of Lewis's University City project, was never successful and the pottery remained defunct.

75. VASE, 1913

University City Porcelain Works
University City, Missouri

Probably designed by Taxile Doat
(1851–1938)

Molded porcelain body with café-au-lait and green crystalline glazes on cream ground.

Height: 12.7 cm.
Diameter: 12.1 cm.
Marks: Incised: U C / 1913; painted overglaze in green: 7 [or L]

1984–84–50

This vase, produced in 1913 during the period of University City Pottery's reorganization, documents the skilled handling of crystalline glazes developed at the pottery by Taxile Doat, as well as the influence of those glazes used at the Sèvres factory in France and at other European and Scandinavian factories. By this date, native American clays had replaced the imported French clays that Doat had first used at University City, due in large part to the efforts of Adelaide Alsop Robineau.

This vase bears no decorator's mark, but its design is clearly related to an earlier design created by Taxile Doat, the pottery's director, while he was at Sèvres.[1] Doat, who was ultimately responsible for developing all of the shapes, glazes, and clays used at the pottery, may have brought the mold to University City from France. Other vases of this shape and size suggest that a mold was used, rather than the wheel.[2]

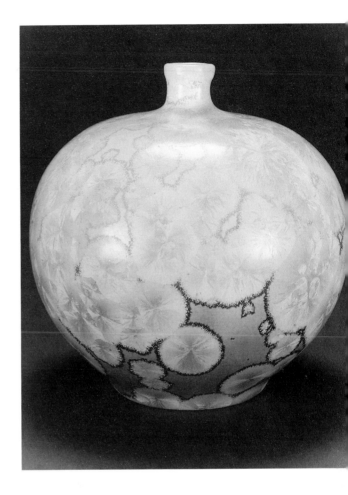

1. For a vase of this shape and approximate size, but made at Sèvres by Doat and dated 1907, see Sotheby's, New York, *Important Art Nouveau and Art Deco*, 11–12 May 1984 (lot 184).

2. For other similar vases, see Paul F. Evans, *Art Pottery* of the United States (New York: Charles Scribner's Sons, 1974), plate 8; and, Christie's, New York, *Important American Architectural Designs and Commissions*, including the *Arts & Crafts of America*, 14 June 1985 (lot 109).

Robineau Pottery

Adelaide Alsop Robineau was one of the most influential figures in the art pottery movement; indeed, in her lifelong commitment to the perfection of her craft, she epitomized the spirit of the Arts and Crafts ideal. Like most women potters of her day, she began by applying her art training to a career in china painting. Her decorated work quickly became successful, and later she began to teach the craft. In 1899, she left a teaching position in Minnesota to study painting under William Merritt Chase in New York. There she married Samuel Edouard Robineau, who, sharing her interest in ceramics, played an important role in her later work. That same year the Robineaus, in association with George H. Clark, bought a magazine called *China Decorator*, and in May 1900, they began publishing it under the name of *Keramic Studio*. The monthly journal, based in Syracuse, New York, where the Robineaus moved in 1901, was devoted to china painting and the latest developments in the ceramic world. Under the editorship maintained by Adelaide Robineau until her death in 1929, *Keramic Studio* became the major forum for serious ceramists.

The Robineaus secured French ceramist Taxile Doat's manuscript on the processes of making high-fire porcelains, and Samuel Robineau translated it for publication in *Keramic Studio*. The treatise was published, beginning in 1903, as a series of articles called "Grand Feu Ceramics," and later compiled in book form in 1905. Doat's expertise in porcelain pastes and glazes inspired Adelaide Robineau to try her hand at developing a porcelain body made from American ingredients. Never daunted by inexperience, Robineau achieved, by the spring of 1903, a group of at least seven experimental slip-cast porcelains, which she displayed at the Syracuse Arts and Crafts exhibition held in the Craftsman Building.[1] She worked with Professor Charles Binns at Alfred University for several weeks that summer, absorbing all she could about clays and pottery production.[2] At the 1904 Louisiana Purchase Exposition in St. Louis, she mounted a major display of her porcelains and presented a variety of newly developed mat glazes. Later that same year she introduced her crystalline glazes at the Art Institute of Chicago, and by 1905 New York's Tiffany & Company was offering a full range of her one-of-a-kind porcelains.

The years prior to Robineau's work at the University City Pottery (late 1909 to early 1911) were particularly productive ones, during which she quickly developed an expertise in the art of high-fire porcelain. Often her porcelain was carved and pierced with designs well-suited to her constantly expanding range of colored mat and semi-mat glazes. Robineau worked and reworked her pieces, reglazing and refiring them as many as seven times in order to achieve perfect results.

At University City, Robineau continued her efforts to perfect the technique of perforating and excise-carving the fragile porcelain pots. She considered her delicately carved "Scarab" vase to be the most important piece of her career.

After the University City Pottery closed, the Robineaus returned to Four Winds, their Syracuse home and studio. In 1912, perhaps inspired by the University City experience, Adelaide Robineau decided to establish an arts and crafts school at her home. The Four Winds Summer School provided instruction in pottery-making and china painting, and held classes in other crafts such as landscape sketching, basketry, jewelry, metal-, and leather-work. The program ran for three summers, closing in 1914. During World War I, operating the pottery itself became economically impossible, and Robineau was forced to close it. But she was still awarded the grand prize for her porcelains at San Francisco's 1915 Panama-Pacific International Exposition, and she received an honorary doctorate of ceramic sciences from Syracuse University in 1917. In 1920 Robineau joined the staff at Syracuse as an instructor of pottery and ceramic design. Moving her kiln to the campus, she continued her work—although not in the complex manner of the period before 1916. She remained at the university until illness forced her to retire in 1928. In 1929, the year of her death, she was honored with a memorial retrospective exhibition at the Metropolitan Museum of Art.

1. Some of these examples are illustrated in *Keramic Studio* 5 (June 1903): 38.

2. Jane Perkins Claney, "Edwin AtLee Barber and the Robineaus: Correspondence 1901–1906," *Tiller* 1 (November–December 1982): 36–37.

76. VASE, 1928

Robineau Pottery
Syracuse, New York

Executed by Adelaide Alsop
Robineau (1865–1929)

Thrown porcelain body with four
carved bands at neck. Overall, dark
red high glaze with maroon and black
streaks and some light green spots.

Height: 18.45 cm.
Diameter: 8.9 cm.
Marks: Excised circular monogram:
AR; incised: 28 [date]; pencil nota-
tion: p c L 43; painted in red:
30.4.43 [Everson Museum of Art
inventory number]

1984–84–52

This vase dates from 1928, the last year of
Robineau's ceramic work and the year she retired
from the faculty of Syracuse University. The
vase exemplifies the trend toward simplification
of technique and design that marks her work of
the late 1920s. Whereas Robineau's earlier de-
signs were often based on natural motifs, her
later work was closer in appearance to Chinese
porcelains and pre-Columbian pottery, and to
geometric designs such as these.

Glaze technology occupied much of Robineau's
experimentation, particularly her quest to obtain
a rich *sang de boeuf* glaze. Other American
potters had succeeded in such experiments,
most notably Hugh C. Robertson at the Dedham
Pottery (see No. 29), and Joseph Bailey, Sr., at
Rookwood (see No. 14). As early as 1908,
Robineau had created an experimental *flammé*
red glaze derived from copper oxide fired in a
reducing kiln. Her results were often inconsis-
tent, with spots or streaks of green, as on this
example. The low alumina content of her glazes,
needed to maintain the brilliancy of the colors,
caused the glazes to flow, and this required that
excess glaze be ground off the bottom.

This piece may have been intended as part of a
group of reduction-fired wares that Robineau was
organizing for an exhibition in London before her
death in 1929. It was later part of a collection of
her work purchased from her studio in 1930 by
the Everson Museum of Art in Syracuse.

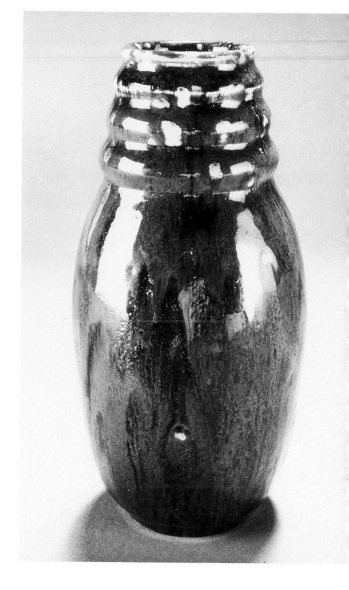

Bibliography

Books and Catalogues

Barber, Edwin AtLee. *Marks of American Potters, with Facsimilies of 1,000 Marks, and Illustrations of Rare Examples of American Wares.* Philadelphia: Patterson and White Co., 1904. Reprint. Southampton, N.Y.: Cracker Barrel Press [1973].

—————. *Pottery. Catalogue of American Potteries and Porcelains.* Philadephia: the author and Pennsylvania Museum and School of Industrial Art, 1893.

—————. *The Pottery and Porcelain of the United States: An Historical Review of American Ceramic Art from the Earliest Time to the Present Day.* New York: G.P. Putnam's Sons, 1893; 2nd ed., 1901; 3rd ed., 1909.

Barnard, Julian. *Victorian Ceramic Tiles.* Greenwich, Conn.: New York Graphic Society, 1972.

Benjamin, Marcus. *American Art Pottery.* Washington, D.C.: privately published, 1907.

Binns, Charles F. *Ceramic Technology.* London: Scott, Greenwood & Co., 1897.

Bruhn, Thomas P. *American Decorative Tiles, 1870-1930.* Storrs, Conn.: William Benton Museum of Art, University of Connecticut, 1979.

Burke, Doreen Bolger, et al. *In Pursuit of Beauty: Americans and the Aesthetic Movement.* New York: Metropolitan Museum of Art, 1986.

Callen, Anthea. *Women Artists of the Arts and Crafts Movement, 1870–1914.* New York: Pantheon Books, 1979.

Clark, Edna Maria. *Ohio Art and Artists.* Richmond, Va.: Garrett & Massie, 1932.

Clark, Garth, ed. *Transactions of the Ceramics Symposium: 1979.* Los Angeles, Calif.: Institute for Ceramic History, 1980.

—————, and Margie Hughto. *A Century of Ceramics in the United States 1878–1978: A Study of Its Development.* New York: E.P. Dutton, in association with the Everson Museum of Art, 1979.

Clark, Robert Judson, ed. *The Arts and Crafts Movement in America, 1876–1916.* Princeton, N.J.: Princeton University Press, 1972.

Clement, Arthur W. *Our Pioneer Potters.* New York: privately published, 1947.

Dale, Sharon. *Frederick Hurten Rhead: An English Potter in America.* Erie, Pa. Erie Art Museum, 1986.

Dietz, Ulysses G. *The Newark Museum Collection of American Art Pottery.* Newark, N.J.: Newark Museum, 1984.

Eidelberg, Martin, ed. *From our Native Clay: Art Pottery from the Collections of The American Ceramic Arts Society.* New York: Turn of the Century Editions, 1987.

Evans, Paul F. *Art Pottery of the United States: An Encyclopedia of Producers and Their Marks.* New York: Charles Scribner's Sons, 1974.

Forms From the Earth: 1,000 Years of Pottery in America. New York: Museum of Contemporary Crafts [1962].

Gilchrist, Brenda, ed. *Pottery: Compiled for the Cooper-Hewitt Museum.* Smithsonian Illustrated Library of Antiques. New York: Cooper-Hewitt Museum, 1981.

Henzke, Lucile. *American Art Pottery.* Camden, N.J.: Thomas Nelson, 1970.

Johnson, Diane Chalmers. *American Art Nouveau.* New York: Harry N. Abrams, 1979.

Kaplan, Wendy. *"The Art That is Life": The Arts and Crafts Movement in America, 1875–1920.* Boston: Museum of Fine Arts, 1987.

Keen, Kirsten Hoving. *American Art Pottery, 1875–1930.* Wilmington, Del.: Delaware Art Museum, 1978.

Kovel, Ralph, and Kovel, Terry. *The Kovels' Collector's Guide to American Art Pottery.* New York: Crown Publishers, 1974.

Ludwig, Coy L. *The Arts and Crafts Movement in New York State, 1890s–1920s.* Hamilton, N.Y.: Gallery Association of New York State, 1983.

McLaughlin, M. Louise. *China Painting. A Practical Manual for the Use of Amateurs in the Decoration of Hard Porcelain.* Cincinnati: Robert Clarke and Co., 1877.

—————. *Pottery Decoration Under the Glaze.* Cincinnati: Robert Clarke and Co., 1877.

Maryland Collects: American Art Pottery, 1882–1946. Baltimore, Md.: Baltimore Museum of Art, 1985.

Nichols, George Ward. *Art Education Applied to Industry.* New York: Harper and Brothers, 1877.

—————. *Pottery: How It Is Made, Its Shape and Decoration.* New York: G.P. Putnam's Sons, 1878.

The Quest for Unity: American Art Between World's Fairs, 1876–1893. Detroit: Detroit Institute of Arts, 1983.

Ries, Heinrich, and Leighton, Henry. *History of the Clay-Working Industry in the United States.* New York: John Wiley & Sons, 1909.

Schwartzman, Paulette. *A Collector's Guide to European and American Art Pottery with Current Values.* Paducah, Ky.: Collectors Books, 1978.

Stiles, Helen E. *Pottery in the United States.* New York: E.P. Dutton & Co., 1941.

Tracy, Berry B. *Nineteenth-Century America: Furniture and Other Decorative Arts.* New York: Metropolitan Museum of Art, 1970.

Watkins, Lura Woodside. *Early New England Potters and Their Wares.* Cambridge Mass.: Harvard University Press, 1950.

Weisberg, Gabriel P., et al. *Japonisme: Japanese Influence on French Art, 1854–1910.* Cleveland: Cleveland Museum of Art, 1975.

Periodicals

Amerikanische Töpferwaren." *Dekorative Kunst* 11 (1903): 228–32.

"An Arts and Crafts Exhibition." *Craftsman* 2 (April 1902): 48–51.

Anderson, Alexandra. "American Art Pottery." *Portfolio* 2 (Feb./March 1980): 94–97.

"Annual Convention of the United States Potters' Association." *Crockery and Glass Journal* 60 (December 1905).

Barber, Edwin AtLee. "The Rise of the Pottery Industry. The Development of American Industries since Columbus. X." *Popular Science Monthly* 40 (December 1891): 145–70.

———. "Recent Advances in the Pottery Industry. The Development of American Industries since Columbus. XI." *Popular Science Monthly* 40 (January 1892): 289–322.

———. "Recent Progress of American Potters." *Clay-Worker* 23 (May 1895): 580–81.

"The Beauty of the Modern Tile and Its Place in Architecture." *Craftsman* 25 (February 1914): 491–93.

Benjamin, Marcus. "American Art Pottery." *Glass and Pottery World* 15 (February 1907): 28–31; (March 1907): 13–18; (April 1907): 35–40; (May 1907): 35–39.

———. "American Pottery at the Jamestown Exposition." *Glass and Pottery World* 15 (October 1907): 23–24.

Binns, Charles F. "Building in Clay." *Craftsman* 4 (July 1903): 303–5.

———. "Clay in the Potter's Hand." *Craftsman* 6 (May 1904): 162–68.

———. "The Craft of the Potter." *Craftsman* 9 (October 1905/March 1906): 854–56.

———. "Education in Clay." *Craftsman* 4 (June 1903): 160–68.

———. "In Defence [sic] of Fire." *Craftsman* 3 (March 1903): 369–72.

———. "The Possibilities of Clay." *International Studio* 32 (August 1907): lxvi–lxxii.

———. "Pottery in America." *American Magazine of Art* 7 (February 1916): 131–38.

Blasberg, Robert W., and Volpe, Todd M. "American Art Pottery." *Nineteenth Century* 5 (Summer 1979): 62–69.

Bowdoin, W.G. "Some American Pottery Forms." *Art Interchange* 50 (April 1903): 87–90.

"Ceramics at the National Society of Craftsmen Exhibition." *Keramic Studio* 10 (February 1909): 222.

"A Class in Design—Mr. Arthur Dow, Instructor." *Keramic Studio* 3 (August 1901): 75–80.

Cox, Paul E. "Frederick Hurten Rhead." *American Ceramic Society Bulletin* 23 (February 1944): 64–65.

Crowley, Lilian H. "It's Now the Potter's Turn." *International Studio* 75 (September 1922): 539–46.

"Decorative Tile-Making: A Modern Craft and Its Ancient Origin." *Craftsman* 25 (March 1914): 613–15.

DeKay, Charles. "The Arts and Crafts in America. I. Pottery as a Fine Art." *Putnam's Magazine* 1 (January 1907): 397–406.

Dietz, Ulysses G. "Art Pottery at the Newark Museum before World War I." *Antiques* 125 (April 1984): 874–79.

Di Noto, Andrea. "A Certain Shade of Green: The Happy Collaboration Between Two Collectors and an Art Dealer." *Connoisseur* 215 (August 1985): 50–57.

Edson, Maria Burr. "Exhibition of Ceramics." *Arts and Decoration* 1 (April 1911): 260–61.

Eidelberg, Martin. "American Ceramics and International Styles, 1876–1916." *Record of the Art Museum, Princeton University* 34, no. 2, (1975): 13–19.

Evans, Paul F. "The Art Pottery Era in the United States, 1870 to 1920." *Spinning Wheel* 26 (October 1970): 52–53, 56; (November 1970): 52–53.

———. "Art Tiles of the New York Subway, 1904." *Spinning Wheel* 35 (November 1979): 8–12.

Fry, Marshal, Jr. "Notes from the Paris Exposition." *Keramic Studio* 2 (September 1900): 98–99.

Fryatt, F. E. "Pottery in the United States," *Harper's New Monthly Magazine* 62 (February 1881): 357–69.

Geijsbeek, S. "The Ceramics of the Louisiana Purchase Exposition." *American Ceramic Society Transactions* 7 (1905): 289–355.

Gray, Walter Ellsworth. "Latter-Day Developments in American Pottery." *Brush and Pencil* 9 (January 1902): 236–43; (February 1902): 289–96; (March 1902): 353–60; (April 1902): 31–38.

Johnson, Henry Lewis. "Exhibition of the Society of Arts and Crafts, Boston, Massachusetts." *Brush and Pencil* 4 (June 1899): 165–73.

Keen, Kirsten H. "American Art Pottery, 1875–1930." *American Art Review* 4 (May 1978): 100–103, 123–25.

Lancaster, Clay. "Taste at the Philadelphia Centennial." *Magazine of Art* 43 (December 1950): 293–97, 308.

Le Boutellier, Addison B. "American Pottery," *Good Housekeeping* 38 (March 1904): 242–48.

Little, Flora Townsend. "A Short Sketch of American Pottery." *Art and Archaeology* 15 (May 1923): 219–27.

Loring, John. "American Art Pottery." *Connoisseur* 200 (April 1979): 279–85.

"Louisiana Purchase Exposition Ceramics." *Keramic Studio* 6 (February 1905): 216–19; (March 1905): 251–52; (April 1905): 268–69; 7 (May 1905): 7–8.

Lovett, Eva. "The Exhibition of the National Society of Craftsmen." *International Studio* 30 (January 1907): lxx–lxxv.

Mason, Maude M. "Exhibition of the New York Society of Keramic Arts." *Keramic Studio* 12 (May 1911): 8–12.

Millet, Frank D. "Some American Tiles," *Century Magazine* 23 (April 1882): 896–904.

Morrell, Dora M. "The Arts and Crafts—Beauty in Common Things." *Brush and Pencil* 5 (February 1900): 222–32.

"National Arts Club." *Keramic Studio* 1 (February 1900): 212–13.

Nelson, Marion John. "Art Nouveau in American Ceramics." *Art Quarterly* 26, no.4, (1963): 441–60.

———. "Indigenous Characteristics in American Art Pottery." *Antiques* 89 (June 1966): 846–50.

"The Ornamentation of the New York Subway Stations in New York." *House and Garden* 5 (February 1904): 96–99; (June 1904): 287–92.

"The Potters of America: Examples of the Best Craftsmen's Work for Interior Decorations: Number One." *Craftsman* 27 (December 1914): 295–303.

Pottery at the Arts and Crafts Exhibit, Craftsman Building, Syracuse. *Keramic Studio* 5 (June 1903): 36–38.

Preston, Thomas B. "Potters and Their Craft." *Chautauguan* 14 (November 1891): 171–75.

Purdy, Ross C. "Why American Pottery is Not the Vogue in America." *Ceramic Age* 18 (October 1931): 220–22.

Ruge, Clara. "American Ceramics—A Brief Review of Progress." *International Studio* 28 (March 1906): xxi–xxviii.

———. "Amerikanische Kunstausstellungen der Saison 1908 bis 1909." *Kunst und Kunsthandwerk* 12 (1909): 562–82.

———. "Development of American Ceramics: American Materials Fashioned by American Artists and Artisans are Taking Their Place Beside the World's Best Potteries." *Pottery and Glass* 1 (August 1908): 2–8.

———. "Das Kunstgewerbe Amerikas." *Kunst und Kunsthandwerk* 5 (March 1902): 126–48.

———. "Die New-Yorker Kunstausstellungen der Saison 1904–1905." *Kunst und Kunsthandwerk* 8 (1905): 455–77.

Sargent, Irene. "Potters and Their Products." *Craftsman* 4 (June 1903): 149–60.

Siegfried, Joan. "American Women in Art Pottery." *Nineteenth Century* 9 (Spring 1984): 12–18.

Smith, Katherine Louise. "An Arts and Crafts Exhibition at Minneapolis." *Craftsman* 3 (March 1903): 373–77.

————. "Ornamental Tiles." *House Beautiful* 7 (May 1900): 347–52.

Spector, Stephen. "American Art Pottery Revived." *Architectural Digest* 33 (July/August 1976): 68–71, 132–33.

Stuart, Evelyn Marie. "Pottery Art at the Panama-Pacific Exposition." *Fine Arts Journal* 32 (January 1915): 32–36.

Townsend, Everett. "Development of the Tile Industry in the United States." *American Ceramic Society Bulletin* 22 (May 15, 1943): 126–52.

Twose, George M. R. "The Chicago Arts and Crafts Society's Exhibition." *Brush and Pencil* 2 (May 1898): 74–79.

Volkmar, Charles. "Hints on Underglaze." *Keramic Studio* 1 (May 1899): 5.

Wentworth, Ann. "The Use of Tiles in Simple Houses." *House Beautiful* 28 (October 1910): 151–53.

Whiting, Frederic Allen. "The Arts and Crafts at the Louisiana Purchase Exposition." *International Studio* 23 (October 1904): ccclxxxiv–ccclxxxix.

Williams, Michael. "Arts and Crafts at the Panama-Pacific Exposition." *Art and Progress* 6 (August 1915): 375–77.

Wynne, Madeline Yale. "What to Give." *House Beautiful* 2 (1901): 22–26.

American Encaustic Tiling Company

Purviance, Evan, and Purviance, Louise. *Zanesville Art Tile in Color.* Des Moines, Iowa: Wallace-Homestead Book Co., 1972.

Taft, Lisa Factor. *Herman Carl Mueller: Architectural Ceramics and the Arts and Crafts Movement.* Trenton, N.J.: New Jersey State Museum, 1979.

Wires, E. Stanley; Schneider, Norris F.; and Mesre, Moses. *Zanesville Decorative Tiles.* Zanesville, Ohio: published by authors, 1972.

California Faience

Andersen, Timothy J.; Moore, Eudorah M.; and Winter, Robert W. *California Design, 1910.* Pasadena, Calif.: California Design Publications, 1974.

Bray, Hazel V. *The Potter's Art in California, 1885–1955.* Oakland, Calif.: Oakland Museum, 1980.

Dietrich, Waldemar F. *The Clay Resources and the Ceramic Industry of California.* Sacramento, Calif.: California State Mining Bureau, 1928. Bulletin 99.

Evans, Paul F. "California Faience." In *Art Pottery of the United States.* New York: Charles Scribner's Sons, 1974.

Chelsea Keramic Art Works, Dedham Pottery

Dale, Nathan Haskell. "The Best American Pottery." *House Beautiful* 2 (September 1897): 87–94.

"Dedham Pottery Distinctively Different." *Glass and Pottery World* 16 (October 1908): 15–16.

Dedham Pottery. Boston, Mass.: Merry Mount Press, 1896.

Foster, Edith Dunham. "Dedham Pottery." *House Beautiful* 36 (August 1914): xii.

————. "William A. Robertson, Master Potter." *International Studio* 51 (November 1913): xcv–xcvi.

Hawes, Lloyd E. *Dedham Pottery and the Earlier Robertson's Chelsea Pottery.* Dedham, Mass.: Dedham Historical Society, 1968.

————. "Hugh Cornwall Robertson and the Chelsea Period." *Antiques* 89 (March 1966): 409–13.

"Hugh C. Robertson." *Glass and Pottery World* 16 (November 1908): 16.

Reynolds, S. Adelaide. "Concerning the Dedham Plates." *House Beautiful* 18 (November 1905): 25.

Robertson, J. Milton. "The Background of Dedham Pottery." *American Ceramic Society Bulletin* 20 (November 1941): 411–13.

Swan, Mabel M. "The Dedham Pottery." *Antiques* 10 (August 1926).

Fulper Pottery Company

"Art Pottery Put to Practical Use." *Pottery and Glass* 6 (April 1911): 16–18.

Blasberg, Robert W. "Twenty Years of Fulper." *Spinning Wheel* 29 (October 1973): 14–18.

Blasberg, Robert W., with Carol L. Bohdan. *Fulper Art Pottery: An Aesthetic Appreciation, 1909–1929.* New York: Jordan-Volpe Gallery, 1979.

"Making Pottery at the Fulper Vase Kraft Shop." *Pottery and Glass* 9 (December 1912): 41–42.

"The Oldest Pottery in America." *Art World* 3 (December 1917): 252–54.

Stuart, Evelyn Marie. "Vasekraft—An American Art Pottery." *Fine Arts Journal* 29 (October 1913): 607–16.

Volpe, Todd M., and Blasberg, Robert W. "Fulper Art Pottery: Amazing Glazes." *American Art and Antiques* 1 (July / August 1978): 76–83.

Gates Potteries, Teco Ware

Crosby, Charles. "The Work of American Potters. Article Four—How Teco Came to Be." *Arts and Decoration* 1 (March 1911).

Darling, Sharon S. *Chicago Ceramics and Glass: An Illustrated History from 1871 to 1933.* Chicago: Chicago Historical Society / University of Chicago Press, 1979.

————. *Decorative and Architectural Arts in Chicago, 1871–1933: An Illustrated Guide to the Ceramics and Glass Exhibition.* Chicago: University of Chicago Press, 1980.

————. *Decorative and Architectural Arts in Chicago 1871–1933: An Illustrated Guide to the Ceramics and Glass Exhibition.* Chicago: University of Chicago Press, 1982.

Edgar, William Harold. "Another American Pottery: Where Artists are in Close Communion with Nature and Mechanical Facilities are Extraordinary." *Pottery and Glass* 1 (December 1908): 14–16.

————. "The Teco Pottery." *International Studio* 36 (November 1908): xxviii–xxix.

Frackelton, Susan Stuart. "Our American Potteries: "Teco Ware." *Sketch Book* 5 (September 1905): 13–19.

Gates, William D. "The Revival of the Potter's Art." *Clay-Worker* 28 (October 1897): 275–276.

Mitchell, Elmer C. "The Art Industries of America—II. The Making of Pottery." *Brush and Pencil* 15 (April 1905): 67–76.

"The Potter's Art: Teco Ware." *Fine Arts Journal* 14 (January 1902): 8–11.

Stradling, Diana. "Teco Pottery and the Green Phenomenon." *Tiller* 1 (March–April 1983): 9–36.

Stuart, Evelyn Marie. "About Teco Art Pottery." *Fine Arts Journal* 25 (August 1911): 338, 340–45.

————. "Teco Pottery and Faience Tile." *Fine Arts Journal* 25 (August 1911): 98–111.

Grueby Faience Company

Belknap, Henry W. "Another American Pottery: Grueby Ware With Its Single Low Toned Colors and Conventional Designs Is Among the Best Art Pottery." *Pottery and Glass* 1 (November 1908): 12–14.

Blackall, C. H. "The Grueby Faience." *Brickbuilder* 7 (August 1898): 162–63.

Blasberg, Robert W. *The Ceramics of William H. Grueby: Catalog of an Exhibition at the Everson Museum of Art.* Syracuse, N.Y.: Everson Museum of Art, 1981.

————. "Grueby Art Pottery." *Antiques* 100 (August 1971): 246–49.

————. "The Grueby Sensation." *Connoisseur* 207 (June 1981): 152–54.

"Boston's Art Product—Grueby Ware." *Crockery and Glass Journal* 54 (December 12, 1901): [131–32, 135].

Bowdoin, W. G. "The Grueby Pottery." *Art Interchange* 45 (December 1900): 136–37.

Dudley, Pendleton. "The Work of American Potters. Article One.—Examples of the Work of the Grueby Pottery." *Arts and Decoration* 1 (November 1910): 20–21.

Eidelberg, Martin. "The Ceramic Art of William H. Grueby." *Connoisseur* 184 (September 1973): 47–54.

"Good Green Ware Gave Fame to Grueby Name." *Glass and Pottery World* 16 (June 1908): 13–14.

Gray, Walter Ellsworth. "Latter-Day Developments in American Pottery." *Brush and Pencil* 9 (January 1902): 236–43.

"Grueby Ceramics." *Ceramics Monthly* 30 (January 1982): 55–57.

"Grueby Faience." *Artist* 23 (December 1898): xxxix–xL.

"The Interesting Tile Work of 'Dreamwold.'" *Brickbuilder* 11 (October 1902): 205–9.

Jones, Annie M. "The Grueby Pottery." *Scrip* 1 (March 1906): 197–99.

Le Boutillier, Addison B. "Modern Tiles." *Architectural Review* (September 13, 1906): 117–21.

"Notes on the Crafts." *International Studio* 24 (February 1905): xci–xcvii.

Perry, Mary Chase. "Grueby Potteries." *Keramic Studio* 2 (April 1901): 250–52.

Russell, Arthur. "Grueby Pottery." *House Beautiful* 5 (December 1898): 3–9.

Saunier, Charles. "Poteries de la Cie Grueby (Boston)." *L'Art Décoratifs* 3 (August 1901): 205–6, 208.

Thompson, Neville. "Addison B. Le Boutillier: Developer of Grueby Tiles." *Tiller* 1 (November–December 1982): 21–30.

Walker, C. Howard. "The Grueby Pottery." *Keramic Studio* 1 (March 1900): 237.

M. Louise McLaughlin (Losanti Ware)

"In the Studios." *Keramic Studio* 1 (May 1899): 19.

Levin, Elaine. "Mary Louise McLaughlin and the Cincinnati Art Pottery Movement." *American Craft* 42 (December 1982): 28–31; (January 1983): 82–83.

McLaughlin, Louise. "Losanti Ware." *Keramic Studio* 3 (December 1901): 178–79.

McLaughlin, Louise M. [sic]. "Losanti Ware." *Craftsman* 3 (December 1902): 186–87.

"Mary Louise McLaughlin." *American Ceramic Society Bulletin* 17 (May 1938): 217–25.

Monachesi, [Nicola di Rienzi]. "Miss M. Louise McLaughlin and Her New 'Losanti' Ware." *Art Interchange* 48 (January 1902): 11.

Sargent, Irene. "Some Potters and Their Products." *Craftsman* 4 (August 1903): 328–37.

Warren, Franklin. "Decorated Porcelain." *Arts and Decoration* 1 (August 1911): 415.

Marblehead Pottery

Baggs, Arthur E. "The Story of a Potter." *Handicrafter* 1 (April / May 1929): 8–10.

Emerson, Gertrude. "Marblehead Pottery." *Craftsman* 29 (March 1916): 671–73.

Hall, Herbert J. "Marblehead Pottery." *Keramic Studio* 10 (June 1908): 30–31.

MacSwiggan, Amelia E. "The Marblehead Pottery." *Spinning Wheel* 28 (March 1972): 20–21.

"Marblehead Pottery." *Glass and Pottery World* 16 (July 1908): 20–21.

Marblehead Pottery. Marblehead, Mass.: Marblehead Potteries, 1919.

"Modern Maiolica." *Handicraft* 5 (June 1912): 42–43.

"The Pottery at Marblehead. The Exquisite Work Produced on the Massachusetts Coast." *Arts and Decoration* 1 (September 1911): 448–49.

Russell, Elizabeth. "The Pottery of Marblehead." *House Beautiful* 59 (March 1926): 362, 364, 366.

Middle Lane Pottery (Theophilus A. Brouwer)

Crane, Anne Winslow. "The Middle Lane Pottery." *Art Interchange* 45 (August 1900): 32–33.

Evans, Paul. "Brouwer's Middle Lane Pottery." *Spinning Wheel* 29 (December 1973): 48–49, 54.

"National Arts Club." *Keramic Studio* 1 (February 1900): 212–13.

Rhead, Frederick H. "Theophilus A. Brouwer, Jr., Maker of Iridescent Glazed Faience." *Potter* 1 (January 1917): 43–49.

Newcomb College Pottery

"The Art-Craft Movement in a College Art Department." *House Beautiful* 15 (March 1904): 204–7.

Baker, Mary F. "The Newcomb Art School and Its Achievements." *Sketch Book* 4 (June 1905): 264–65.

Blasberg, Robert W. "Newcomb Pottery." *Antiques* 94 (July 1968): 73–77.

———. "The Sadie Irvine Letters: A Further Note on the Production of Newcomb Pottery." *Antiques* 100 (August 1971): 250–51.

Cox, Paul E. "Mary G. Sheerer, An Appreciation." *Ceramic Age* 65 (January 1955): 52.

———. "Newcomb Pottery Active in New Orleans." *American Ceramic Society Bulletin* 13 (May 1934): 140–42.

———. "Technical Practice at the Newcomb Pottery." *American Ceramic Society Journal* 1 (August 1918): 521–28.

"Ellsworth Woodward." *American Ceramic Society Bulletin* 18 (May 1939) 179–80.

Evans, Paul. "Newcomb Pottery Decorators." *Spinning Wheel* 30 (April 1974): 54–55.

Frackelton, Susan Stuart. "Our American Potteries—Newcomb College." *Sketch Book* 5 (July 1906): 430–33.

Hutson, Ethel. "Newcomb Pottery. A Successful Experiment in Applied Art." *Clay-Worker* 45 (May 1906): 732–34.

Joor, Harriet. "The Art Industries of Newcomb College." *International Studio* 41 (July 1910): 4, 6, 8, 10, 12, 14, 36, 38.

"Newcomb Pottery." *Brush and Pencil* 6 (April 1900): 15–17.

"Newcomb Pottery." *Keramic Studio* 3 (February 1902): 214–15.

"Newcomb Pottery of Old New Orleans." *Glass and Pottery World* 16 (September 1908): 13–14.

Ormond, Suzanne, and Irvine, Mary E. *Louisiana's Art Nouveau: The Crafts of the Newcomb Style.* Gretna, La.: Pelican Publishing, 1976.

Poesch, Jessie. *Newcomb Pottery: An Enterprise for Southern Women, 1895–1940.* Exton, Pa.: Schiffer Publishing, 1984.

Robinson, Ednah. "Newcomb Pottery: Its Makers and the Lesson They Are Teaching Southern Women." *Sunset Magazine* 11 (June 1903): 131–35.

Sargent, Irene. "An Art Industry of the Bayous: The Pottery of Newcomb College." *Craftsman* 5 (October 1903): 70–76.

Sheerer, Mary G. "The Development of Decorative Processes at Newcomb." *American Ceramic Society Journal* 7 (August 1924): 645–49.

———. "History of Newcomb Pottery." *American Ceramic Society Journal* 1 (August 1918): 518–21.

———. "Newcomb Pottery." *Keramic Studio* 1 (November 1899): 151–52.

Silva, William P. "Newcomb Pottery." *Art and Progress* 2 (June 1911): 230–33.

Smith, Kenneth E. "The Origin, Development, and Present Status of Newcomb Pottery." *American Ceramic Society Bulletin* 17 (June 1938): 257–60.

Two Decades of Newcomb Pottery: Pieces from the Period 1897 to 1917. New Orleans: Newcomb College Art Department, 1963.

Woodward, Ellsworth. "Newcomb Pottery." *Art Education* 7 (September 1900): 9–12.

Woodword, E. [sic.] "The Work of American Potters. Article 2: Newcomb Pottery Typical of the South." *Arts and Decoration* 1 (January 1911): 124–25.

George E. Ohr (Biloxi Art Pottery)

Anderson, Alexandra. "George Ohr's 'Mud Babies.'" *Art in America* 67 (January–February 1979): 60–61, 63.

Bensel, L. M. "Biloxi Pottery." *Art Interchange* 46 (January 1901): 8–9.

"Biloxi Pottery from an Artistic Standpoint." *China, Glass and Pottery Review* 4 (June 1899).

Blasberg, Robert W. *George E. Ohr and His Biloxi Art Pottery.* Port Jervis, N.Y.: J.W. Carpenter, 1973.

———. *The Unknown Ohr. A Sequel to the 1973 Monograph.* Millford, Pa.: Peaceable Press, 1986.

Carpenter, J. W. "Geo. Ohr's 'Pot-Ohr-E.'" *Antique Trader Weekly* (September 19, 1972): 42–43.

Clark, Garth. *The Biloxi Art Pottery of George Ohr.* [Jackson, Miss.]: Mississippi Department of Archives and History and the Mississippi State Historical Museum, 1978.

———. "George E. Ohr." *Antiques* 128 (September 1985): 490–97.

———. "George Ohr: Clay Prophet." *Craft Horizons* 38 (October 1978): 44–49, 65.

"Concerning the Biloxi Potteries." *China, Glass and Pottery Review* 4 (April 1899).

Cox, Paul E. "Potteries of the Gulf Coast: An Individualistic Ceramic Art District." *Ceramic Age* 25 (April 1935): 116–19, 40.

Hutson, Ethel. "Quaint Biloxi Pottery." *Clay-Worker* 44 (September 1905): 225–27.

King, William A. "Ceramic Art at the Pan-American Exhibition." *Crockery and Glass Journal* 53 (May 30, 1901).

Ohr, George E. "Some Facts in the History of a Unique Personality." *Crockery and Glass Journal* 54 (December 12, 1901): [123–25].

Shuman, Susan W., and Shuman, John A., III. "George E. Ohr: Eccentric and Genius." *Antiques Journal* 32 (June 1977): 12–14, 47.

Smith, Dolores. "Echoes from the Past: George Ohr's Pottery." *Popular Ceramics* 17 (September 1965): 8–11.

Wallach, Amei. "The Flamboyant Pottery of George E. Ohr." *Antiques World* 1 (November 1978): 64–70.

Overbeck Pottery

Artists in Indiana Then and Now: The Overbeck Potters of Cambridge City. 1911–1955. Muncie, Ind., Ball State University, 1975.

Cox, Paul E. "American Ceramics for Interior Decorating." *American Ceramic Society Bulletin* 4 (September 1925): 418–23.

Crowley, Lilian H. "It's Now the Potter's Turn." *International Studio* 75 (September 1922).

"The Overbeck Pottery." *American Ceramic Society Bulletin* 23 (May 15, 1944): 156–58.

Postle, Kathleen R. *The Chronicle of the Overbeck Pottery.* Indianapolis, Ind.: Indiana Historial Society, 1978.

———. "Overbeck Pottery." *Spinning Wheel* 28 (May 1972): 10–12.

Paul Revere Pottery

Blasberg, Robert W. "Paul Revere Pottery." *Western Collector* 7 (January 1969): 13–16.

Edson, Mira B. "Paul Revere Pottery of Boston Town." *Arts and Decoration* 1 (October 1911): 494–95.

Northend, Mary H. "Paul Revere Pottery." *House Beautiful* 36 (August 1914): 82–83.

"The Paul Revere Pottery: An American Craft Industry." *House Beautiful* 51 (January 1922): 50, 70.

Pendleton, Margaret. "Paul Revere Pottery." *House Beautiful* 32 (January 1912): 74.

Pochman, Ruth Fouts. "The Paul Revere Pottery, 1912–1942." *Spinning Wheel* 19 (November 1963): 24–25.

"A Social and Business Experiment in the Making of Pottery." *Handicraft* 3 (February 1911): 411–16.

"The Story of Paul Revere Pottery." *Craftsman* 25 (November 1913): 205–7.

Wright, Livingston. "Girls' Club Establishes Pottery and Ultimately Makes It a Financial Success." *Art World* 2 (September 1917): 578–79.

Pewabic Pottery

Bleicher, Fred; Hu, William C.; and Uren, Marjorie E. *Pewabic Pottery: An Official History.* Ann Arbor, Mich.: Ars Ceramica, 1977.

Brunk, Thomas. "Pewabic Pottery." In *Arts and Crafts in Detroit, 1906–1976, The Movement, The Society, The School.* Detroit: Detroit Institute of Arts, 1976.

———. *Pewabic Pottery: Marks and Labels.* Detroit: Historic Indian Village Press, 1978.

Garwood, Dorothy. "Mary Chase Stratton." *Ceramic Monthly* 31 (September 1983): 29–33.

Hegarty, Marjorie. "Pewabic Pottery." *Detroit Institute of Arts Bulletin* 26, no. 3 (1947): 69–70.

Highlights of Pewabic Pottery. Ann Arbor, Mich.: Ars Ceramica / Michigan State University, 1977.

Holden, Marion L. "The Pewabic Pottery." *American Magazine of Art* 17 (January 1926): 22–27.

Lacey, Betty. "Pewabic Pottery in Detroit." *National Antiques Review* 2 (March 1971): 22–23.

"Michigan State University Revives Pewabic Pottery." *Impresario* 7 (February–March 1968): 16–17, 55–56.

Pear, Lillian Myers. "Pewabic Pottery." *Spinning Wheel* 31 (October 1975): 11–14.

———. *The Pewabic Pottery: A History of Its Products and Its People.* Des Moines, Iowa: Wallace-Homestead, Book Co., 1976.

Pearce, Clark. "Mary Chase Perry Stratton and the Detroit Society of Arts and Crafts." *Tiller* 2 (November–December 1983): 11–29.

Plumb, Helen. "The Pewabic Pottery." *Art and Progress* 2 (January 1911): 63–67.

Stratton, Mary Chase. "Pewabic Records." *American Ceramic Society Bulletin* 25 (November 15, 1936): 363–65.

Adelaide Alsop Robineau

"Adelaide Alsop Robineau." *American Ceramic Society Bulletin* 8 (May 1929): 121–24.

"Adelaide Alsop Robineau, A Significant American." *Design* 37 (December 1935): 20–22, 41.

Atherton, Carlton. "Adelaide Alsop Robineau—Master Potter." *Ceramic Age* 19 (May 1932): 208–10, 234.

Binns, Charles F. "The Art of Fire." *Craftsman* 8 (May 1905): 205–10.

Blasberg, Robert W. "American Art Porcelain: The Work of Adelaide Alsop Robineau." *Spinning Wheel* 27 (April 1971): 40–43.

Breck, Joseph. *A Memorial Exhibition of Porcelain Stoneware by Adelaide Alsop Robineau, 1865–1929.* New York: Metropolitan Museum of Art, 1929.

Claney, Jane Perkins. "Edwin Atlee Barber and the Robineaus: Correspondence 1901–1916." *Tiller* 1 (November–December 1982): 31–54.

Eidelberg, Martin. "Some Robineau Porcelains." *Carnegie Magazine* 56 (September / October 1983): 21–24.

"Four Winds Pottery Summer School." *Keramic Studio* 14 (October 1912): 115–22.

High Fire Porcelains: Adelaide Alsop Robineau, Potter, Syracuse, New York. San Francisco, Calif.: Panama-Pacific International Exposition, 1915.

Hull, William. "Some Notes on Early Robineau Porcelains." *Everson Museum of Art Bulletin* 22, no. 2 (1960): [1–6].

Hunt, W. D. "Porcelains." *Keramic Studio* 9 (December 1907): 178–80.

Levine, Elaine. "Pioneers of Contemporary American Ceramics: Charles Binns, Adelaide Robineau." *Ceramic Monthly* 23 (November 1975): 22–27.

Morris, Alfred. "The Robineau Porcelains." *Sketch Book* 5 (January 1906): 228–33.

Olmstead, Anna W. "The Memorial Collection of Robineau Porcelains." *Design* 33 (December 1931): 153.

Rawson, Jonathan A., Jr. "Teco and Robineau Pottery." *House Beautiful* 33 (April 1913): 151–52.

Rhead, Frederick Hurten. "Adelaide Alsop Robineau, Maker of Porcelains." *Potter* 1 (February 1917): 81–88.

Robineau, Adelaide Alsop. "American Pottery, Artistic Porcelain-Making." *Art World* 3 (November 1917): 153–55.

————. *Porcelains from the Robineau Pottery.* New York: Tiffany & Co., [c.1906].

Robineau, Samuel E. "Adelaide Alsop Robineau." *Design* 30 (April 1929): 201–9.

————. "The Robineau Porcelains." *Keramic Studio* 13 (August 1911): 80–84.

Sargent, Irene. "An American Maker of Hard Porcelain—Adelaide Alsop Robineau." *Keystone* 27 (June 1906): 921–24.

————. "Clay in the Hands of the Potter." *Keystone* 57 (September 1929): 131–33, 135, 137, 139, 141.

Shrimpton, Louise. "An Art Potter and Her Home." *Good Housekeeping* 50 (January 1910): 57–63.

Weiss, Peg, ed. *Adelaide Alsop Robineau: Glory in Porcelain.* Syracuse, N.Y.: Syracuse University Press, in association with the Everson Museum of Art, 1981.

Wise, Ethel Brand. "Adelaide Alsop Robineau— American Ceramist." *American Magazine of Art* 20 (December 1929): 687–91.

Rookwood Pottery

"Art Gossip." *Art Interchange* 8 (May 25, 1882): 123.

Barber, Edwin AtLee. "Cincinnati Women Art Workers." *Art Interchange* 36 (February 1896): 29–30.

Bopp, H.F. "Art and Science in the Development of Rookwood Pottery." *American Ceramic Society Bulletin* 15 (December 1936): 443–45.

Boulden, Jane Long. "Rookwood." *Art Interchange* 46 (June 1901): 129–31.

Burt, Stanley Gano. *Mr. S.G. Burt's Record Book of Ware at Art Museum (2,292 Pieces of Early Rookwood in the Cincinnati Art Museum in 1916).* Reprint. Cincinnati: Cincinnati Historical Society, 1978.

————. "The Rookwood Pottery Company." *American Ceramic Society Journal* 6 (January 1923): 232–34.

"Cincinnati Art Pottery." *Harper's Weekly* 24 (May 29, 1880): 341–42.

"The Cincinnati Pottery Club." *Crockery and Glass Journal* (January 29, 1880): 14; (May 31, 1880): 28.

"Cincinnati's Greatest Art Enterprise." *Clay-Worker* 81 (January 1924): 24–26.

"Clara Chipman Newton, Pioneer Secretary, Rookwood Pottery Company." *American Ceramic Society Bulletin* 18 (November 1939): 443–45.

Cox, Paul E. "Two Human Interest Stories of a Ceramic Pioneer." *Ceramic Age* 48 (November 1946): 213–14.

Cummins, Virginia Raymond. *Rookwood Pottery Potpourri.* Silver Springs, Md.: Cliff R. Leonard and Duke Coleman, 1980.

Davis, Chester. "The Latter Years of Rookwood Pottery, 1920–1967." *Spinning Wheel* 25 (October 1969): 10–12.

Elzner, A. D. "Rookwood Pottery." *Architectural Record* 17 (April 1905): 294–304.

Evans, Paul F. "Cincinnati Faience: An Overall Perspective." *Spinning Wheel* 28 (September 1972): 16–18.

Fitzpatrick, Paul J. "Maria L. Nichols and the Rookwood Pottery." *Antiques Journal* 35 (October 1980): 24–29, 50–51.

Frackelton, Susan Stuart. "Rookwood Pottery." *Sketch Book* 5 (February 1906): 272–77.

Freeman, Helen. "The Rookwood Pottery in Cincinnati, Ohio." *House Beautiful* 47 (June 1920): 499–501, 530.

Hall, Alice C. "Cincinnati Faience." *Potter's American Monthly* 15 (November 1880): 357–65.

Hasselle, Bob. "Rookwood: An American Art Pottery." *Ceramics Monthly* 26 (June 1978): 27–37.

Haswell, Ernest Bruce. "American Pottery: A Recent Development of Faience in the Middle West." *Art World* 3 (October 1917): 78–80.

"Have You No Rookwood?" *Ceramic Monthly* 2 (January 1896): 4–5.

Hawley, Henry. "Two Rookwood Vases." *Bulletin of the Cleveland Museum of Art* 72 (November 1985): 378–387.

Haywood, Maude. "Founded by a Woman." *Ladies Home Journal* 9 (October 1892): 3.

"An Historical Collection of the Rookwood Pottery." *Keramic Studio* 8 (April 1907): 274.

Hungerford, Nicholas. "The Work of American Potters. III.—The Story of Rookwood." *Arts and Decoration* 1 (February 1911): 160–62.

"Karl Langenbeck." *American Ceramic Society Bulletin* 17 (October 1938): 429–30.

Keen, Kirsten H. "Rookwood Pottery at the Turn of the Century: Continuity and Change." In *Celebrate Cincinnati Art: In Honor of the One Hundredth Anniversary of the Cincinnati Art Museum.* Cincinnati: Cincinnati Art Museum, 1982, pp. 71–89.

Kingsley, Rose G. "Rookwood Pottery." *Art Journal* 33 (London) (November 1897): 341–46.

Kircher, Edwin J. *Rookwood Pottery: An Explanation of Its Marks and Symbols.* [Terrace Park, Ohio]: published by author, 1962.

————; Kircher, Barbara; and Agranoff, Joseph. *Rookwood: Its Golden Era of Art Pottery, 1880–1929.* Cincinnati: published by authors, 1969.

Koch, Robert. "Rookwood Pottery." *Antiques* 77 (March 1960): 288–89.

Long, Deborah D.; Macht, Carol; and Trapp, Kenneth R. *The Ladies, God Bless 'Em: The Women's Art Movement in Cincinnati in the Nineteenth Century.* Cincinnati: Cincinnati Art Museum, 1976.

McDonald, W.P. "Rookwood at the Pan-American." *Keramic Studio* 3 (November 1901): 146–47.

Macht, Carol M. "Rookwood Pottery." *Antiques Journal* 21 (February 1966): 16–18, 25.

Mendenhall, Lawrence. "Cincinnati's Contribution to American Ceramic Art." *Brush and Pencil* 17 (February 1906): 47–58, 61.

Necrology: Mrs. Bellamy Storer." *American Ceramic Society Bulletin* 11 (June 1932): 157–59.

Newton, Clara Chipman. "The Cincinnati Pottery Club." *American Ceramic Society Bulletin* 19 (September 1940).

Peck, Herbert. "The Amateur Antecedents of Rookwood Pottery." *Cincinnati Historical Society Bulletin* 26 (October 1968): 317–37.

————. *The Book of Rookwood Pottery.* New York: Crown Publishers, 1968.

————. "Rookwood Pottery and Foreign Museum Collections." *Connoisseur* 172 (September 1969): 43–49.

————. *The Second Book of Rookwood Pottery.* published by the author, 1985.

————. "Some Early Collections of Rookwood Pottery." *Auction* 3 (September 1969): 20–23.

Perry, Mrs. Aaron F. "Decorative Pottery of Cincinnati." *Harper's New Monthly Magazine* 62 (May 1881): 834–45.

"Rookwood at the Pan-American." *Keramic Studio* 3 (November 1901): 146–48.

"Rookwood, America's Foremost Art Pottery—A Trip Through the Great Plant." *Clay-Worker* 41 (January 1904): 25–29.

"Rookwood Architectural Faience." *Keramic Studio* 5 (September 1903): 110–11.

"Rookwood Pottery: A Woman's Contribution to American Craftsmanship." *Independent* 77 (March 16, 1914): 377.

Rookwood Pottery Company. *The Rookwood Book. Rookwood: An American Art.* Cincinnati: Rookwood Pottery, 1904.

————(promotional pamphlet). *Rookwood Pottery.* Cincinnati: Rookwood Pottery Co., [c. 1902].

————(promotional pamphlet). *Rookwood Pottery.* Cincinnati: Rookwood Pottery Co., [c. 1898].

"The Rookwood Pottery: 'Dux Foemina Facti.'" *Craftsman* 3 (January 1903): 247–48.

"Rookwood Pottery for Paris Exhibit." *Keramic Studio* 1 (March 1900): 221, 228, 231.

Rookwood Pottery Shape Record Book, 1880–c.1903. Rookwood Archives. Cincinnati Historical Society. Cincinnati, Ohio.

Sayre, Stuart. "A Rookwood Selling Campaign." *Glass and Pottery World* 15 (February 1907): 13–14.

Shephard, Martin T. "Modern Faience Tiles for the Fireplace: The Architectural and Pictorial Character of Some Recent Rookwood Products." *Arts and Decoration* 2 (August 1912): 367–68.

Shirley, Bernice Cook. "Rookwood Pottery." *American Antiques Journal* 3 (November 1948): 10–12.

Smith, Kenneth E. "Laura Anne Fry: Originator of Atomizing Process for Application of Underglaze Color." *American Ceramic Society Bulletin* 17 (September 1938): 368–72.

Storer, Maria Longworth. *History of the Cincinnati Musical Festivals and of the Rookwood Pottery.* Paris: published by author, 1919.

"Suit Against Rookwood Pottery." *Ceramic Monthly* 8 (January 1899): [9].

Tanenhaus, Ruth Amdur. "Rookwood: A Cincinnati Art Pottery." *Art and Antiques* 3 (July / August 1980): 74–81.

Taylor, William Watts. "The Rookwood Pottery." *Forensic Quarterly* 1 (September 1910): 203–18.

Trapp, Kenneth R. "Japanese Influence in Early Rookwood Pottery." *Antiques* 103 (January 1973): 193–97.

————. *Ode to Nature: Flowers and Landscapes of the Rookwood Pottery, 1880-1940.* New York: Jordan-Volpe Gallery, 1980.

————. "Rookwood and the Japanese Mania in Cincinnati." *Cincinnati Historical Society Bulletin* 39 (Spring 1981): 51–75.

————. "Rookwood's Printed-Ware." *Spinning Wheel* 29 (January / February 1973): 26–28.

————. "Toward a Correct Taste: Women and the Rise of the Design Reform Movement in Cincinnati, 1874-1880." In *Celebrate Cincinnati Art: In Honor of the Hundredth Anniversary of the Cincinnati Art Museum.* Cincinnati: Cincinnati Art Museum, 1982, pp. 48–70.

————. *Toward the Modern Style: Rookwood Pottery, The Later Years, 1915-1950.* New York: Jordan-Volpe Gallery, 1983.

Triggs, Oscar Lovell. *Chapters in the History of the Arts and Crafts Movement.* Chicago: Bohemia Guild of the Industrial Art League, 1902.

Valentine, John. "Rookwood Pottery." *House Beautiful* 4 (September 1898): 120–29.

Volpe, Todd M. "Rookwood Landscape Vases and Plaques." *Antiques* 117 (April 1980): 838–46.

"The World Famous Rookwood Ware." *Crockery and Glass Journal* 54 (December 12, 1901): 113–14.

Tiffany Pottery

Eidelberg, Martin. "Tiffany Favrile Pottery: A New Study of a Few Known Facts." *Connoisseur* 169 (September 1968): 57–61.

Koch, Robert. *Louis C. Tiffany, Rebel in Glass.* New York: Crown Publishers, 1964.

————. *Louis C. Tiffany's Glass—Bronzes— Lamps; A Complete Collector's Guide.* New York: Crown Publishers, 1971.

McKean, Hugh F. *The "Lost" Treasures of Louis Comfort Tiffany.* Garden City, N.Y.: Doubleday & Co., 1980.

Ruge, Clara. "Amerikanische Keramik." *Dekorative Kunst* 14 (January 1906): 167–76.

Stover, Donald L. *The Art of Louis Comfort Tiffany.* San Francisco: M.H. de Young Memorial Museum, 1981.

University City Pottery

Doat, Taxile. *Grand Feu Ceramics.* Translated by Samuel E. Robineau. Syracuse, N.Y.: Keramic Studio Publishing Co., 1905.

Evans, Paul F. "American Art Porcelain—Two: The Work of the University City Pottery." *Spinning Wheel* 27 (December 1971): 24–26.

Jervis, William P. "Taxile Doat." *Keramic Studio* 4 (July 1902): 54–55.

Kohlenberger, Lois H. "Ceramics at The People's University." *Ceramics Monthly* 24 (November 1976): 33–37.

Sargent, Irene. "Taxile Doat." *Keramic Studio* 8 (December 1906): 171–73, 193.

Verneuil, M. P. "Taxile Doat, Céramiste." *Art e Décoration* 16 (September 1904): 77–86.

Zimmer, William. "Crystallized Glazes." *American Ceramic Society Transactions* 4 (1902): 40–42.

Van Briggle Pottery

"A Colorado Industry." *House and Garden* 4 (October 1903): 165–68.

Arnest, Barbara M., ed. *Van Briggle Pottery: The Early Years.* Colorado Springs, Colo.: Colorado Springs Fine Art Center, 1975.

Best, Alice M. "The Art-Crafts Society of Denver." *International Studio* 30 (January 1907): cxiv–cxvi.

Bogue, Dorothy McGraw. *The Van Briggle Story.* Colorado Springs, Colo.: Dentan-Berkeland Printing, 1968.

Galloway, George D. "The Van Briggle Pottery." *Brush and Pencil* 9 (October 1901): 1–11.

Koch, Robert. "The Pottery of Artus Van Briggle." *Art in America* 52 (June 1964): 120–21.

Nelson, Scot H. et al. *A Collector's Guide to Van Briggle Pottery.* Indiana, Pa.: A. G. Halldin Publishing Co., 1986.

[Randall, J. E.] "A Structure of Combined Beauty and Strength in Clay—New Factory of Van Briggle Pottery, At Colorado Springs, Novel in Every Feature." *Clay-Worker* 49 (June 1908): 793–95.

Riddle, F. H. "The New Pottery and Art Terra Cotta Plant of the Van Briggle Pottery Company at Colorado Springs, Colo." *American Ceramic Society Transactions* 10 (1908): 65–75.

Sargent, Irene. "Chinese Pots and Modern Faience." *Craftsman* 4 (September 1903): 415–25.

Van Briggle, Anna Gregory. "The Potter's Art." *Scrip* 1 (February 1906): 157–61.

"Van Briggle Name Adds to Colorado's Fame." *Glass and Pottery World* 16 (April 1908): 15–16.

"Van Briggle Pottery." *Clay-Worker* 43 (May 1905): 645–47.

Weller Pottery Company

Cook, May Elizabeth. "Our American Potteries— Weller Ware." *Sketch Book* 5 (May 1906): 340–46.

Henzke, Lucile. "Weller's Sicardo." *Spinning Wheel* 25 (September 1969): 26–28, 67.

Huxford, Sharon, and Bob Huxford. *The Collectors Encyclopedia of Weller Pottery.* Paducah, Ky.: Collector Books, 1979.

Latour, Graf Vincenz. "Die Fayencen mit Metallreflexen von Golfe Juan." *Kunst und Kunsthandwerk* 2 (1899): 327–29.

Markham, Kenneth H. "Weller Sicardo Art Pottery." *Antiques Journal* 19 (September 1964): 18.

Purviance, Louise, Evan Purviance, and Norris F. Schneider. *Weller Art Pottery in Color.* Des Moines, Iowa: Wallace-Homestead Book Co., 1971.

————; Purviance, Evan; and Schneider, Norris F. *Zanesville Art Pottery in Color.* Leon, Iowa: Mid-America Book Co., 1968.

Rose, Arthur Veel. *S. A. Weller's Sicardo Ware.* New York: Tiffany and Co., 1903.

————. "Sicardo Ware." *China, Glass and Pottery Review* 13 (October 5, 1903): 19–21.

————. *Weller Art Pottery in Color.* Des Moines, Iowa: Wallace Homestead Book Co., 1971.

"S. A. Weller's new 'Mat Glazes.'" *American Pottery Gazette* 1 (April 5, 1905): 41.

Schneider, Norris F. *Zanesville Art Pottery.* Zanesville, Ohio: the author, 1963.

Tarter, Jabe. "The Art of Clewell Pottery." *Antiques Journal* 25 (February 1970): 22–23.